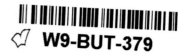
UNDERMINING

A WILD RIDE THROUGH LAND USE, POLITICS, AND ART IN THE CHANGING WEST

LUCY R. LIPPARD

THE NEW PRESS
NEW YORK & LONDON

SEDAN CRATER

Requests for permission to reproduce selections from this book should be mailed to: Permissions Department, The New Press, 120 Wall Street, 31st floor, New York, NY 10005.

Published in the United States by The New Press, New York, 2013
Distributed by Perseus Distribution

Cover Photo Credit: © Joan Myers 2013

ISBN 978-1-59558-619-3 (pbk.)
ISBN 978-1-59558-933-0 (e-book)
CIP data is available

The New Press publishes books that promote and enrich public discussion and understanding of the issues vital to our democracy and to a more equitable world. These books are made possible by the enthusiasm of our readers; the support of a committed group of donors, large and small; the collaboration of our many partners in the independent media and the not-for-profit sector; booksellers, who often hand-sell New Press books; librarians; and above all by our authors.

www.thenewpress.com

Book design by Bookbright Media
This book was set in Adobe Garamond and Century Gothic

Printed in the United States of America

2 4 6 8 10 9 7 5 3 1

DEDICATION

To my grandsons' generation, hoping that they are learning some lessons we learned too late, and that they will pursue them with creative energies. And to New Mexico, one of the loves of my life.

*

In memory of André Schiffrin, publisher extraordinaire, whose support over the years has meant so much to so many of us.

Members of El Consejo at camp protesting outside development of a traditional land grant, Tierra Amarilla, NM, 1988, following up the famous land grant battle of 1967, led by Reyes Tijerina. ● Levi Romero, Descanso y Leñeros, 2011. A roadside memorial in Española, NM, and trucks of firewood for sale, evoking the longstanding struggles in northern New Mexico over land use in the National Forests.

"Check out my gravel pit/A mystery unraveling. . . ./Don't go against the grain/If you can't handle it."

—Wu-Tang Clan

"Far from being a child of nature, the West was actually given birth by modern technology and bears all the scars of that fierce gestation, like a baby born of an addict."

—Donald Worster

"What I am saying does not mean that there will henceforth be no form in art. It only means that there will be a new form and that this form will be of such a type that it admits the chaos and does not try to say that the chaos is really something else. . . . To find a form that accommodates the mess, that is the task of the artist now."

—Samuel Beckett

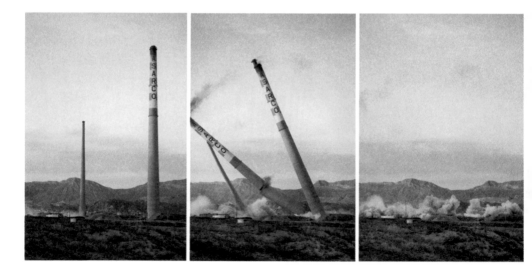

Martin Stupich, *Demolition of Lead Stock and Copper Stock*, ASARCO, EL Paso Smelter, April 2013.

ACKNOWLEDGMENTS

Above all, I am grateful to the photographers and artists who generously donated use of their images and to the good people at Creative Capital for their patience as they waited years for the results of a grant for "creative non-fiction" (never did figure out what that was) that allowed me to write this quirky book. To Jim Sloan for inadvertently inspiring the original lecture in 2000 by awakening my interest in gravel pits; Chris Taylor for suggesting I go ahead with the book after hearing a related lecture; Joan Myers for a fill-in photography trip around Galisteo; my local newspaper, the *Santa Fe New*

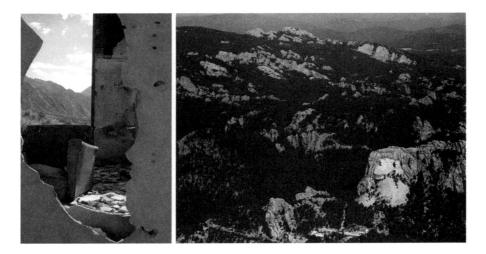

Jacques Garnier, *You Can Never Hold Back Spring*, chromogenic print, 2005, from Second Chances, Twentynine Palms, CA. ● John Willis, *Mount Rushmore National Monument*, 2007, in the sacred Paha Sapa (Black Hills), South Dakota. The grandeur of the land (stolen from the Sioux in the 1870s) puts into perspective the 60'-tall faces of four U.S. presidents carved by John Gutzon Borglum, 1926–41. The site, called Pilmaya (Six Grandfathers) by Lakota, is also sacred to Cheyenne, Arapaho, and Kiowa. (See Willis, *Views from the Reservation*. Chicago: The Center for American Places at Columbia College, 2010.)

Mexican, for consistent reporting on the politics of local land use, and *High Country News* for caring about the West. The following people offered crucial information and image leads: Kirk Bemis of Zuni Pueblo, Ann M. Wolfe of the Nevada Museum of Art, Mariel Nanasi of New Energy Economy, Ruth Hardinger, Simone Swan, Jan Willem Jansens, Jaune Quick To See Smith, Ethan Ryman, Katherine Wells, Rebecca Solnit, Jennifer Denetdale, Susana Torre, Phillip and Judy Tuwaletstiwa, the New Mexico Environmental Law Center, and, as usual, Jim Faris for enduring this endless process. And of course, The New Press, my stalwart publisher for twenty-five years: founder Andre Schiffrin, editor Marc Favreau, assistant editors Jed Bickman and Azzurra Cox, Managing Editor Maury Botton; Ebonie Ledbetter, Beth Long, and Cinqué Hicks of Bookbright Media.

I have occasionally plagiarized myself from previously published essays, lectures, and books, repeating some ideas that won't go away. Among them: "Land Art in the Rear View Mirror," *Art and the Landscape*. Marfa, TX: Chinati Foundation, 1995; "Gravel Pit: Cerrillos, New Mexico," *New Observations*, 2001; "The Fall," Joan Ockman and Salomon Frausto, eds., *Architourism: Authentic Escapist Exotic Spectacular*. New York: Buell Center/Columbia School of Architecture, 2005; "Peripheral Vision," Taylor and Gilbert, eds., *Land Arts of the American West*, 2009; "Land Art in the New West," *Land/Art New Mexico*; "Too Much: The Grand Canyon(s)," Saunders, ed., *Nature, Landscape, and Building for Sustainability*, 2008; and "Green Zones," *Lab Report*, no. 2, Phoenix Urban Research Laboratory/ASU College of Design, 2008.

Unless otherwise specified, all images are courtesy of the artist/photographer, and quotations in the captions are by the artists. Unattributed photographs and quotations are by the author.

CAPTIONS: Page i, left: Peter Goin, *Sedan Crater*, Nevada Test Site, 1987. The crater—635' deep, 1280' in diameter, was created by a thermonuclear device that moved 12 million tons—a test by the Plowshares Program to explore peaceful uses of nuclear explosions for roads, mining, and aggregate production. (See Peter Goin, *Nuclear Landscapes*. Baltimore: Johns Hopkins University Press, 1991.) ● *Page i, right:* David Taylor, *Border Monument No. 81. N31 [degrees] 20.048' W109 [degrees]*, 2009. Taylor documented these shabby official obelisks in the 2,000 miles of harsh and barren landscape of the US/Mexico border and the social contexts in which they exist. (See *David Taylor: Working the Line*. Santa Fe: Radius Books, 2010.)

UNDERMINING

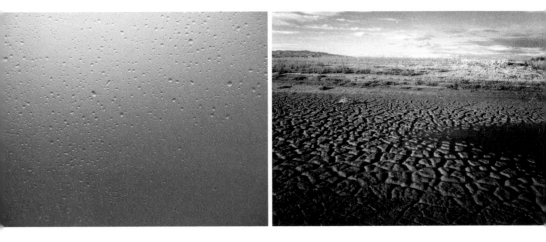

Gregory Sholette, *Torrent*, February 2013. Video installation, window of Printed Matter, art-ists' bookstore in New York City, after its basement archive was flooded by Superstorm Sandy. "Books float, documents sink, and memories are laundered" (Photo: Matthew Greco). ● Robert Dawson, *Drying Rye Patch Reservoir*, western Nevada, 1994, dye color print.

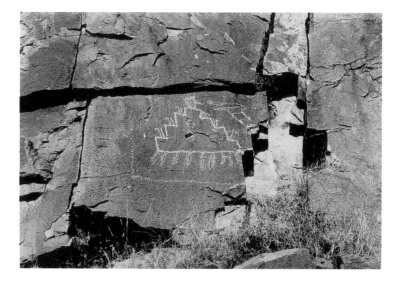

Edward Ranney, *Cloud Terrace, Southern Creston*, 2009. Petroglyph by Tano (Southern Tewa), Galisteo Basin, NM, c. 1300–1500. This stepped form, associated with life-giving rain and the cloud home of ancestors and deities, also appears in many of today's Pueblo ceremonies, where women dancers often wear stepped headdresses.

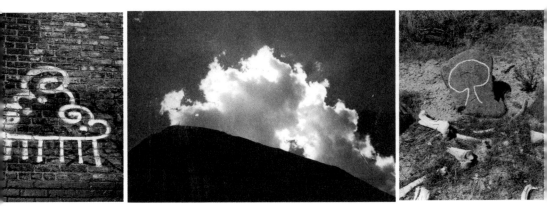

I LIVE IN ONE OF THE LOWER LEVELS OF A PIT, AN ARID ANCIENT
seabed in northern New Mexico called the Galisteo Basin, where clouds of
moisture circle the mountains and then ignore us, going on to other high
places. The Tano (Southern Tewa) people lived "down country" for some
five centuries (circa 1250–1782) in the eight huge pueblos scattered through-
out the basin. Once two or three stories high, these impressive buildings are
now pits and mounds of melted adobe covered by grass and cactus. In their
ceremonies, the Tanos evoked clouds, rain, mountains, and springs—the un-
derworld from which their people emerged and the heights where ancestors
and deities awaited their prayers. They used gravel as mulch in their gardens
to capture warmth and water for the crops.

Gravel—an aggregate formed by water—became the unlikely inspiration
for this book, a collage of concerns about the ways humans intersect with
nature in the arid Southwest. The humble gravel pit offers an entrance to the

Tom Martinelli, *Cloud Terrace Graffiti*, New York City, 2006. • *Cloud Terrace*, Galisteo Basin.
• Peter Goin, *Mushroom Cloud*, 2001. This modern petroglyph from the Black Rock country of
northern Nevada is by the eccentric artist DeWayne Williams, who decorated over a mile of
roadside with engraved rocks, arranged artifacts, and pop culture monuments.

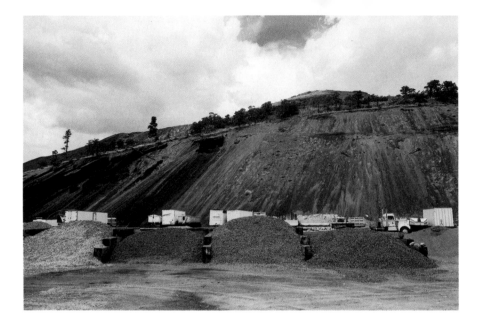

strata of place, suggesting some fissures in the capitalist narrative into which art can flow. The title, *Undermining*, has been attached to the project since its haziest inception: undermining literally—as in pits and shafts that reflect culture, alter irreplaceable ecosystems, and generate new structures; undermining's physical consequences, its scars on the human body politic; undermining as what we are doing to our continent and to the planet when greed and inequity triumph; undermining as a political act—subversion is one way artists can resist. The elements play their part: earth (mining, land art, adobe, archaeology), air (breath, pollution, death), fire (global warming) and water (from above, stored below). Water and natural resources, and their unnatural exploiters—developers, along with the coal, uranium, gas, oil, gravel, and other industries—offer both vertical and horizontal images, wells and rain, underground aquifers, drilling equipment, mountain runoff, irrigation and ditches . . . and the kitchen sink.

John Ganis, *Landscaping Stone*, Flagstaff, AZ, 1995, chromogenic print. In a poem accompanying Ganis's images, anthropologist Stanley Diamond writes: "A culture is its refuse. . . ." (See Ganis, *Consuming the American Landscape*. Stockport, UK: Dewi Lewis Publishing, 2003.) In this case, nature itself is the refuse, or product.

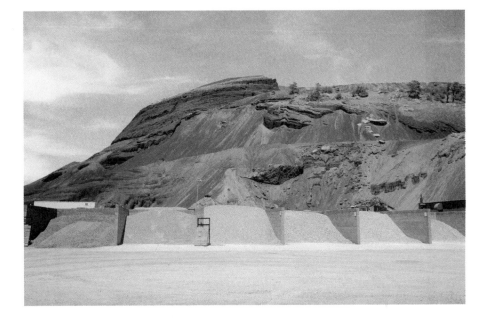

Gravel pits provide a dialectical take on the relationship between my own three-and-a-half decades in the Lower Manhattan activist/avant-garde art community and two decades in Galisteo—a tiny New Mexico village (population 250). An influential few years were spent part time in the foothills of the Colorado Rockies, where my maternal grandparents were raised, and where I began to explore indigenous pasts. And for three decades contemporary Native (American) artists have challenged many of my Yankee predispositions. Sometimes the tools I bring from a lifetime in and on the edge of the arts are pretty useless when confronting land use and abuse. During roughly twenty-five years in the western United States, I've learned a new vocabulary, or perhaps forgotten the old one. It's a stretch to squeeze modernism, modernity, post-modernity, and the shifting mainstreams of the art world into the framework of my current lived experience, which is what I always work from. John Fraser Hart defined geography as "curiosity about places." Once

Center for Land Use Interpretation Photo Archive, *Sheep Hill Cinder Cone*, AZ, 2012. James Turrell's nearby Roden Crater, a massive, experiential, sky-and light-viewing earthwork in a long-extinct volcano, has been in process in a similar cinder cone since 1979.

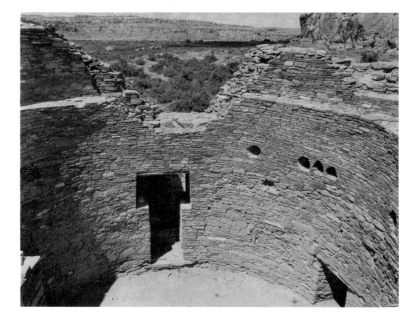

in the West, I began to write about "place" and landscape, encompassing history and archaeology. Eventually, thanks to growing involvement in local politics, I realized that "land use" could be a more realistic replacement for the too easily romanticized notion of "land" and "earth" as in landscape, land art, and earthworks. So this book is more concerned with land use than with landscape, more focused on what we learn from living in place than what we see when we look out the windows.

Beginning with gravel pits and archaeology, I'm trying to see what art will finally fit in my baggage as I cross disciplines and wander further afield. Because of course I have baggage, and a lot of packing and unpacking to do as I travel the roads between local and global, rural and metropolitan, stopping at historical markers and the roadside attractions of photography and land art. Symbiotic pits and erections—riffs on the vertical reversed, negative and positive, ups and downs, past and present—kept emerging to form the grid

Peter Goin, *Kiva N Complex, Chetro Ketl*, 2000, Chaco Culture National Historical Park, NM. Chetro Ketl is the second largest of Chaco Canyon's monumental "great houses," built by Ancestral Puebloans from around 850–1200. It has some four hundred rooms, possible Mesoamerican architectural influences, and numerous kivas, or subterranean gathering places. This "great kiva" accommodated large numbers of people, possibly for periodic ceremonies involving the entire "Chaco world."

(or conceit) on which this parallel visual/verbal narrative is constructed. The book is less about the many subjects covered as it is about the connections between them. The challenge is keeping the warps and wefts on the loom. My methodology is simple and experiential: one thing leads to another, as in life. Arthur Rimbaud put it more viscerally: "thought latching on to thought and pulling."

Cultural history and cultural geography are the operative factors here—the base for digressions into more technical information. I agonized about the role of statistics in this story, cutting them out, putting them back in. We are susceptible to the sea of numbers engulfing us, and they are, like maps, easily manipulated. Yet even in their volatility, they do convey the enormity of some of the problems our lands and people are confronting. So I have retained some—not as thorough or indisputable data so much as suggestions of what we are up against.

Author's longtime loft home in Lower Manhattan, 2013. ● Galisteo, NM, 2013. A classic northern New Mexico juxtaposition: a nineteenth-century adobe ruin, a modernist rastra home (designed by Beverly Spears), and the author's neo-traditional house in the right background (Photo: Ethan Ryman).

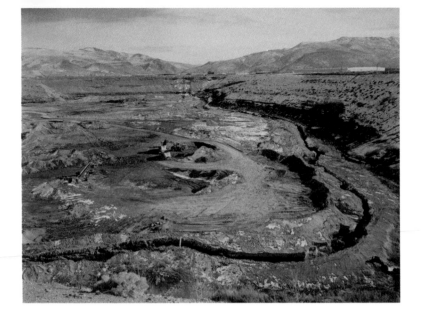

MY ACCIDENTAL PREOCCUPATION WITH GRAVEL PITS BEGAN
in 2000 when I wrote an editorial in my community newsletter bemoaning
the incursion of gravel mines west of our rural village. I was taken aback when
the local earth mover—a progressive guy who's also a painter and a skepti-
cal environmentalist—reproved me. He said (in so many words): Hell, you
used gravel for your road. Everybody wants gravel, but they don't want gravel
mines. Robert Baker [a friend's pseudonym for an unpopular local gravel tsar]
is a son of a bitch, but he's our son of a bitch. If you're going after gravel min-
ers, take on Lafarge, a multinational gravel mining company. They're taking
over the American West, putting the locals out of business.

That was a surprise. I'd naively considered gravel pits, when I considered
them at all, as the epitome of local enterprise. Mom and Pop have some oth-
erwise unproductive land and a pickup, they need money, and they go for it.
I'm told this is the way it used to be. Global takeovers are harder to imagine.

Peter Goin, *Helms Gravel Pit*, Sparks, NV, just north of the Truckee River, 1990. In 1987, a 250'-wide
oil slick from a tank farm and railyard seeped into this 120'-deep gravel pit, preventing millions
of gallons of oil from reaching the river. The oil companies paid for remediation but Helms went
bankrupt. During the New Year's Day flood of 1997, the Truckee River flowed into the pit, erod-
ing and closing Interstate 80 for several days, but ironically facilitating the emergence of the
Sparks Marina Park.

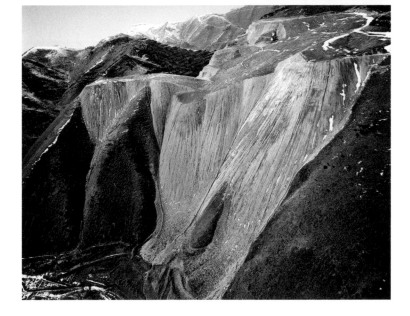

Scale is a big issue, visually and economically, even in the once open-ended West. Most landscapes are actually designed by culture at the hands of anonymous amateurs who work by trial and error and privilege function over form. Then hired professionals try to make sense of what's there and capitalize on it with their own individual talents. The very term cultural landscape is a way of thinking about art and landscape issues that was partially invented by John Brinckerhoff (J.B.) Jackson—a seminal cultural geographer who lived in New Mexico, just west of where I settled. He defined landscape as "a concrete, three-dimensional, shared reality"—a collaboration between people and nature rather than an idealized picture or view of what lies beyond our own centers.

Soon after my conversation with the earth mover, I was looking for a novel way to approach land use through an art frame for a symposium on cities. I began to think about gravel pits as a metaphor for the underground level of

Michael Light, *Tailings of Barney's Canyon Gold Mine Looking North*, near Bingham Canyon, UT, 2006, 40" x 50", pigment print. © Michael Light. (Courtesy of Hosfelt Gallery, San Francisco). At 8,000 feet in the Oquirrh Mountains, southwest of Salt Lake City, the Bingham Canyon open-pit copper mine (capitalized by the Guggenheim family in 1906) is the largest human-made excavation on the planet, over ½ mile deep with a 3-mile rim. Its smelter stack is the tallest free-standing structure west of the Mississippi.

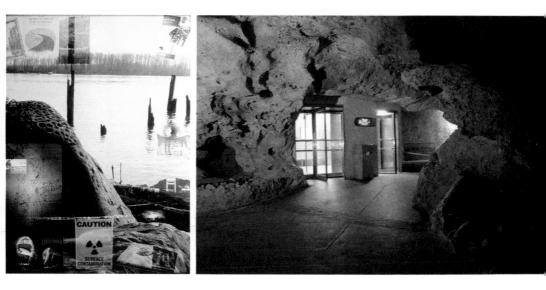

a twenty-first-century cultural landscape, or the "subterranean economy," to take a Jackson phrase out of context. That seemed a fitting subtext for cultural practice. An increasing number of artists/activists are taking up the land use challenges—not just shooting photographs of undermining, but digging deeper, so to speak, into the underlying issues.

Chiseled on the façade of an old grammar school in Fort Benton, Montana, is this admonition: "INDUSTRY IS USELESS WITHOUT CULTURE," a message that still resonates in the post-industrial age. Culture is a far broader term than art and can embrace social energies not yet recognized as art. If much contemporary art appears divorced from the popular expectations of "fine arts," it remains a way of seeing, sometimes more connected to or embedded in life than previously expected. While entangling visual art with the cold realities of our current environment, some artists are realizing that they can envision alternative futures, produce redemptive and restorative vehicles

Brad Yazzolino, *Landscape Obscured by Documents*, 1992, oil and carbon transfer on paper, 30" x 44". The montaged documents, ranging from the 1940s to the 1970s, relate to land use, salmon, boundaries, water supplies, private and public property, "wise use," and more, in the Bull Run Watershed within the Mount Hood National Forest near Portland, Oregon. Others in this series include nineteenth-century oil paintings and U.S. Geological Survey papers. ● The Center for Land Use Interpretation Photo Archive, (CLUI) *Carlsbad Caverns National Park, New*

with which to open cracks into other worlds, and rehabilitate the role of the communal imagination. Artists are good at slipping between the institutional walls to expose the layers of emotional and esthetic resonance in our relationships to place. They can ask questions without worrying about answers. I continue to count on the reconstructive potential of an art that raises consciousness on the land, about land use, history, and local culture and place, considered at length in my 1997 book, *The Lure of the Local*. Writing about conceptual, feminist, and political art as "escape attempts," I've concluded that the ultimate escape attempt would be to free ourselves from the limitations of preconceived notions of art, and in doing so, help to save the planet.

In the 1930s, Henri Cartier-Bresson complained: "The world is going to pieces and people like [Ansel] Adams and [Edward] Weston are photographing rocks!" In a plea for the importance of the esthetic at a time, like today, when art can seem insignificant compared with the perils offered by

Mexico, from CLUI's Subterranean Renovations: The Unique Architectural Spaces of Show Caves, 1998—a project on natural caves developed into tourist attractions, from surface to underworld. This elevator, allowing larger crowds, deliveries, and accessibility, was preceded by a bucket lift delivering workers down to the cavern's guano mine in the 1920s. • Mitch Do-browner, *Bentonite Waves*, Caineville, UT, 2007.

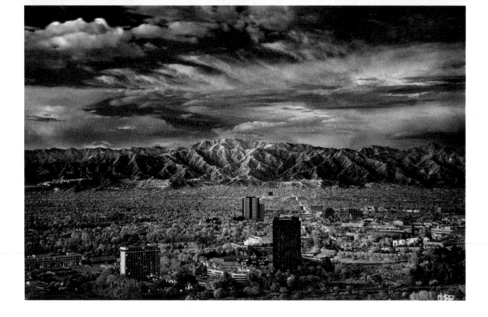

life, Adams replied that a rock was more socially significant than a line of unemployed. I wouldn't go that far. I'm usually on Cartier-Bresson's side, but maybe I'm following Adams here by forcing the gravel pit on you because it offers a way to create in writing and images a *context* for the microcosmic aspects of global change our western landscapes and rural villages are undergoing—cultural and social changes similar to those that took place in the Southwest after World War II.

Out on the margins, where local scars cover for global perpetrators, we live in a distorted mirror image of the center, which perceives our "nature" as primarily resource. Here negative space can be more important than what's constructed from its deported materials elsewhere. The gravel pit, like other mining holes, is the reverse image of the cityscape it creates—extraction in aid of erection. If the modern city is vertical (a climb, leading to a privileged penthouse overview), landscape is predominantly horizontal (a walk, through

Mitch Dobrowner, *Daybreak, Los Angeles*, 2009. An eerie image highlighting the intrusion of urban erections into dramatic natural locations. Despite its reputation for sprawl, LA is the densest city in the U.S. ● *Kapulani Landgraf, Waikapū (Sacred Waters)*, 2011, hand-etched silver gelatin print, 23½" x 28", from *Ponoiwi* installation. Waikapū is an ancient burial site being sand mined by American Hawai'i and shipped to Oahu for the construction industry. Native Hawaiians believed their ancestors' mana lived in the bones. ● Phil Young (Cherokee), *Genuine Indian Trad-*

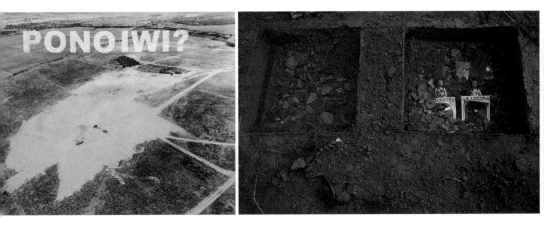

all walks of life). Like archaeology, which is time read backwards, gravel mines are metaphorically cities turned upside down, though urban culture is unaware of its origins and rural birthplaces. Where the vertical rules—from nineteenth-century surveyors planting flags and proclaiming dominion from the loftiest mountain peaks to the hundredth stories of skyscrapers where corporate CEOs (the real occupiers of Wall Street) peer down at protestors—the power of upward is added to outward mobility.

Like graves, these pits—whether they are dwellings or burial grounds or archaeological digs or the remnants of industries that claim to keep us alive—are eventually abandoned, their meanings forgotten, leaving stubborn scars on the land. Such "dead zones" are illuminated by Timothy J. LeCain in *Mass Destruction*, his fascinating book on the giant western copper mines. Sometimes the graves are more recent. In February 2004, an Albuquerque man died in a gravel pit, New Mexico's "first mine fatality" of the year. And

ing Post and Burial Site, 1991, detail, multimedia installation, Gallery of the State University of New York College at Oneonta. The gaudy commercial "trading post" included archaeological grid lines and burial, two plastic "princesses," and a postcard of a "proud, stoic chief" at Mt. Rushmore, reflecting Young's satiric humor and indignation at the desecration and stereotyping of indigenous people and places.

after the European conquest, the graves of innumerable Native people were cheerfully excavated and "collected" by cultural institutions, while others have been turned under in the process of mining.

Since 1990 it is required by law (The Native American Graves Protection and Repatriation Act, or NAGPRA) that human remains found on public lands be returned to the tribes for proper burial. It is rare that non-Native people have the same problem, though consider the clamor for proper burial of unidentified scattered body parts after September 11, 2001. Or the 2012 newspaper report about the Lowellville Cemetery in eastern Ohio, beneath which, "Deep underground, locked in ancient shale formations, are lucrative quantities of natural gas." With two other local cemeteries, Lowellville received offers from a Texas firm for their mineral rights, plus percentages of oil and gas royalties from companies claiming that no graves would be disturbed. The offer was rejected. Area activists are fighting for a citywide drilling ban.

Sometimes there is justice. In 2004, gas drillers plowed through the cemetery of a historic Black coal camp community in West Virginia. The resulting lawsuit took six years, but the company was ordered to pay $200,000 in punitive damages, plus $700,000 in compensatory damages.

REAL GRAVEL—NATURALLY CREATED PEBBLES—IS GEOLOGICAL debris, constructive disintegration, alluvial, water-born, dug from old streams and lake beds. Fake gravel is just crushed rock, produced by the ecologically destructive processes of dynamite and hard rock mining. Scarce water is used to separate it from its mother lode, encouraging erosion and sometimes polluting precious drinking water in the process. In the arid Southwest, gravel pits can be less than eyesores. If the site is not squirming with machines, it isn't clear whether the pit is industrial or natural, recently broken into for profit, or eroded by wind and water over millions of years, or art—massive outdoor

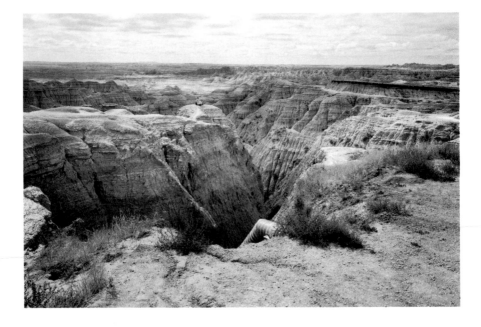

productions first called earthworks in the 1960s. As traditional rural western industries like ranching and mining subside, bowing to the contradictory needs and concerns of changing economies, gravel pits remain, sometimes as quarries full of discarded appliances gradually giving nature indigestion. As ruins, gravel pits are decidedly unspectacular. Their emptiness, their nakedness, and their rawness suggest an alienation of land and culture, a loss of nothing we care about.

Gravel pits transform the incomprehensibly distant geological past into dubious futures. For many, gravel pits represent pure financial potential as the bedrock of skyscrapers and the backbones of highways. They are crucial to the production of modern spaces in landscapes like New Mexico, one of the poorest states in the union, where opinions on land use divide not only along political lines, but along historical lines between Native peoples, longtime Nuevo Mexicanos, and Anglos (relative newcomers from Texas, California,

John Ganis, *Family at Badlands National Park*, SD, 1990, chromogenic print. Ganis combines metaphor with "lens-formed" facts about a "world littered with the remains" of human enterprise. ● Michael Light, *Interchange of Highways 60 and 202 Looking West*, Mesa, AZ, 2007, pigment print 40" x 50". (Courtesy of Hosfelt Gallery, San Francisco). © Michael Light. From 2000 to 2008, Phoenix's metropolitan area expanded a stunning 32 percent. "The Valley of the Sun" is

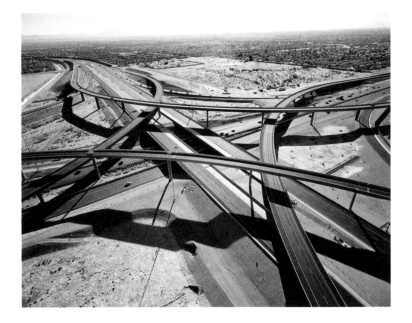

or "back East") and, to add to the complexity, the *new* (often undocumented) New Mexicans from Old Mexico.

GRAVEL AND TRAVEL ARE SYMBIOTIC. THE HORIZONTAL IS iconic in the western landscape, representing the onward and outward of western expansion, or Manifest Destiny. First came footpaths, then exploratory trails, most following those made by the First Nations—a history unfolding "as a geometry of interruption and yearning," writes artist/historian Andrew Menard in his book *Sight Unseen: How Fremont's First Expedition Changed the American Landscape*. Then came wagon roads, railways, highways—extended construction leading to sprawl. We are drawn through the American landscape on "the fingers of imperialism," as Chellis Glendinning once put it. The road becomes a place in itself—described as a "site of mobility" by Jackson. Carl Andre, whose horizontal focus helped redefine the sculptural axis in

now the fifth largest incorporated city in the U.S., supporting 4.5 million people. The Central Arizona Project, the nation's largest and most expensive aqueduct system, brings water 336 miles from the Colorado River to make the desert bloom, at least for now, "amidst a topography of unfettered capitalism, a geology of socioeconomic stratification, and an architecture of unapologetic hubris."

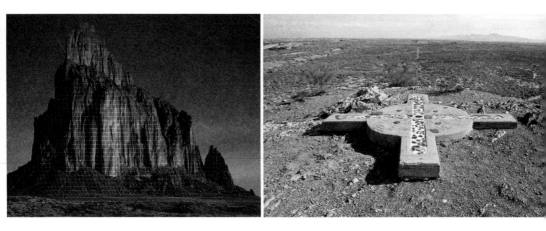

the 1960s, saw his work as a road. From 2000–02, Albuquerque's "Big I"—a looping vertical and horizontal crossroad of the two major interstate highways (I-25 north/south and I-40 east/west)—was remodeled in an extraordinary two-year public construction project—the best show in town. Local land artists suffered from Big I envy, recalling sculptor Tony Smith's epiphany in the 1950s when he saw the New Jersey Turnpike under construction.

Western expansion eventually laid an awkward Jeffersonian grid of townships and sections across an apparently untamable land. "The grid," writes Menard, "was basically an attempt to overcome history by design . . . the republic would be reborn each time the grid advanced." Today living "off the grid," as I do on solar, is a political statement as well as a metaphor. Every rejection of the national, corporate, electric grid is a declaration of independence from capitalism. Alteration of the Minimalist grid in art (especially feminist art) paralleled the ways in which "back roads" twist and turn, tan-

Jim Sanborn, *Topographic Projection: Shiprock, New Mexico*, 1995, cibachrome print, 20" x 36". The ironic/esthetic imposition of the universal colonial grid on the 7,178' Navajo sacred site (Tsé Bit'a'í, or the Rock with Wings) looming from the desert floor, has implications rooted in both contemporary art and American history. ● The Center for Land Use Interpretation Photo Archive, *Anchors of American Grids*, 2012, Gila + Salt River Meridian, Arizona. CLUI's project was executed with the Institute of Marking and Measuring. ● Bill Gilbert, *For John Wesley Pow-*

talizing and seducing in their intimacy, inviting invasion of previously wild or private places, and urging us, paradoxically, to follow others in search of solitude. These "blue highways" inspired William Least Heat-Moon's homage to the increasingly outdated paper road map, now almost replaced by automotive GPS systems. Along the back ways are "borrow pits," where civilization "borrows" from nature to build roads—a term that could be used much more widely in the western landscape.

Lines across the map, across the land, inform a way of seeing that flattens and blurs the places they run through, like photography—one reason it is the art form preferred by so many contemporary western artists; it has grabbed me too in my decades in the West. In his last book—*West and West*, the late Joe Deal talked about his intention to reimagine what lies beneath the surveyor's grid in the open and relatively featureless spaces of the Missouri Plateau in North Dakota. If the square employed in surveys of public lands,

ell, *Attempt to Walk the Grid*, September 9, 2005, Good Hope Bay, Lake Powell: walk one hour in each cardinal direction, orientation true north. Gilbert's series on the difficulties of walking the grid, even with hi-tech aids, examines the experiential contradictions within "nature" and "culture." • Carl Andre, *Joint*, 1968, hay bales, Windham College, VT. (Courtesy of Paula Cooper Gallery, Licensed by VAGA). Temporary piece in conjunction with an exhibition curated by Seth Siegelaub.

he said, "could function like a telescope, framing smaller and smaller sections of the plains down to a transect, it can also be used as a window, equilaterally divided by the horizon, that begins with a finite section of the earth and sky and restores them in the imagination to the vastness that now exists only as an idea: the landscape that is contained within the perfect symmetry of the square implies infinity." Like many contemporary photographers, Deal can make what initially looks like nothing look like something we should have noticed—as opposed to the kind of photography described by William Fox as merely "an advertisement for nature."

MY LOCAL ROADS AND, SYMBIOTICALLY, OUR LOCAL GRAVEL pits, have their own stories to tell. Rural New Mexico's blue highways and "scenic byways" are being widened for commercial traffic and bike lanes, altering domestic viewsheds and wildlife migration trails, encroaching on open

The Hill, Galisteo, NM. Site of the original Hispano village founded c. 1814.

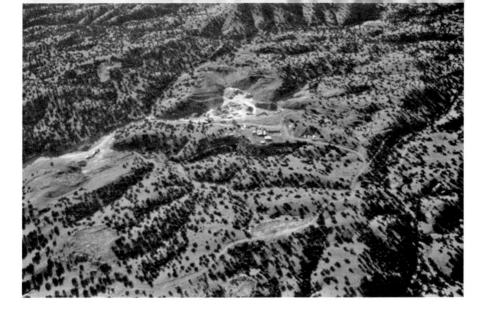

space. My own little house by the highway lies next to a two-lane rural artery that runs straight through the heart of our village, where once a wide, undefined dirt plaza in front of the church centered a community surrounded by fields and orchards. Outside of rush hours (those from the south county who can't afford to live in Santa Fe, where they work), there has never been much traffic. But now we see more than thirty gravel trucks per day, as well as gas and oil tankers weighing some 40 tons, tearing through from Moriarty, 28 miles south, passing over a concrete bridge built by the WPA in 1936, with a 15-ton capacity.

The extraction process itself is problematic enough, but these behemoths barreling through tiny adobe villages spew dust and stones, shake historic adobe buildings to their foundations, crack these chunks of cultural history and rend the illusion of quiet village life. Like others of its kind in the region, this minor state highway is slated to become a multilaned "throughway" to

Ross Lockridge/LightHawk, *Aerial View of Cerrillos Gravel Products Pit*, 1998, western Galisteo Basin north of the Ortiz Mountains. Nearby is the Cerrillos Hills Park (a cross-cultural redundancy; *cerrillos* means little hills), locally initiated by a County bond issue for open spaces, then adopted by State Parks. It is the site of many closed mines, including historically significant galena mines worked for centuries. Sale to the County for preservation remains in question.

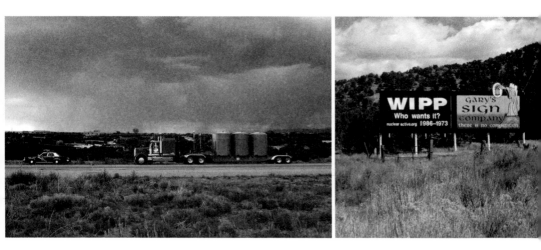

make it more accessible to commerce and less so to wildlife and village residents. Local groups protesting overload seek the designation of "scenic byway," which offers some protection.

Across ranchland a couple of miles to the east, another rural highway—U.S. 285—was transformed into a four-lane speedway a decade ago, cutting through archaeological sites to accommodate the special trucks bearing transuranic nuclear waste to WIPP, the Waste Isolation Pilot Plant, which opened in 1999 in southeastern New Mexico. The third road on our village's radar is County Road 42, connecting the two "arterials" that run north/south on either side of the Galisteo Basin (confusingly numbered NM 41 and NM 14). The western road is the tourist-touted "Turquoise Trail," which has been successfully designated a scenic byway, thanks to intense local activism. Until a few years ago CR 42 was a hilly, twisting, washboard dirt road through empty rangeland, crossing an arroyo that is dangerous in flood season, and

Donald Woodman, *WIPP Transport Truck with New Mexico Police Escort*, 1989. © Donald Woodman. ● *Anti-WIPP sign*, near El Dorado, NM, late 1990s.

generally avoided by strangers. But in the last decade it too has been paved, widened, and renamed Camino de los Abuelos, or Grandparents' Road. (I lobbied unsuccessfully for Mad Gal Road, since it connects Madrid and Galisteo.) When it was paved, more houses followed, and huge gravel trucks roar around its curves—a disaster waiting to happen.

The western half of the Galisteo Basin has been constantly exploited as a mining district since at least the tenth century. First turquoise, then lead, and later silver, gold, copper, and coal have been mined there. The basin is also a source of Bentonite clay; the family of a ceramic artist from Galisteo is restoring and using what was once an ancient Pueblo clay source after years of commercial mining by a brickworks. In the adjacent Ortiz Mountains, an 1820s gold rush preceded the Forty Niners. Between 1980 and 1987, Gold Fields Limited, a South African corporation, operated a gold mine on the site of centuries-old diggings in the Ortiz, complete with deadly cyanide leach ponds. Twenty-five

Joan Myers, *Coke Ovens*, Waldo, NM, 2013. Waldo—long gone—was the site of a rail spur bringing coal from nearby Madrid mines. (See William Baxter, The *Gold of the Ortiz Mountains*. Santa Fe: Lone Butte Press, 2004.)

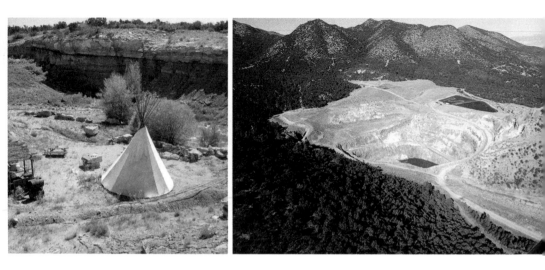

million tons of rock were removed and 250,000 troy ounces of gold were extracted, leaving behind an open pit, 385 feet deep, that is slowly filling with water. When LAC Minerals took over the mine, an Acid Mine Drainage problem emerged—a plume of cyanide and nitrates found in the ground water. Citizens' opposition to the mine intensified and it was closed in 1990. The company spent a rumored $19 million in remediation and eventually donated the highest mountain portion of their holdings to the Santa Fe Botanical Garden, which has in turn embarked on a decades-long process to sink the exposed sulfides in the deep pit. This has not deterred another multinational affiliate, Santa Fe Gold, from proposing a huge new gold and copper mining operation somewhat south in the same mountain range. In 2013 the corporation sent out thousands of glossy brochures touting an environmentally friendly, cyanide-free technology as it forges ahead with the permitting process. Opposition includes local residents, archaeologists, and tribal members protecting sacred sites.

Pueblo Blanco Clay Pit, Galisteo Basin, 2009. ● *Goldfields Ltd. Arroyo Viejo Gold Mine*, Cunningham Gulch, on the eastern slopes of the Ortiz Mountains, Santa Fe County, 2000 (Photo: William Baxter/LightHawk). In 2007–08, the Galisteo Basin's tiny communities managed to push back a Texas firm's oil and gas leases, resulting in the county's rigorous ordinance regulating gas and oil development in scenic, culturally, and environmentally sensitive areas.

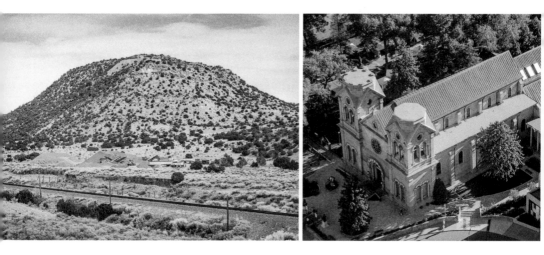

There are several gravel pits in Galisteo's immediate environs. The one nearest the village—a relatively modest affair with piles of dirt and big yellow dozers—lies on the bank of the Galisteo Creek, our riparian water supply, which was pushed off course by construction of the railway in 1880. Owned by another local curmudgeon (who once recommended that property owners finding archaeological sites should destroy them and tell no one, because otherwise development would be slowed), it lies in the shadow of Cerro Colorado, a small hill stepped by a nineteenth-century sandstone quarry for construction of the Saint Francis Cathedral in Santa Fe. Across the creek from the pit are the almost imperceptible ruins of a twelfth- to thirteenth-century pueblo. This is the pit that coughed up the gravel for my driveway, among others.

Yet another proposed gravel pit to the west would have taken out half of Buffalo Mountain (sacred to Kewa or Santo Domingo Pueblo). It was saved

Joan Myers, *Cerro Colorado and Gravel Pit*, Lamy, NM, 2013. ● Joan Myers, *St. Francis Cathedral*, Santa Fe, NM, 2007.

when the cities of Albuquerque and Rio Rancho rescinded deals to supply 15,000 to 20,000 gallons of water a day to the J.R. Hale Company, a smaller-time competitor of Lafarge and Old Castle—the largest gravel contractors in the area. The County Development Review Committee and Kewa Pueblo joined in opposition. Hale withdrew its application. Buffalo Mountain was saved, for the time being.

All of these pits offer up lessons in local and global power relations. The contractor on CR 42 was the aforementioned "Robert Baker," the gravel tsar of northern New Mexico—a litigious despoiler of archaeological sites who has stooped to using ancient rock art as raw material. Gravel trucks destroyed the dirt road; then he was paid to repair it. Further north, Baker once planned to level an entire mountain next to a pre-European pueblo ruin and a contemporary village, in order to provide gravel for the widening of the WIPP route. He has been the target of an activist group, Vecinos del Rio, from

Madrid, NM, with coal tailings, 2013 (Photo: Barbara Anschel). The company coal town of Madrid (accent on the first syllable), in the Ortiz Mountains, operated from 1919 to 1954, when it was put up for sale for $250,000; there were no takers. In the 1970s, Madrid pulled itself up out of the abandoned slag heaps to become a funky tourist destination anchored by the Mineshaft saloon and a "mining museum." This is where David Bowie "fell to earth."

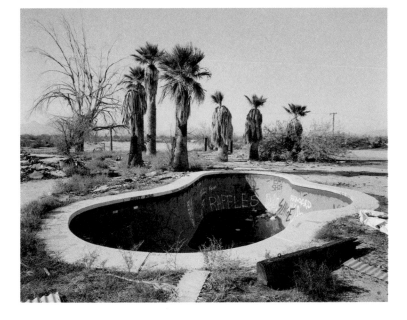

northern villages. In 2006, when his Copar Pumice Company's El Cajete mine in the Jemez Mountains came under fire for noise and toxic dust, the *Santa Fe New Mexican* published "A Look Back" at a list of nine controversies involving Baker's ventures over an eight-year period, ranging from Highway Commission contracts to violations, private and public lawsuits and settlements, to his suspicious appointment to the state's Mining Safety Advisory Board (he resigned after three years). He has been frequently cited for violation of the Clean Air Act; local populations complain of a high asthma rate. He pays the fines and goes his merry way. As the ground is leveled, the ironies continue to pile up. There is some poetic justice in the fact that further north, the Indian pueblo of Ohkay Owingeh, whose ancestors created the petroglyphs near the northern village of Velarde threatened by Baker's gravel enterprise, is one of the few communities to have successfully resisted his invasions by enforcing (for a while) a longstanding weight limitation ordinance

Michael Berman, *Pool and Palms*, Gila Bend, AZ, from the portfolio *Under a Dry Moon, One Hundred Views of the Gran Desierto*, Golden, CO: Infinite Editions, 1999.

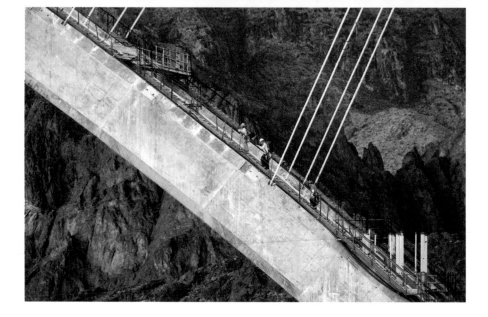

on their through road. Ultimately that didn't stop him any more than a 1999 Rio Arriba County gravel ordinance did. At the same time, he has cooperated with the local Petroglyph Project to record rock art—sometimes one step ahead of his bulldozers, but also displaying an apparent interest in long-term support for preservation and an eventual National Monument.

GRAVEL IS THE MAJOR INGREDIENT IN CONCRETE—AN AMALGAM of cement, gravel, crushed stone, sand, and water, plus possible additives. It is the bottom line for, among other things, dams—monuments to western expansionism and global disarray. Hoover Dam, southeast of Las Vegas, Nevada, boasting 3.2 million cubic yards of the stuff, was once the largest concrete structure in the world (outdone in 2009 by China's Three Gorges Dam). "New York City adds concrete to itself at the rate of approximately one Hoover Dam every eighteen months," wrote David Owen in an eloquent

Jamey Stillings, *The Bridge at Hoover Dam, Ironworkers on Arch,* April 30, 2009. Each shift, workers climbed up the Nevada-side arch segment. Cable stays supported the arch construction until the span was completed. (See Stillings, *The Bridge at Hoover Dam.* Portland, OR: Nazraeli Press, 2011.)

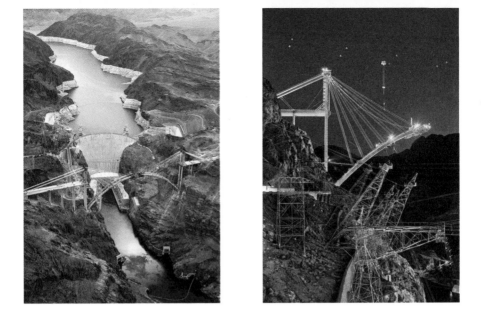

paean to concrete's role in the construction of Manhattan, which was gridded in the early nineteenth century: "The tight spacing left little room for yards or gardens or parks, and, as new buildings rose and multiplied, the sky withdrew. Pavement smothered earth. Soaring rooftops defined a sort of alternate topography, while foundations, sewers, and tunnels gnawed the landscape from below. . . . New York became an island of concrete."

Gravel is today's plebian gem of choice—consistently valuable in the larger scheme. The aggregate industry (gravel, crushed rock, and sand) is "easily the largest mining industry in the country," fueling 10,000 quarries and employing 120,000 workers. It is used in home construction (20 percent), commercial construction (20 percent), public works projects (20 percent) and roads (40 percent). The source of this data is the only art organization to train its lens on gravel pits. The Center for Land Use Interpretation (CLUI) is a far reaching hybrid of art and geography conceived and directed since 1994

Jamey Stillings, *Morning Aerial View*, June 30, 2009. The Hoover Dam and the Mike O'Callaghan-Pat Tillman Memorial Bridge with its arch nearly complete; temporary pylons and cable stays support each segment. ● Jamey Stillings, *The Bridge at Hoover Dam, Arizona Arch Segment*, April 28, 2009. Transmission towers between the dam and bridge support power lines from the powerhouse out of the canyon.

by Matthew Coolidge with Sarah Simons. Modestly based in Culver City, California, it has slowly spread its tentacles with artist residencies across the continent—most notably on the defunct Wendover Air Force Base on the Utah-Nevada border. "The Center is fixated on the ground," says Coolidge. "We work within this miasmic gray area where conflicting and even contradictory things can exist at once, overlapping. . . ." CLUI's documentary range and strategy place it in an intriguing neutral buffer zone. My favorite example of a new conceptual art (or not art), the center is disingenuously dedicated to "the increase and diffusion of information about how the world's lands are appropriated, utilized, and perceived." No ego is involved. No artists' names (except for occasional photo credits) are attached to its projects.

But CLUI is by no means "just the facts, ma'am." Perception of land and nature is a major element of its work, and we the perceivers are forced to look where we had never looked closely before, at the quotidian, ordinary,

Center for Land Use Interpretation Photo Archive, *Margins in Our Midst*, 2003. Irwindale straddles the San Gabriel River, a major alluvial fan "bringing marginal material from the mountains into the L.A. Basin." That material is commercially viable, but the mountains are also the source

and downright weird. Its work is about the U.S.A.: "Who are we? How does our landscape, built and altered by our society, harbor meaning about us, collectively, and even individually?" CLUI's real and virtual tours of "unusual and exemplary land use sites" have become the model for an interdisciplinary analysis of land use. Its subversively critical work is presented with a sly blandness that foregrounds some hard information about militarism, corporate destruction, "deleted communities," Nellis Air Force Base, rave sites, the Nevada Test Site, fire warden's towers, Mom and Pop tourist caves, the cement barricades erected all over Washington, D.C. after 9/11 . . . and gravel pits.

"Margins in Our Midst" was a 2003 CLUI exhibition about "the material that makes up the ground we live on" in the Los Angeles suburb of Irwindale. The center's newsletter, *The Lay of the Land*, informs us that the city's "marginal real estate" is actually "the largest aggregate mining area in the state,

of catastrophic debris flows that have destroyed parts of the city, necessitating the Santa Fe Dam, a 5-mile "pile of rock built to hold back other piles of rock," in the event of unpredictable avalanches. Behind the dam are "oddly disorganized wildlife areas and recreation zones."

if not the nation." The town is "so full of holes that more of the land in the city is a pit than not." (One is reminded of Butte, Montana, undermined quite literally by a vast maze of tunnels that occasionally swallows the real estate above.) Many of Irwindale's pits are inactive, having been mined to the permitted depth of 200 feet. Some become dumps or landfills. One is a race car speedway. One was envisioned as a stadium for the LA Raiders. Another is owned by the Catholic Archdiocese. Irwindale's water is also mined, processed, and exported in the form of nearly 200 million gallons of beer annually from the Miller Brewery, which has opposed a trash-burning power plant and wastewater percolation ponds in order to preserve "its" water purity. Just downstream on the San Gabriel River is a Superfund site. "We will be going to some of the most banal and dramatic landscapes in Los Angeles," announced Coolidge on a bus tour of the pits, "and by the time we are done, we probably won't be able to tell the difference."

Jeff Wall, *Fieldwork. Hope*, University of California at Los Angeles, working with Riley Lewis of the Sto:lo band, 2003, transparency in light box. Wall spent three weeks at the archaeological site, photographing from a scaffolding as the strata of previous lives were revealed. He documented the real-time process by reenacting history as it happened.

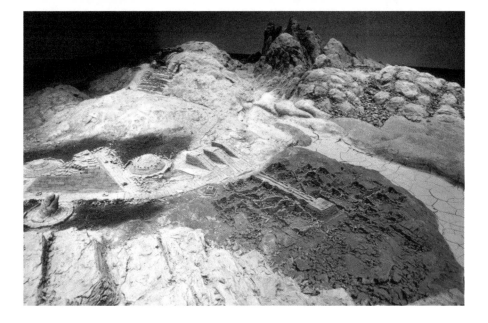

GRAVEL PITS OFFER A CASUAL ARCHAEOLOGY OF THE MEETING

places of nature and culture, past and present, construction and destruction, indigenous peoples and colonizers, art and life, creeping globalization and local survival. Archaeology is the opposite of industrial construction. It is defined by pits in the present and imagined erections in the past. (Some of the pits are the creations of scholars, others of looters.) Pithouses were the first permanent dwellings of the Ancestral Puebloans (formerly known as the Anasazi) to be recognized in the Southwest. As Pueblo architecture evolved vertically, underground structures eventually became kivas—communal and religious gathering places honoring the emergence of the Pueblo people from three earlier worlds beneath the one we know.

Archaeology is a model for this book in the sense that it is a construction of fragments that could be put together any number of ways. Reading the sometimes contradictory strata of time and space is archaeology's primary strategy.

Charles Simonds, **Δ**, installation at the Fridericianum, Documenta 6, Kassel, Germany, 1977. Simonds's architectural fantasies imagine civilizations of invisible "Little People" (with whom he identifies). Originally inspired by childhood visits to southwestern Pueblo ruins, since 1970 his miniature public art of tiny bricks and clay landscapes has appeared in the cliffs and crevices of urban neighborhoods from Lower Manhattan to Europe and China. (See Charles Simonds, *Galerie Enrico Navarra*, Paris, 2001.)

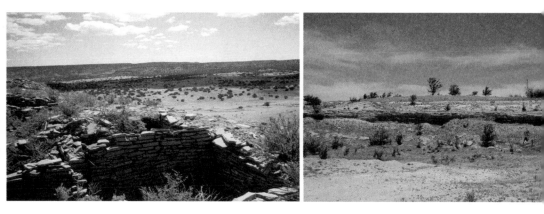

Early archaeologists simply dug up and shipped out "museum pieces," ignoring the order in which they appeared. The literally groundbreaking technique of stratification was partially invented from 1912 to 1914 in the Galisteo Basin. Nels Nelson, and others around the same time, realized that if they carefully documented the finds in each layer, they would create a backwards chronology for each site. Simultaneously they created new pits and significant absences.

HIDDEN EVIDENCE OF THE DISTANT PAST—FROM DINOSAUR bones to Clovis points—often lies buried in landscapes ripe for profitable extraction. George McJunkin was a former slave who worked on a ranch near Folsom, NM in 1908. Looking for stray cattle in Wild Horse Arroyo, he discovered the bones of extinct Ice Age bison with spectacular human-made projectiles. Knowing they were something special, he showed them to local

Pueblo Ruin, Galisteo Basin, c. 2004. Stone walls remain; adobe components have melted down. Archaeologists making pits to discover lost erections are dealing with "ruins in reverse," a phrase of artist Robert Smithson's that has become iconic since his death in 1973. ● *Blackwater Draw, dig site, exterior* (Photo: Jim Dodson).

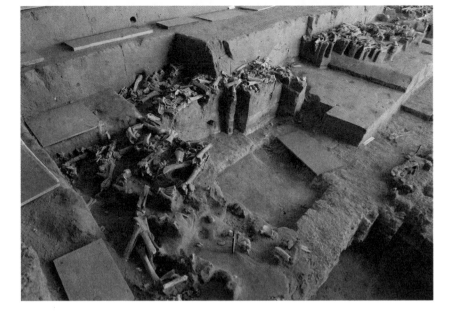

people, who were uninterested. It was not until 1926 that paleontologists got to the bone bed and "made history."

Blackwater Draw in eastern New Mexico offers a gravel pit parable. Once a watering hole for mammoths and their ilk, and also the site of the oldest well found in the New World, on February 5, 1929, Blackwater Draw revealed the first Clovis point in association with mammoth bones, bringing the human record on the continent back to thirteen thousand years ago. The discoverer was nineteen-year-old James Ridgely Whiteman (who was part Native American). He realized the significance of his find, and three times he alerted the Smithsonian, which ignored him. An archaeologist finally came to check it out and deemed it "too unimportant to work on." In the early 1930s, the state of New Mexico, using horse-drawn scrapers, began to dig gravel from the site. They unearthed masses of huge bones. Now archaeologists swarmed to the site, finding ancient hearths around its edge and

Blackwater Draw, dig site, interior (Photo: Jim Dodson). In 1962, Dr. Fred Wendorf of the Museum of New Mexico's Laboratory of Anthropology announced this site was the most important archaeological discovery in the western hemisphere.

continuous remains dating from Paleolithic to Pueblo cultures. Avid scholarship and excavations followed. Whiteman was one of the diggers. Then the pendulum swung again. The archaeologists were foiled in turn by the post-WWII highway boom. Blackwater Draw became one of the largest gravel mines in the state. The past was sacrificed to the present, and the spectacular archaeological evidence was reburied. No Clovis human remains have ever been found, although a gravel operator once uncovered a skeleton; worried that he would be punished for damaging it, he turned it back under and it was never seen again.

Finally, in yet another turnaround, what little could be salvaged at Blackwater Draw was placed on the National Register of Historic Places in 1966. A small museum, partly built into the old gravel pit, is open to the public—a modest tourist destination banned by local fundamentalists because of its Darwinian significance. This ironic sequence of events incorporating

David Kozlowski, *Adobes*, 2013, digital photographs. Adobe is sacrosanct in the marketplace. In 2012, a New York couple sued the seller of a downtown Santa Fe condo because it was adver-

cultural/commercial, and local/global paradigms—the stuff of which this book is made—was one of its inspirations.

NEXT TO LITTLE ADOBE HOUSES IN THE SOUTHWEST, THERE ARE sometimes traces of a pit, the womb from which the mud for the bricks was taken, perhaps a millennium or a century ago, perhaps yesterday. Earth is the rawest of raw materials. At the end of the twentieth century, one-third of the people in the world were living in mud houses, including those in older, poorer villages in the American Southwest. Three quarters of the earth's soil is suitable for earthen architecture, once mixed with water, sand, and straw, then dried by the sun. Southwestern earth builder David Yubeta says that dirt is "very simple, very forgiving." Adobe was commonly used in puddled bands or in bricks for pre- and post-Conquest architecture well into the twentieth century. When Tewa architect and scholar Rina Swentzell asked her

tised as "historic adobe" and turned out to be historic PenTile (made by prisoners in the State Penitentiary between 1885 and 1955).

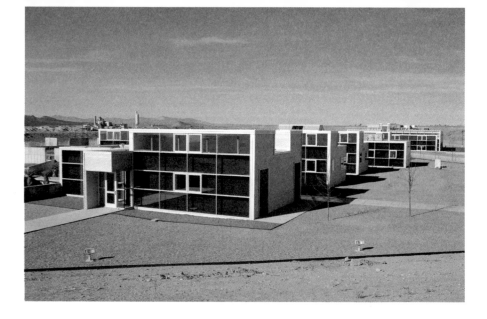

grandmother why a house in Santa Clara Pueblo was being allowed to crumble away, the response was that the house had had a good life, fed, blessed, and healed, as it should have been. Now it is time for it to go back into the earth. Swentzell recalls how she and other children used to *taste* the houses and kivas because each group of adobes were different, depending on the source of the clay. When abandoned, these houses return gradually to the earth, piles of mud, like the pueblo ruins surrounding my fake adobe home in the Galisteo Basin.

When the Santa Fe Trail opened in 1821, merchants and adventurers arriving from the eastern United States saw the city of Santa Fe as nothing but a dismal cluster of mud huts. By 1848, when the U.S. took possession of the Southwest, and especially by 1880, when the railroad arrived, new materials (such as tin for pitched roofs) transformed the ancient city. By the beginning of the twentieth century, when New Mexico was still angling for statehood,

Santa Fe County Public Works Complex Administration Building (architect: Michael Freeman), 2009 (Photo: Bart Kaltenbach). "Artfully sited among the reconfigured berms and depressions" of a former gravel pit, the building provides virtually all of its own energy, including a wind generator and passive solar.

tourism began in earnest, and the tourist-targeted "City Different" was born. Roofs were flattened again into "Pueblo Revival" style, and pitched roof tin was scattered into the poor communities of northern New Mexico. From then on, the exteriors of all buildings in the "historic district" of Santa Fe have been rigorously regulated (sometimes to the point of absurdity) by the city's Historic Design Review Board.

Archaeology was the starting point for the mud architecture and restoration career of Santa Fean Edward Crocker, one of my primary sources on adobe and earthen architecture. He admits to illegally pot-hunting Pindi Pueblo near Santa Fe in his youth; eventually he dug legitimately in the Grand Canyon, investigating the dwellings of Ancestral Puebloans. Citing adobe houses all over the world, including Asia, southern England, New York, Wyoming, and North Dakota, Crocker declares that "all other building materials on the planet are alternatives to earth." He quotes Pliny the Elder on

Stucco wall of author's fake adobe house. Much as I would have loved to build with adobe, it was way beyond my budget, so I got the *Mexicano* workers to fake it, adding straw to the stucco surfaces, which they found déclassé, avoiding it when I wasn't around to nag. ● *Adobes Ready to Go.* Woody Guthrie sang, "I've got some mud and you've got some clay . . . to build a house that won't go away," and writer Charles Bowden has observed, "The poor mix mud and dream of bricks."

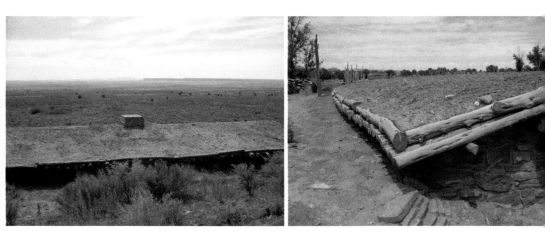

adobe buildings in Africa and Spain: "These walls will last for centuries, are proof against rain, wind and fire . . ." In his local newspaper columns extolling the virtues of real, old-fashioned adobe, Crocker is clear about what it isn't: "a 40-pound block of earth impregnated with asphalt emulsion, laid up in Portland cement mortar, all sprayed with polyurethane insulation and coated with elastomeric plasters. Excuse me? No way can that be called adobe. Call it Contemporary Composite, call it faux, and call it Santa Fe Style. Just don't call it adobe." Crocker has worked on government-funded restoration projects at several contemporary pueblos, where he and the residents have balked at rigid rules that allow for no change. He contends that one reason there is not much broader support for earthen architecture is that its very simplicity "scares the bejesus out of the testing lab guys, the engineers, and consequently the code enforcers."

Today, adobe also faces competition from the so-called green techniques

Dirt Roof, Pipe Spring National Monument, northern Arizona, c. 2008. Pipe Spring, on former Kaibab Paiute land, was a Mormon stronghold during the polygamy raids of the late nineteenth century and is now a Native and "pioneer life" site, including this dirt-roofed structure bermed into a hillside.

of straw bale, rammed earth, and rastra (made from recycled Styrofoam), but longtime local builders agree that when the amount of energy expended is totted up, adobe remains king. "Without adobe," writes Alejandro Lopez, "northern New Mexico would drift unmoored from its spiritual and cultural past." Bart Kaltenbach, architect/builder of my house, and his partner Barbara Anschel—coauthors of *Sun Sticks & Mud*, a delightful tour of a vast variety of adobes in the desert Southwest—always return to "truly indigenous" adobe when considering "green buildings'" environmental costs: "high energy uses in manufacture, transportation distances, and the original sources of raw materials (i.e. petroleum)." But they also have to consider "the economics and the motivation of clients." Today this most common of materials is reserved for the wealthy. The ancient, efficient building process is labor-intensive, and therefore expensive for homes, a situation exacerbated by complicated regulations.

Adobe Ruin, Stanley, NM. ● Steve Fitch, *Benally House*, Design Build BLUFF, Bluff, UT, 2008, color photograph. Inspired by his friend Samuel Mockbee, Hank Louis established Design Build BLUFF (after the eponymous town in the Four Corners area) at the University of Utah to construct inventive earth-based homes, off the grid, on the Navajo Reservation. (See Kaltenbach, Anschel, and Fitch.)

39

Attempts to restore respect for vernacular adobe, even in the Southwest, have not been hugely successful, thanks to pervasive short-term thinking. One of the more interesting attempts to repopularize affordable adobe is the non-profit Adobe Alliance, improbably founded by a cosmopolitan art world insider who once directed the Menil Foundation in Houston. Simone Swan (raised in the U.S., Belgium, and the Belgian Congo) apprenticed in the late 1970s in Egypt with Hassan Fathy, advocate of "barefoot architects" and author of *Architecture for the Poor*, who demonstrated that totally earthen homes with vaulted roofs and domes were cheap to build by hand without industrial material, cool in summer and easy to heat in winter. (Fathy was also the architect of the Dar al-Islam Mosque in Abiquiu, NM; the local story is that he sent his Nubian workers home when he discovered New Mexicans were so skilled in the adobe tradition.)

Swan returned to the U.S. and other pursuits, but on a visit to Big Bend

Steve Fitch, *Swan House*, near Presidio, TX, 2008, color photograph. ● Dar-al- Islam Mosque, Abiquiu, NM, c. 2005. The mosque was built near the Chama River in 1979 as the first planned Islamic community in the U.S. No longer residential, it operates as an educational facility. ● Rural Studio, *Mason's Bend Glass Chapel and Community Center*, Sawyerville, Hale County, AL, 2000, rammed earth and recycled Chevrolet Caprice windows. Rural Studio, founded in 1993

National Park in 1991, she wandered into Fort Leaton, a nineteenth-century adobe trading post being restored by the Texas Parks and Wildlife Department. On impulse, she asked curator Gilberto Velasquez if she could work with him, and by the end of the year she was volunteering, molding adobes, and extolling the dome and vault construction she had learned from Fathy. With little or no lumber and extraneous metal, the price of housing decreased. Having persuaded local *adoberos* (adobe makers/builders) that it was feasible, she moved to the border town of Presidio, Texas, and began to work with Daniel Camacho in Ojinaga, on the Mexican side, where Swan hoped to introduce the Egyptian all-adobe domed roof as affordable housing in both Texas and Mexico. Camacho's house cost $9.04 per square foot (as opposed to some $250 for Santa Fe Style). Although Swan was convinced that she could cut even that cost and still meet federal regulations, the venture succumbed to lack of support and workable loans, so she built her own elegant "demonstration home" near Presidio. (I can

by the late visionary architect Samuel Mockbee with D.K. Ruth, brings Auburn University architecture students to design and build homes for low-income residents, using found or donated materials—layers of carpet samples, concrete rubble, discarded tires, old road signs, baled yarn—nothing is useless. ● *Bryant Haybale House*, 1995, Mason's Bend, detail of tiny "wagon wheel" rooms protruding from the house for visiting children.

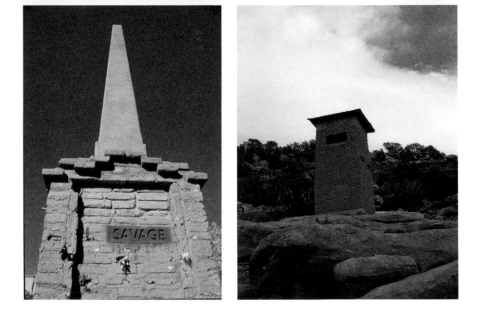

testify firsthand to its beauty and energy efficiency.) Unfortunately, Swan is a visionary, not a businesswoman. When she moved to New Mexico, she found the building codes too restrictive, and traditional people unreceptive to adobe alternatives. While the Adobe Alliance never took off in the U.S., she continues, in her eighties, to lead workshops and lecture internationally, where her ideas are better received.

Adobe is also a popular sculptural medium in the Southwest, used by a broad range of artists, from Nicasio Romero, based in rural El Ancón, NM, to Bill Gilbert, director of the Land Arts of the West Program at the University of New Mexico, as well as Native artists Charlene Teters, Rose Simpson and Nora Naranjo Morse. In 1986, public artist Nancy Holt teamed up with Argentine architect Juan Behr-Menendez to propose (unsuccessfully) a park in a lower income neighborhood of New York City demonstrating affordable earth building and alternative energy sources. In 1992, Adobe LA was

Charlene Teters (Spokane), *Obelisk: To the Heroes*, 1999, adobe, stucco, cement base with mementoes embedded in the adobe by the community, outside the NM State Capitol (Photo: Don Messec). This public work counters the obelisk in the Santa Fe Plaza, dedicated "To the heroes who have fallen in the various battles with the savage Indians. . . ." The word savage was chiseled out by an unknown person posing as a workman and has remained that way. Teters resurrects the lost word and turns it around. ● Nicasio Romero, *Adobe Tower*, 1987. A

founded by a group of bilingual architects to create shelters for the homeless and "combine avant-garde art and social purpose." A project to train *adoberos* has recently been initiated at the Northern New Mexico College in Española, and Cornerstones Partnership of Santa Fe has long been active in the preservation and restoration of traditional adobe architecture all over the state, including La Sala de San José in Galisteo, a turn of the (last) century dance hall.

AS VISIONARIES OFFER ALTERNATIVES AND AUTHORITIES concoct regulatory obstacles, southwestern villages are experiencing a microcosm of global change sparked by rural gentrification. In the 1980s the character of newcomers to the Santa Fe area changed. Preference for traditional small scale shifted toward McMansions, and the City Different became a favored site for second homes, some built obtrusively on ridgetops around the ancient city. The descendents of the original European settlers, whose first language is

native New Mexican, once head of the NM Acequia Association, longtime Mayordomo of the local ditch, Romero, with his artist wife Janet Stein, has built a domestic environment of adobe structures blurring the boundaries between art, life, architecture, and community. ● *La Sala de Galisteo*, c. 2008, and *Renovation*, 2013 (Photo: David van Dyk/Eric Thomas). The hall is being restored by residents for a community exhibition space, with the aid of Cornerstones Partnership.

still Spanish and who still live in modest adobe houses like the Native populations who preceded them, are passing on. Given the demand by out-of-staters for old adobe homes, their children are (understandably) selling out and moving into cheaper, more comfortable, more modern, less maintenance-intense manufactured homes. (A local holdout on the gallery-ridden Canyon Road is sometimes greeted by passing friends with the cry, "*No se vende*, Roberto!") Some of the old adobes are bought and lovingly restored. Others are gutted and remain traditional only in façade. Or they are replaced by gigantic trophy homes in Santa Fe Style that imitate their humbler antecedents. The organically constructed adobe building with its little pit in the yard is a far cry from the mansion, the huge fake adobe hotel, the skyscraper or freeway that emerges from the greater pit at a greater distance from its product.

In January 2001, Santa Fe County tabled a request by multinational corporation Lafarge to mine gravel from 38 acres on the south side of the city,

Joan Myers, *Roberto Moya House*, Canyon Road, Santa Fe, 2013. Its plain façade stands out amidst the glitz of Santa Fe's most famous art market, recalling the street's not-so-distant residential past.

presumably in a move to support local small business. The relationship between gravel mining and the gentrification of Santa Fe is reflected in the sixty-year-old Montaño Sand and Gravel company. The third-generation owner's father made adobes for a living—650,000 of them per year, using materials from the Santa Fe River, which "flows" dry through the historic downtown. Today the business caters to landscapers with "character boulders" for rock gardens, and a broad variety of colored gravels from all over the Southwest and Mexico ("Santa Fe Brown" is particularly popular). These are elements of xeriscaping—a sustainable southwestern style replacing lawns with gravel; the largest grassy area recommended is the size of a king-size bed. So droughts support the gravel business.

THE WESTERN INDIAN TRIBES ARE INTRICATELY INVOLVED IN this story of undermining as they struggle to recapture and protect what is left

Joan Myers, *Buffalo Thunder Resort & Casino*, Pojoaque Pueblo, NM, 2013. This huge traditionally inspired (and economically precarious) resort just north of Santa Fe includes a Hilton Hotel and three golf courses; just off one course are the remains of a pre-European Pueblo kiva.

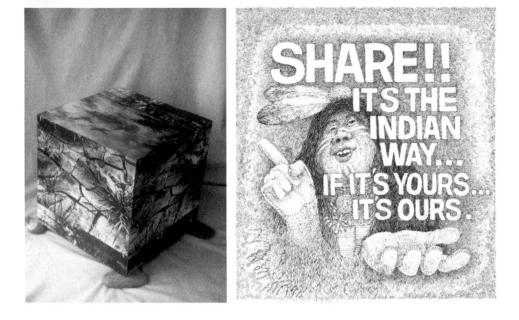

of their ancestral lands and sacred sites, respecting tradition while hoping to improve their economies and profit from their resources, just as the dominant culture does. Land use conflicts where indigenous and non-indigenous values collide are taking place all over the West, the hemisphere, and the world. "If we can't protect the Earth, can't protect the sky, if we can't protect our sacred sites, then we've failed the world," says Jewell Praying Wolf James of the Lummi Nation. Natives who are no less passionate about the lands than environmentalists, but come to the issues from a very different angle, search for a middle ground between conventional and traditional trajectories. Some of them are artists.

Since place is experienced through a filter of culture and history, looking in Native arts and cultures for firsthand responses to land, landscape, and history in the Western sense is a frustrating task for the outsider. There are good historical reasons to keep the most important feelings and knowledge within

Jolene Rickard (Tuscarora), *One Square Foot of Earth or One Square Foot of Real Estate—You Decide*, 1993, silver gelatin prints on cube, 12" x 12" x 12". ● Clayton B. Sampson (Washoe/Paiute, 1943–2013), *Share*, 2010–12, ink on paper (Courtesy of Donald W. Reynolds Center for the Visual Arts, E.L. Wiegand Gallery, Reno, NV). Sampson worked in advertising. His satirical drawings exploring stereotypes of Native people were "intended for an 'insider audience' of American Indians."

the tribes, to maintain a kind of emotional as well as political sovereignty in the face of well- and not-so-well-meaning scholars, thieves, and wannabes. Indian views of nature have been so overstated, misunderstood, diluted, and abused over the last four centuries that it's difficult to sift out pertinent perceptions about landscape from the little we actually know. As tourism scholar Dean MacCannell says, "the best way to keep a cultural form alive is to pretend to be revealing its secrets while keeping its secrets."

Land use issues in the Southwest merge past and present, and Native peoples resist their relegation to "pre-history" to claim their place on the treadmill of a continuous present. Native claims to traditionally sacred spaces have been particularly controversial. Graves continue to be destroyed by looters and developers, along with rock art and other sacred sites that are often embedded in or embodied by nature herself. "Tribes are battling all over the country to protect sacred sites," says Andy Baldwin, a lawyer for the Northern

Jaune Quick To See Smith (Salish), *The Court House Steps*, Petroglyph Park series, 1987, oil/canvas, 72" x 60" (Collection Elise and Lee Sacks). Kiva steps, or cloud terraces, refer to a petroglyph-covered boulder taken from an escarpment west of Albuquerque and left on the courthouse steps to lobby for blasting near the Petroglpyh National Monument, making room for subdivisions. The judge was not swayed. (See Carolyn Kastner, *Jaune Quick To See Smith: An American Modernist*. Albuquerque: University of New Mexico Press, 2013.)

Arapaho. "The number of sites are just shrinking. This is an effort to hang on almost by our fingernails to what's left."

It is ironic that this country, founded on the notion of religious freedom, denies such rights to the First Americans. From the moment of contact, then conquest, through the 1930s, indigenous religions were officially discouraged and outlawed, even on reservations. The American Indian Religious Freedom Act, signed by President Carter in 1978, was a step in the right direction, but it is so generalized that it has proved legally toothless in the face of powerful economic interests, such as the flooding of sites sacred to Cherokee by the Tennessee Valley Authority. Site protection "can be obtained only through prevention of the proposed activity, as opposed to modification," says attorney Jack Trope.

Indian reservations were historically located in places considered useless by the U.S. government and East Coast capitalists. By the early twentieth

Jacques Garnier, *Left Behind*, 2007, chromogenic print, Twentynine Palms, Mojave Desert, CA, from the series Second Chances, exploring the mindsets of those who have chosen or been forced to move out of the mainstream into isolated desert regions. © Jacques Garnier. • John Pfahl, *Minuteman Missile/Galisteo Basin Petroglyphs*, 1984–85. The artist was thinking "Rock and metal. Metal and rock," juxtaposing them in form and content—early cultures in the South-

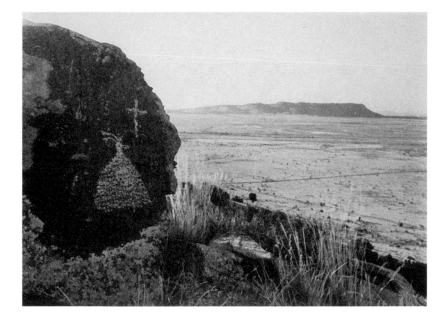

century, when some of these "wastelands" turned out to be rich in mineral resources, industrial intrusion—with and without the sovereign nations' consent—became rampant, trampling on Native rights and land ethics. Exploitative treaties forced Indians to cede millions of acres of tribal land, with the government retaining the responsibility to protect and manage them for the benefit of the tribes, not to mention the rest of the nation. How well this did not work was exposed by a lawsuit on behalf of all Indian tribes initiated by the late Elouise Cobell, a Blackfeet lawyer who posthumously won her case against the government in 2011 with a disappointing settlement of $3.4 billion—a pittance given the losses and its distribution to some one hundred thousand Native claimants in 2012. Another hopeful step was taken in December 2012, however, when a memorandum of understanding pledging "protection of sites held sacred by American Indians and Alaska Natives" on federal land was signed by the Advisory Council on Historic

west with contemporary artifacts (in Albuquerque's National Atomic Museum), providing the means to destroy all cultures. ● Edward Ranney, *Shalako, Southern Creston, Galisteo Basin, New Mexico*, 2009. The Shalako is a deity associated today with the Zuni tribe's December/Winter Solstice ceremonial. The square cross often represented a star, but the elongated version was usually European.

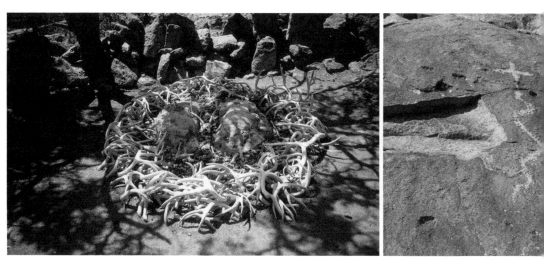

Preservation and the federal departments of Agriculture, Defense, Energy, and Interior.

There are 565 federally recognized sovereign tribes in the U.S. alone. They have very long memories. Given oral tradition and the fact that they and any number of now-unknown Native peoples inhabited the entire continent for millennia, it is not surprising that sacred sites are ubiquitous in virtually every state. Nor is it surprising that ignorant non-Indians dismiss claims to apparently undistinguished natural features, whole migration paths, almost invisible shrines, or places where medicinal plants are gathered or legendary events took place. The fundamental issue here is that we colonials are hard put to understand the sanctity of an "unimproved" piece of earth. Comparisons to the desecration of Christian churches and Jewish cemeteries apparently cut no ice.

The intricate connections between land, water, and Native culture are par-

Stone Lions, Bandelier National Park, NM, c. 1994. Purportedly "spiritual" acts, like placing antlers on this ancient shrine, can be as harmful to Native sacred sites as careless recreational tourism. New Age offerings are considered by the tribes as a form of desecration and mockery.
● *Snake and Cross Petroglyph*, NM, c. 2007.

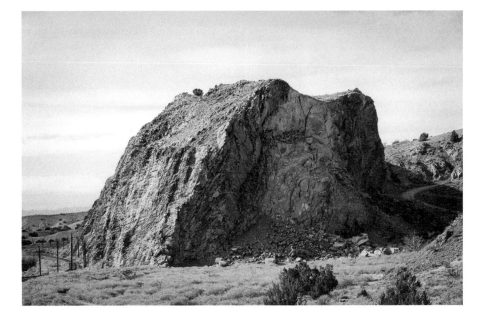

ticularly evident in the Southwest. For Pueblo peoples in New Mexico and beyond, two of the sacred directions are up and down, represented by mountains and springs or lakes. Belief systems focus on water, emphasizing height and clouds as the source of rain and snowmelt, balanced by the underworld— sacred site of emergence, often guarded by horned serpents that live in the springs and rule the breathing underground water. Mountains are "teachers, and places from which necessary things flow," wrote Alfonso Ortiz, the late Tewa anthropologist from Ohkay Owingue Pueblo.

Ortiz pointed out that in the Old West, Indian sites were perceived to oppose the Christian God; many place names given by settlers are associated with evil because of their ceremonial significance to the original inhabitants—Devil's Tower, Mount Diablo, and in my own neighborhood—Devil's Throne— near the Cerrillos gravel pit and the disputed Buffalo Mountain. Over the last two centuries, New Mexican sheepherders often scratched crosses near

Joan Myers, *Devil's Throne*, near Cerrillos, NM, 2013. A precarious dirt road paralleling the railroad tracks leads over the hill toward Interstate 25, a commercial gravel pit, and recently laid tracks for the Railrunner, a commuter train from Belen to Santa Fe.

ancient petroglyphs perceived as pagan symbols (especially the ubiquitous snakes, though they were related to water, not satanic cults). Hispanos prayed for rain in their own fashion, carrying a carved wooden San Juan through farmed fields on his June saint's day or during droughts.

Western mountains may be sacred to Native people, but they are also grist to industry's many mills. Imagine the spiritual horror if mountaintop removal were to pervade the Southwest on the scale practiced today in Appalachia, where it has caused untold suffering in mountain communities. This crude (and inexpensive) mining technique of blowing up mountains, removing over 1,000 feet of ridgelines, dumping the rubble into valleys and waterways and leaving hideous open pits as scars on once bucolic landscapes, was encouraged by the George W. Bush administration's softening of environmental regulations. Coal is processed on site and toxic slurry is stored in dammed impoundments that leak into drinking water sources. The result is an unbear-

Lewis de Soto (Cahuilla/Hispanic), *El Cerrito Solo (Tahualtapa Project)*, CA, 1983–1988. The four photographs reflect the four historical chapters and gradual disappearance of Tahualtapa, or Hill of the Ravens, which was sacred to the Cahuilla people before it was renamed El Cerrito Solo (Lone Hillock) by Spanish missionaries. Marble Mountain was its first Anglo name, as a marble mine, then it became Mount Slover, a cement quarry. De Soto's feathers, marble dust,

able level of dust and noise pollution, contaminated water, and houses shaken from their foundations.

On a smaller scale, wine-red volcanic cinder hills in New Mexico and Arizona are regularly sacrificed to highways (as gravel for winter ice-clearing) and also dedicated to art. *Roden Crater*, James Turrell's well-known earthwork in progress, is carved out of the interior of just such a dark red hill in Arizona, which will remain as a monument to its disappeared siblings. Another cinder cone, at Woodruff Butte, Arizona, was the site of Hopi shrines passed over by an archaeological survey (despite discussions with the tribe), then deliberately destroyed by a gravel miner providing material for federally funded highways in 1990. Nor are tribal entities themselves always innocent. Vandalism of Hopi shrines and prayer sticks (*pahos*) found on Navajo land has been an explosive issue, exacerbating the intertribal struggle about overlapping land claims in the Navajo/Hopi "joint use" area around Big Mountain.

marble slabs, and cement refer to these four histories. The artist likes cars and was undisturbed by the mountain's transformation into a freeway, perceiving it as a natural and cultural "revalu-ation." "The piece is as much about the metamorphoses of perceptions of the mountain as of the mountain's own metamorphosis." (Rebecca Solnit, *As Eve Said to the Serpent*. Athens: University of Georgia Press, 2000.)

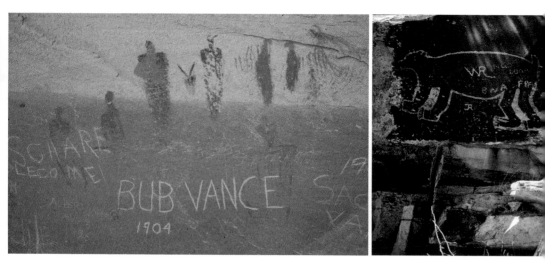

Such attacks on tradition make my own village's problems with truck traffic and road widening seem trivial, but the gradual erosion of local quality of life is a problem on any scale. "You can't fight progress," is one way of shrugging off the unpleasant consequences of development. But progress implies something positive, and not all change measures up. The scale of both conventional and alternative energy development and associated transmission corridors poses new and considerable challenges to the preservation of traditional cultural landscapes. Publication of sacred locations in tourist or scholarly magazines poses more problems, as does identification in the public domain, even in the interest of protective planning. It is critical that federal agencies involve tribes as early as possible in planning and selection of project sites—seldom an uncomplicated process. In New Mexico recently, a utility company planned to place power lines across lands that included a pueblo's sacred sites, but tribal elders were unwilling to reveal the specific locations. A

Phil Young (Cherokee), *Rock Art Vandalism*, 1986, Horseshoe Canyon, Canyonlands National Park, UT. Beside the well-known (and questionably named) "Holy Ghost Panel," someone has dynamited a section to take home as a souvenir, or to sell. ● *Desecrated Bear Petroglyph*, Pueblo Blanco, Galisteo Basin, c. 1998. A photo by archaeologist Nels Nelson taken around 1912 shows this stunning image before W.R. got to it.

kind of blind man's bluff ensued: the company would draw a map—could we put it here? No. What about here? No. If it went this way? That might be ok.

TWO OF THE MOST COMPLEX AND AS YET INCONCLUSIVE LEGAL relationships concerning mountains and lakes in New Mexico concern the disputed cultural ownership of Mount Taylor and the Zuni Salt Lake. Mount Taylor—an 11,301-foot volcanic peak in northwest New Mexico—is the site of a battle between Native peoples, Hispano land grant heirs, local ranchers, and the uranium industry. Sacred to at least five tribes, to Navajo it is *Tsoodzil*, female bringer and taker of life, home of Turquoise Boy and Yellow Corn Girl, guarded by Big Snake deity. To Zuni it is *Dwankwi Kyabachu Yalanne*, where "the lighting hole" at its summit must be kept open to fend off drought, and to Acoma/Laguna it is *Kaweshtima*, Rainmaker of the North, created by two sisters who shaped and populated the earth. The Spanish

Larry Crumpler, *Mount Taylor*, June 16, 2002. Mount Taylor, taken "from about 20,000 feet looking north across the summit." The horseshoe-shaped summit amphitheater is the remnant of the volcanic crater. Water Canyon is the deepest canyon, right and downward. Beyond, to the north, is the high volcanic plateau of Mesa Chivato. In June 2013, Mount Taylor was still under siege; a uranium mining permit appears on the verge of approval by the U.S. Forest Service.

called it Cebolleta and San Mateo. The Anglo name dates from 1849, honoring then-President Zachary Taylor.

Mount Taylor was first despoiled by the uranium boom of the 1960s to 1980s, then allowed to rest. But in recent years, with rising uranium prices and revived interest in nuclear power, the mountain is under attack again. As the result of a nomination filed in 2007 by the tribes, the New Mexico Cultural Property Review Board designated 434,000 acres of Mount Taylor a Traditional Cultural Property (TCP) on the New Mexico Register of Historic Places. Companies like Neutron Energy Inc. and Urex Energy Corp. (their names evoke science fiction monsters) immediately applied for permits to restart operations on thousands of acres next to the protected area. Ranchers who support mining and to whom private property is sacred added their voices. (One ranch operates a profitable coal mine.) To further muddy the waters, Hispano land grant activists (many ranchers themselves) joined the in-

Eve Andrée Laramée, *Mount Taylor Mine, Fence Line*, 2008, near San Mateo, NM. "According to the *Los Angeles Times*, close to 4 million tons of uranium ore were mined between 1944 and 1986, mostly from Navajo land, to make atomic weapons." Navajo people (and their livestock) inhaled radioactive dust and drank contaminated water. Homes were built from radioactive rock piles. Responsibility for reclamation of the Mount Taylor mine is in the courts.

dustry in opposing the Native groups. Although the TCP designation would protect 89,000 acres of developed private lands not eligible for historical protection and did not (as claimed) ban uranium mining or "grab" any part of the Cebolleta Land Grant, nobody was mollified. The case is pending in the state supreme court. In spring 2013, the Cibola National Forest Service issued a Draft Environmental Impact Statement that violates existing standards for cultural properties and appears to favor the huge mine proposed by Roca Honda (Rio Grande Resources), though conceding that a staggering 80,000 acre-feet of water would be consumed over its life span.

Water always runs through these disputes. The ever-diminishing flows, runoff, and monsoons haunt us as we face increasing demand and decreasing supply. When all the water is sucked out from beneath us by industrial and municipal interests, we go down together. Acoma Pueblo expressed concern about groundwater protection in the entire area when a Mount Taylor

Larry McNeil (Tlingit), *X'áant xwaanúk Tléil yee ushké, I'm angry you are bad*, 2010, digital print/analog multi-media, 33.75" x 23". Collaged photos made in Joliet, IL, San Francisco, CA, and Juneau, AK. © Larry McNeil. "Layers were added bit by bit, beginning with Raven and an abstract Killer Whale. . . . In ancient indigenous stories Raven is a changeling, a transformer, like the humans who have made this environmental morass."

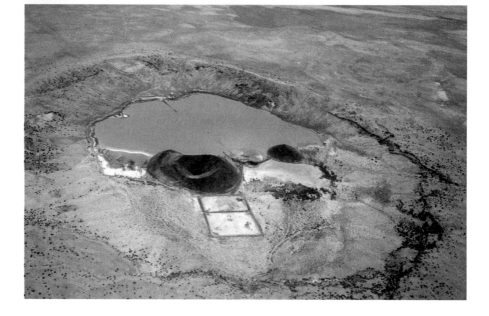

uranium mine operating from 1986–89 produced as much as 8,000 gallons per minute of "mine water" (more than 12,000 acre-feet of tainted liquid per year), which had to be removed to access tunnels. Farmlands in the Rio San José Valley were contaminated with sewage due to inadequate infrastructure in the nearby boomtown of Grants. When the mine shut down, it was allowed to flood, leaving 145 million gallons of water useless, unless treated. The controversy has fueled racial tensions, and led to a series of brutal beatings (identified as hate crimes) of Native people, reminding Navajo Nation President Ben Shelly of "New Mexico's dark history." As it turned out, the TCP designation does not work well for such a large area—a landform, a single topographic feature, which is worshipped as such, but claimed by so many interests.

THE ZUNI SALT LAKE IN WESTERN NEW MEXICO IS AN EXEMPLARY case study of the overlap of indigenous sacred sites, water, and coal in the New

Edward Wemytewa (Zuni), *Aerial Photograph of Zuni Salt Lake*, 2006.

West. Central to the religion of Zuni Pueblo (population around ten thousand), the lake is the home and the embodiment of the revered deity Salt Woman, as well as an ancient pilgrimage site for several tribes including Acoma, Laguna, Navajo, Hopi, and White Mountain Apache. The lake is surrounded by the Sanctuary Zone—a neutral 182,000 acres where existing hostilities were traditionally lifted by the tribes whose pilgrimage trails led through it—declared eligible for the National Registry of Historic Places in July 1999.

The small, shallow lake lies on a gravel spit within the bowl of a volcanic caldera, a cinder cone that produces natural brine. In summer, the water evaporates and the lake becomes a sheet of salt. While Taos Pueblo's sacred Blue Lake—finally restored to the tribe in 1970 after years of legal battles with the federal government—is doubly important in the high desert, Zuni Lake's product is equally significant. Young Zuni men go to there for spiritual guidance, to make offerings, and to collect salt for domestic and ceremonial

Edward Wemytewa (Zuni), *Salt Woman*, detail of painting, *The Zuni World*, 2006.

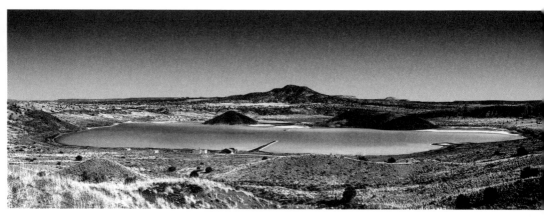

purposes. (Ironically women may not visit Salt Woman.) Navajo use this salt when an infant first cries and smiles; it is an element in a summer ceremonial dance at Acoma.

In the late nineteenth century, Zuni Salt Lake was included in the "checkerboard"—gridded state, federal, Indian, and private lands designated for railway expansion. In 2001, reporter Ben Neary described the "dilapidated buildings, the sagging rusted steel frames of conveyor belts, and the husks of wrecked cars" at the lake—the wreckage of a commercial salt recovery business that operated before the Zunis were able to reclaim the land in 1985. An initial cleanup was undertaken with the aid of Laguna Pueblo; when further funding is available, the lake will eventually be integrated into a landscape more appropriate to its sacred purpose. On a gravel bar extending into the lake, where "salt has dried white on the surface of the black gravel," a few prayer sticks have been planted.

In the 1980s another powerful industrial claw reached out for Salt Woman.

David Ondrik, *Zuni Salt Lake*, 2006, archival pigment ink print. "This photograph was taken at the Zuni Salt Lake the year that the proposed coal mine was officially blocked."

WATER
ABSENCE-PRESENCE

The Salt River Project (SRP) an Arizona utility corporation supplying the overpopulated and water-wasteful Phoenix Valley, obtained the rights to mine for coal on state lands south of the main Zuni reservation and east of the Salt Lake. Projected for almost forty years, the 18,000-acre mine was to pay the state of New Mexico the far-from-munificent price of $130 million for the 80 million tons of coal they planned to extract and transport to Arizona on 44 miles of railway track that would cross pilgrimage trails running north/south.

But the Fence Lake Mine was also required to get a permit to pump water from the Dakota aquifer, primarily for dust suppression. The company claimed to have enough water rights to operate 5,424 acre-feet per year, or over 200 million gallons. Public hearings in May 1996 were not broadly communicated and Native reaction to the threat only gained momentum at the last moment. Though the hearing was held 80 miles from most of

Wanda Hammerbeck, *Untitled*, 1991. Hammerbeck's conceptual inclusion of text sharpens the messages of her images.

the reservations, it was attended by busloads of Zuni, Acoma, Hopi, and Navajo. Young tribal members and distinguished elders passionately protested the project on behalf of Salt Woman.

Nevertheless, the director of the New Mexico Mining and Minerals Division granted SRP its permit, and in July 2001 extended it for five years, despite an independent hydrology report by an engineering professor at New Mexico State University stating that the monitoring plan was deficient and pumping at the mine site would affect the inflow of water and salt at the lake. By this time the Zunis were well organized, working with a coalition that included the Sierra Club, New Mexico's Water Information Network, Coal Council, and the litigious Center for Biological Diversity, which raised the consequences for endangered species in this "unique high-desert oasis." In July, as Zuni representatives went to Washington, D.C. to testify at the Senate, a 270-mile protest run from Phoenix to Zuni was staged by five

Juan Rios, *Permian Period Salt*, 2012, a chunk brought from 2.5 miles underground in southeastern NM, where it had been for 225 million years. ● Basia Irland, *Zuni Salt Lick*, 1992, salt crystals from Zuni Salt Lake and salt lick, 9" x 4" x 3" (Photo: Damian Andrus). Irland's extended collaborative project, *A Gathering of Waters*, is a model for innovative art and community participation. (See Irland, *Water Library*. Albuquerque: University of New Mexico Press, 2007).

tribes. In April 2002, the lights at Zuni and Jemez Pueblos were ritually extinguished, temporarily rejecting the coal that kept them burning.

The federal government had yet to weigh in. Contending that the slightest exploration would damage the area, the tribes raised the issue of federal trust responsibility for Indian lands, citing the American Indian Religious Freedom Act, but to no avail. Zuni Pueblo governor Malcolm Bowekaty, noting the need to move away from coal to cleaner fuels, demanded a new environmental impact statement. The opposition was represented by the aptly named Jake Flake, the late Arizona State senator, who grumbled: "I haven't seen any project in northern Arizona or New Mexico that the Zuni don't object to because of it being sacred ground. If it was their sacred ground, why didn't they buy it? I say let's move on with civilization."

In May 2002, Gail Norton, the Bush administration's Secretary of the Interior, took Flake's advice and approved the federal permit—a decision

John Pfahl, *Highway Department Salt Pile*, Buffalo Harbor, NY, October 1997.

A few more examples of confrontations between sacred sites and mining or other industrial interests in the West. The list could go on and on:

- In 1906, President Theodore Roosevelt annexed Blue Lake—Taos Pueblo's place of emergence, or primordial home—to the Carson National Forest. It took the pueblo sixty-four years to regain possession of the 48,000 acres around its sacred lake. A statement produced during that long struggle, which ended successfully in 1970 under President Nixon, read: "The story of my people and the story of this place are one single story. No man can think of us without thinking of this place. We are always joined together." This was the first highly publicized battle of its kind, setting a precedent for the future, such as the ongoing struggle for the sacred Black Hills by various Lakota/Dakota tribes. In an ironic twist, Teddy Roosevelt's own beloved Elkhorn Ranch on the Little Missouri River in North Dakota, once at the heart of "wilderness," is today threatened by oil development and a gravel mine.

- A Denver oil company donated two leases in south central Montana to the National Trust for Historical Preservation to protect Weatherman Draw, or Valley of the Chiefs, rich in 1,100-year-old rock art

allegedly made by her deputy, the controversial Steven Griles, a former coal industry lobbyist. In addition, since hydrologists had proved that the Dakota aquifer was the Salt Lake's reservoir, the mining company was restricted to the shallower Atarque aquifer. The tribe demanded new hydrological studies (given the development of new science in the interim) to ensure that this aquifer too was not connected to the lake. The mining company ludicrously offered to make culverts (like those for migrating animals) through which pilgrims could pass. Since the entire area includes shrines and graves, the company promised to create a mass grave for any human remains found. The tribes found these solutions decidedly unsatisfactory and contrary to NAGPRA, which offers a tool to oppose some, but not all, cases of disrespect.

The National Trust for the Preservation of Historic Places put the Zuni Salt Lake on its 2003 list of America's Most Endangered Historic Places, and an unusual coalition of U.S. Senators Pete Domenici (R) and Jeff

and a gathering place for Crow, Blackfeet, Comanche, Apache, and Lakota. This outwardly generous act served the company well, helping it to avoid legal challenges. The Bureau of Land Management was accused (not for the first time) of failing to conduct a proper environmental review or to consider cultural values before issuing drilling permits.

- The Northern Arapaho have unsuccessfully tried to ban rock climbing on the sheer sides of Bear's Lodge (aka Devil's Tower) in northeast Wyoming, site of an annual ceremonial.

- A uranium recycling facility next to the Little Ute Reservation between Blanding and Bluff, Utah, was built on top of more than two hundred Ute, Navajo,

and Ancestral Puebloan ceremonial and burial sites. The stink of sulphur has limited the tribes' ability to create a tourist economy.

- The Bighorn Medicine Wheel in Wyoming was made a National Historic Landmark after tribes opposed development in 1988. It is protected by the Forest Service, but is still not in Indian hands.

- In a conflict pitting science against religion, Western Apaches fought for their sacred Mount Graham in Arizona but were unsuccessful in stopping the construction of two giant telescopes on its summit.

- Development of a ski area and the use of effluent (treated wastewater) for

Bingaman (D) and Representatives Tom Udall (D) and Steve Pearce (R) asked the Department of the Interior to suspend potential mining, pending hydrology reports. Meanwhile, Republican State Land Commissioner Patrick Lyons (R) was attacking the hydrological studies and urging the miners to charge ahead. The battle continued until August 2003, when the Salt River Project suddenly withdrew its plans, citing cheaper coal in Wyoming and acknowledging that Zuni resistance and the threat of a lawsuit from environmental organizations had played a part. Victory was claimed. The pueblos celebrated.

And then, only days later, the state of New Mexico announced that it was opening 120,000 acres near and adjacent to the Sanctuary Zone to oil and gas exploration. Tacheene Resources of Albuquerque immediately began buying leases for extracting coal-bed methane, which threatened the aquifers and the Zuni Salt Lake all over again and would devour even more prodigious amounts

snowmaking on the San Francisco Peaks in Arizona—sacred to at least a dozen tribes—is considered by them an ongoing outrage. Although their protests failed in the courts, tribal members continue to rally outside government buildings and to chain themselves to construction equipment at the ski resort. An advisory panel has been appointed to study contaminants in the wastewater.

- The Bush administration cleared the way for a controversial mine on lands "that form the core of the spiritual beliefs" of the Quechan Indians in California, whose rare geoglyphs are drawn on the land and have lasted many centuries.

- At the Tiwa Pueblo of Picuris in the Sangre de Cristo Mountains of northern New Mex-

ico, protesters have taken to the pic lines and the media to protect micace clay pits used by Picuris potters for cer ries, where a succession of companies mined mica for decades; uses range fr construction to cosmetics. By the 19 access to the site, known to Picuris Mowlownan-à, or "pot dirt place," beca difficult. By 1994 the ancient clay pits w totally buried. In 2001 Ohio-based Ogle Norton, having already agreed to pa fine of $73,000 for air quality violatic filed for bankruptcy, but mining continu In 2004, after a state suit failed, the t filed a lawsuit and blocked trucks en ing the mine. In May 2005, Mowlowna was returned to the pueblo, which took sponsibility for reclamation of the 194-a site. "We are eager to heal the land," s

of water than the coal mine. While nothing seems to have come of this particular venture, in 2003 the BLM (U.S. Bureau of Land Management) also began to lease federal lands for oil/gas development, without notifying the tribe. When called on this, the BLM finally committed to selling no leases within the Sanctuary Zone, assuring Zuni that the pueblo would be informed if any actual development was proposed. So far no proposals have been presented, and Zuni has taken no action since 2004. However, the tribe was actively involved in the years-long process of writing the BLM Resource Management Plan, completed in 2010, in which the lake and the Sanctuary Zone are protected by designation as Areas of Critical Environmental Concern (ACEC), where no mining leases will be allowed.

The Zuni tribe remains relatively confident that it will be included in any further proposals, although some private and state lands remain vulnerable. For instance, in 2007–08, part of the SRP's private land was sold to Broe

Picuris governor Richard Mermejo. "We understand our ability to gather clay is based on a sacred trust with Mother Earth. The clay is a special gift, and we make gifts and offer prayers in return." Former Governor and artist Gerald Nailor added, "The clay is not only a pot. It teaches you how to live. It guides you. It gives you strength."

- On June 16th, 2012, "smoke from smoldering sage rose like a thin mist around nearly 160 Native and non-Native protesters dressed all in black, who beat drums, sang and lined the parking lot holding signs that read 'No Celebration for Desecration'" of a shellmound and burial ground at the fifteen-acre Glen Cove Waterfront Park on the Carquinez Strait in Vallejo, CA.

- Red ochre is mined to make sunscreen in Canyon de Chelly, near sites sacred to Pueblos and Navajos.

- Tribal representatives visiting the pre-European Amity Pueblo in Arizona in late 2012 found thousands of scattered skeletons, bones, and artifacts casually unearthed by the state Game and Fish Department while building a public fishing pond on the site.

- A Kiowa sacred mountain near Carnegie, OK, will be reduced to gravel, although the tribe continues to cut cedar there to burn in ceremonies.

Land Acquisitions III, LLC, which applied for even more wells than SRP had required—purportedly for ranching and farming, although the owner's connection to then-State Land Commissioner Lyons, a mining supporter, made everyone nervous, along with the possibility that he would resurrect the coal project. Eventually, however, that application too was withdrawn.

Finally, in November 2010, New Mexico Governor Bill Richardson signed an executive order to protect Zuni Salt Lake, recognizing that "Native American sacred sites are an irreplaceable and valued part of New Mexico's heritage and are deserving of respect and protection." The Office of the State Engineer was directed to consult with the tribe on management of surface and groundwater and possible designation as a "critical well-management area." Despite the prevailing right-wing conviction that Native sacred sites are some sort of scam, Salt Woman's home is safe, at least for the time being.

AT THE HEART OF MANY WESTERN LAND USE CONTROVERSIES is the General Mining Act of 1872, signed by President Ulysses Grant as an incentive to settlement on the moving frontier. It may have made sense in the era of mule trains and pickaxes "six generations ago, but today it's so obsolete it actually requires taxpayers to underwrite the pillaging of some of the finest lands in America," writes William Least Heat-Moon. Establishing virtual private property rights on federal land, this antiquated ordinance requires no royalties from hardrock miners (including gravel), while gas and oil industries have paid royalties for decades—balanced out, of course, by gigantic tax breaks handed over to them by an enabling Congress. To this day, mining claims are still leased for the absurd price of $2.50 to $5 per acre. According to the Congressional Research Service, over $2.4 billion worth of precious metals have been taken each year "without taxpayer compensation." Despite

longstanding protests and legal attempts at reform, this obsolete "law that keeps on giving," also keeps on bleeding the nation.

Tracked locally, the ubiquity of mining enterprises and giant open pits pocking the New West is stunning. The world's largest surface coal mine complex is Arch Coal's Black Thunder/Jacobs mine in the Powder River Basin of eastern Wyoming. Along with a dozen or so other Wyoming mines in what may also be the world's largest single fossil-fuel reserve, they produced more than 40 percent of the nation's electricity-generating coal. Some of their product goes to China, which has its own reserves but finds it easier to import it from here than to mine it there.

A NATIONAL SACRIFICE ZONE HAS BEEN CREATED IN THE FOUR Corners region (where New Mexico, Utah, Colorado, and Arizona meet), especially in San Juan County, NM, and parts of the Navajo (Diné) and Hopi

Center for Land Use Interpretation Photo Archive, *Wyoming Coal Train*, 2004 (from Coal: Dig It Up, Move It, Burn It). More coal comes from Wyoming's Powder River Basin than any other place in the nation. As coal-fired plants come under attack for carbon emissions, corporations have begun exporting their product to China via the West Coast of the U.S. and Canada, expending still more energy and powdering their routes with coal dust in the process.

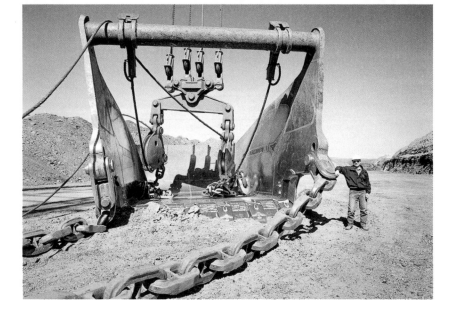

nations. This zone is emblematic of the short-term thinking that also characterizes the official U.S. response to climate change. In 2009, New Mexico had the highest mercury emissions in the nation, and San Juan County led the state. Nevertheless, the county asked the U.S. Office of Surface Mining Reclamation and Enforcement to approve expansion of the Navajo Coal Company mine, operating since 1957 southwest of Farmington, NM, on tribal trust land leased from the federal government by Australia-based BHP Billiton—the biggest mining firm in the world. (Not coincidentally, the corporation donates money to the Native Studies program at San Juan College in Farmington, NM.) Permission was denied in 2005 and BHP eventually announced it was withdrawing. The Navajo Nation is in the process of buying the mine, which supplies the Four Corners Power Plant.

When the federal Environmental Protection Agency (EPA) listed the biggest polluters in New Mexico as of 2010, coal-fired plants were in the top two

Joan Myers, *Dragline*, Navajo Mine, NM, 1999. © Joan Myers 1999. The Environmental Impact Statement will offer an opportunity to evaluate the Four Corners Power Plant/Navajo Mine transmission lines.

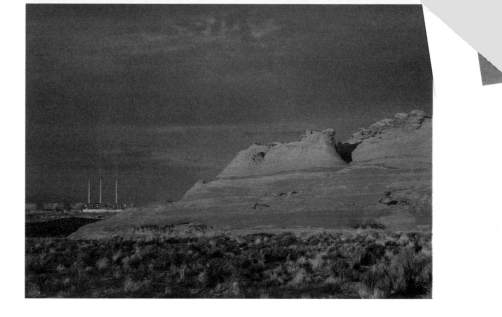

spots. The more than fifty-year-old Four Corners Generating Station near Fruitland, NM, operating since 1963, has repeatedly violated the Clean Air Act, emitting over 13,063,000 metric tons of carbon dioxide, 32,430 metric tons of methane, and 69,633 metric tons of nitrous oxide. About 15 miles to the west is the San Juan Generating Station, providing power for Public Service of New Mexico (PNM), which emitted 10,651,738 metric tons of carbon dioxide, 5,198 metric tons of methane, and over 4,000 metric tons of nitrous oxide. Other plants are located near Lake Powell, a popular recreation spot created by flooding scenic canyons and thousands of archaeological sites.

In December 2011 the EPA announced the first national requirement for coal-fired power plants to reduce emissions of mercury, arsenic, cyanide, and other toxic pollutants—potentially a landmark moment in the development of renewable energy if it is not gutted by politicians bought and sold by the

John Pfahl, *Navajo Generating Station (Evening)*, 1984, Lake Powell, AZ. Pfahl notes that power companies often choose "the most picturesque locations," in part because of access to water. Even the names of the plants often "conjure up an Arcadian vision. . . ." By seeking out these sites he hopes to make images that "approach the truth by a more circuitous route." (See Estelle Jussim and Cheryl Brutvan, *A Distanced Land: The Photographs of John Pfahl*. Albuquerque: University of New Mexico Press in association with the Albright-Knox Gallery, 1990.)

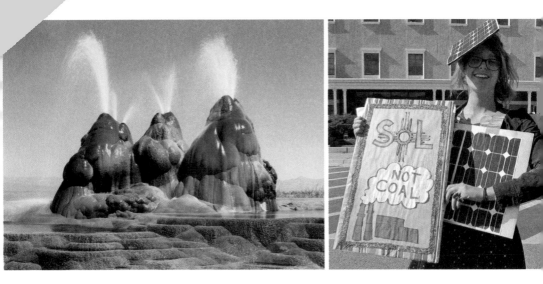

powerful extraction industries. The EPA estimates that the new requirements would annually prevent as many as 11,000 deaths, 4,700 heart attacks, and 130,000 cases of childhood asthma. Predictably, the corporations are claiming that the new regulations would cost too much, citing potential job loss (the current sacred cow). PNM continues to drag its feet, challenging the new rules, claiming they are too expensive, and allegedly lying about the cost—all the while reporting increased profits. Current Navajo President Ben Shelly joined the utility in opposing added pollution controls as "enormously burdensome." His position is hard to swallow, given the lethal history of mining on Navajo land. These plants bring crucial jobs and revenue to the Rez, while many people are suffering from health issues. Poverty makes it difficult to think very far ahead, but healing is at the heart of Navajo religion, and many Diné join the national movement pledged to replace coal with renewable energy: "Sol Not Coal."

Peter Goin, *Fly Geyser*, 2002. A small geothermal geyser in Hualapai Flat, north of Gerlach, NV, gateway to the Black Rock Desert, created accidentally in 1916; in the 1960s its weakened wall spewed waters, creating the geyser's base. It has since become a tourist feature. The spectacular coloration derives from the mix of different minerals. ● *Sol Not Coal*, demonstration at Governor's office, Santa Fe, November 9, 2011 (Photo: Mariel Nanasi). Young activists from New Energy Economy delivered a singing "solar-gram" based on "You Are My

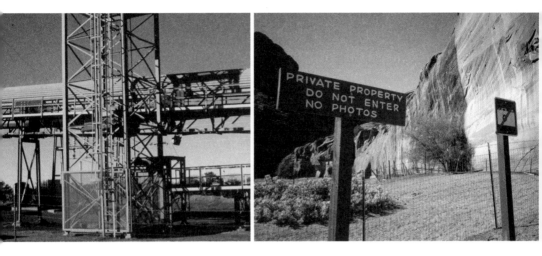

SEVERAL YEARS AGO, I WAS DRIVING WITH A FRIEND THROUGH northwestern New Mexico. The road ran through Peabody Coal's domain on Black Mesa, which supplied energy primarily to Las Vegas, Nevada, a desert gambling city with a population of 1.5 million and counting. Since the 1920s, the beautiful dark mesa and a lot of the area's very scarce and sacred water have disappeared into Peabody's pockets. We pulled over to take a couple of pictures of the humongous pits and machinery on this fenced-off industrial preserve within the Navajo Nation. A drive-by Peabody security officer, a Navajo woman, stopped to say "No photographs."

Myriad Navajo and Hopi sacred places and major archaeological sites are located on Black Mesa. But Peabody Coal? Maybe it's sacred to capitalism. Or maybe the Navajo security officer had a double agenda. "No photographs" is a common and all too historically justified admonition on Indian lands, especially at sacred sites and during the seasonal ceremonial dances that outsiders

Sunshine" to Governor Susana Martinez, inviting her to that night's lecture by climate activist/author Bill McKibben. New Mexico has a 20 percent renewable energy standard, and Public Service Company of New Mexico has not been meeting this mandate. Its 1973 San Juan Generating Station is one of America's largest single sources of harmful air pollutants. In 2013, two of its four units were scheduled to be closed. ● *Black Mesa*, c. 2000. ● *Canyon de Chelly*, c. 2000.

are allowed to attend only on their best behavior. In some of the pueblos, visitors can pay to take pictures, but for the most part they are discouraged. Without explicit permission, photographs have been unacceptable invasions for more than a century.

Black Mesa Mine, operated since the 1960s by Peabody Coal (now Peabody Western Coal, a subsidiary of Peabody Energy), straddled the Hopi and Navajo reservations in northeastern Arizona, providing much-needed employment and a huge portion of both tribes' annual budgets. Historically, the mesa had supported roughly ten thousand Hopi and twenty thousand Navajo sheep with its marshes, springs, and wetlands—most of which have vanished as the water table drops, drought intensifies, and both tribes continue to try to farm and graze their flocks. From 1970, more than a billion gallons per year of pristine water from the N-aquifer under Black Mesa—sole source of drinking water in the region—was used to cool the plants and transport coal

Thomas Greyeyes (Diné), *Angel*, c. 2011, site specific installation, water bottles and other throwaways found in trash pile "in the middle of nowhere" on the San Carlos Apache Reservation.
● *Water Is Power*, c. 2011, Navajo Reservation, AZ. Greyeyes was arrested in 2011 for "criminal damage" for writing "Peaks" in mud on a Flagstaff wall to call attention to desecration of the San Francisco Peaks. "There's a challenge in finding where my art really fit," he says. "But I have no choice but to get it out there."

in slurry through a pipeline to the Mojave Generating Station 276 miles away in Nevada. There the coal was separated from the water to provide electricity for Las Vegas, Phoenix, and southern California. From the 1970s until 2009, the Mojave Station, one of the Colorado Plateau's seventeen coal-fired power plants, dubbed "the last real stinker," belched soot and smoke over the borders of Nevada, Arizona, and California. In shifting winds, laundry hanging out to dry in Laughlin, Nevada, was "dusted with a thin layer of charcoal powder," and 75 miles northeast, an "infamous haze" obscured views of the Grand Canyon. Black Mesa mine was closed in 2005. But Peabody has not given up. In September 2013, its website announced that it "continues working with the tribes to identify coal-related opportunities that would allow the Black Mesa Mine to resume operations."

In the 1970s it was suggested that Peabody dig its wells into briny water instead of wasting scarce drinking water, but nothing came of it. Years later,

Jetsonorama, *Water Is Life*, 2012, along Highway 89, near Tuba City, Navajo Nation. An African American physician who has lived and worked on the Navajo Nation since 1987, Jetsonorama makes poignant, hard-hitting "street art" in rural environments, gaining an international reputation. The black and white photographic images—often overwritten with texts ("What we do to the mountain we do to ourselves")—are enlarged and wheat-pasted on isolated sites. Among the subjects are a local "party dog," sheep, and many portraits of those living near the sites.

Peabody had an extraordinary idea, offering to fill its last mining cut with water to be used as a reservoir, ignoring the fact that strip-mined land is so full of silt and chemicals that it could kill anything it irrigated. By the 1990s, thanks to Peabody's 2,500 to 3,000-feet-deep wells, the springs and Moenkopi Wash (the only flowing stream on the Hopi Nation) were drying up; Hopi and Navajo wells from shallower sources were also minor contributing factors.

A HOPI PROPHECY TELLS OF THE WATER SERPENT PAALÖLÖQANGW rebelling against *koyaanisqatsi*, "a life of chaos"—the title of a famous experimental film by Godfrey Reggio with music by Philip Glass. When the serpent lashes its tail, creating an earthquake—the land will return to ocean depths. (In 1987 and 1988, there were two rare earthquakes on Black Mesa, thought to be related to the removal of so much water and coal.) For some other Pueblo peoples the Awanyu, or water serpent, turns to flame in response

to evil. "Water is our bloodline," said a Hopi elder. "That is the only way this world is going to survive."

The Hopi tribe's 2003 water conference *Hisot Navoti* (knowledge of the old) was introduced and concluded with prayers for water and blessings with water from a Hopi spring. Vernon Masayesva, executive director of the Black Mesa Trust, announced that Hopi had broken a covenant and placed its destiny at risk when it sold the pure drinking water to Peabody in 1968 for a mere $1.67 per acre-foot. (Navajo had negotiated a higher price, $5 per acre-foot, from the same aquifer.) Yet Hopi received 80 percent of its national revenue from Peabody royalties and water leases, which may explain the reluctance of tribal council members to attend the conference. Steve Blodgett, who helped set up Hopi's Environmental Protection Office, observed that the aquifer was drying up under industrial use. (At the time, Hopi did not know that their Mormon attorney was also working for Peabody in a blatant conflict of

Michael Namingha (Hopi-Tewa), *Voyeur*, 2011, inkjet on canvas, 22" x 30".

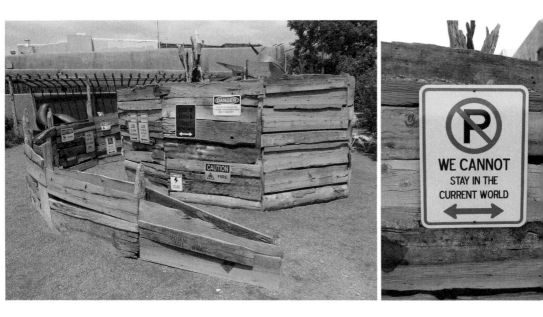

interest.) Another elder declared that the ongoing Navajo/Hopi land dispute around Big Mountain was fabricated to divide Native people and gain access to Black Mesa's resources, while Masayesva contended that the 2001 attack on the World Trade Center was the result of failing to protect sacred land and water, according to Hopi prophecies: "Indigenous people know why it happened."

In 2010, after years of controversy and environmental damage, Peabody's permit was revoked by a judge who found that its Environmental Impact Statement did not meet the requirements of the National Environmental Protection Act. The plant closed down, only to be replaced by plans existing since 2003 for an oxymoronic "clean coal" operation called Desert Rock, officially supported by the Navajo Nation but resisted by many Navajo communities, as were right-of-way easements for transmission lines. Grass roots organizations, including Diné CARE and *Dooda* (No) Desert Rock opposed

Anna Tsouhlarakis (Diné), *Edges of the Ephemeral*, 2012, aluminum signage, reclaimed wood, found objects, 18' x 18' x 9', Museum of Contemporary Native Arts, Santa Fe. In each previous world, in Navajo history, an event disrupted harmony (*hozho*) and forced the people to move on. "For this project I explored Navajo narratives of the future worlds." Findings were merged into a spiral installation, combining a quasi-scientific survey with the very real role of oral tradi-

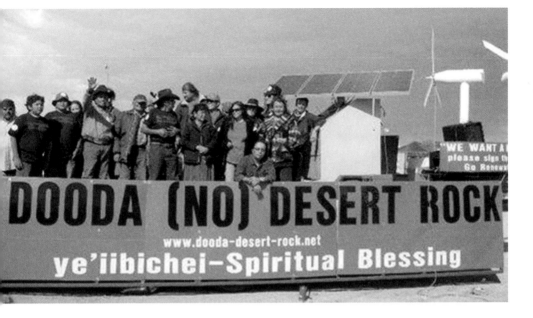

DOODA (NO) DESERT ROCK
www.dooda-desert-rock.net
ye'iibichei–Spiritual Blessing

the plant, and Governor Bill Richardson joined them. Finally, the EPA rescinded its air quality permit. Yet the loss of a possible $50 million per year was a blow to the Navajo Nation, where unemployment often reaches 50 percent.

Renewable energy has been proposed for the arid West since the early 1970s and is particularly meaningful to indigenous people who still have no electricity and suffer from polluting coal. A 2008 report from Northern Arizona University found potential wind capacity on tribal lands to be over 11,000 megawatts and solar capacity over 48,000 megawatts. Yet alternative energy projects are not free of cultural collisions either. While the Department of the Interior has acknowledged southern California's Coyote Mountains Wilderness Area as an established archaeological site, citing the prehistoric and historic presence of the Quechan tribe of the Fort Yuma Indian Reservation, in May 2012, Secretary of the Interior Ken Salazar approved construction of the Ocotillo Wind Energy Facility—a massive industrial field

tions. Much of the wood is hand cut and comes from the artist's family's land, representing tradition, while the signage is manufactured and has no history. Beyond the blocked entrance to the center is a wooden ladder and wooden hatch—"entrance or exit?" ● *Dooda Desert Rock*, c. 2003 (Photo: Elouise Brown). The campaign against Desert Rock, led by Brown and other Navajos, was a rare success. The plant was never built.

of 112 turbines, each standing 450 feet tall—across 10,150 acres some 90 miles east of San Diego. The land is public, but sacred to the Quechan, Kumeyaay and Cocopah Nations. And the Genesis solar array east of Los Angeles is being protested by Colorado River Indian tribes, invoking NAGPRA, because fast-tracked, developer-led archaeological surveys "overlooked" grinding stones and a layer of charcoal that may indicate a cremation site.

In North Dakota, there is a flip side to these indigenous protests. The Fort Berthold Reservation was left out of the Bakken oil boom with its twelve thousand wells, where hydrolic fracking is killing cattle and threatening the nation's food supply. Now Fort Berthold is struggling to catch up by suing the U.S. government for failing to protect their economic interests, since the Bureau of Indian Affairs had approved agreements below market value. The actions of the historic preservation community, energy resources, and Native sacred site protection form a complicated matrix. A federal blog asks, "How

Jamey Stillings, *Aerial View of Ivanpah Solar Electric Generating System*, June 2012. Stillings cites "our collective ability to shift from a society based on fossil fuels to one that embraces sustainable energy production." When completed, Ivanpah "will be the world's largest concentrated solar thermal power plant. 344,000 mirrors (heliostats) will focus the sun's thermal energy toward three towers," creating electricity to power 140,000 homes. Yet there are also fears that solar plants could devour the Mojave and its wildlife. (See *High Country News*, April 14, 2013).

do we balance the need for alternative energy and other development with the preservation of traditional cultural landscapes and other large-scale historic places?" Balance has not been our forte.

SOMEWHERE IN AN INDETERMINATE TIME ZONE BETWEEN THE Old and New Wests loom the massive outdoor sculptures dubbed earthworks in the late 1960s, now more broadly defined as land art. In the U.S., the best known of these sculptures drawn or cut from the earth itself, or made from its products, are Robert Smithson's *Spiral Jetty*, Nancy Holt's *Sun Tunnels*, the late Walter De Maria's *Lightning Field*, Charles Ross's *Star Axis*, James Turrell's *Roden Crater*, and Michael Heizer's *Double Negative* and *City Complex*—titles indicative of the ambitious visions driving them. All of the artists are white; all but one are men (sporting cowboy boots and ten gallon hats), as it is rare for women artists (Holt is the exception) to raise the thousands of dollars it

Terry Evans, *Oil pipeline right-of-way*, Mountrail County, ND, June 2011, from Evans's 2012–13 portraits and landscapes: Fractured: North Dakota's Oil Boom. Chippewa writer Louise Erdrich calls the Bakken oil fields in her native North Dakota an "energy sacrifice area," noting that fracking "has resulted in a methane burnoff so large that the flares can be seen from outer space." (OnEarth, Summer 2013). ● *Robert Smithson's Spiral Jetty, Sunset*, 2012 (Photo: Tom Martinelli). Spiral Jetty and the artist's film based on it were both created in 1970.

takes to create such monumental works. Three of those listed above focus on the heavens; three have been under construction for some thirty years; one has been changed constantly by nature during its forty-year existence. All are endowed with extraordinarily beautiful surroundings and enhanced by weather, seasons, light and shadow. They surrender scale to the adjacent spaces, while drawing their emotional power from distance—distance from people, from environmental issues, and even from places. Land art tends to be site-specific but not overtly place-specific. Local geology, history, and identity are secondary, if acknowledged at all. Local residents are considered primarily in their roles as workers and incidental audiences. The on-site viewer is as likely to be deeply affected by the landscape as by the art object. It is this combination that is so compelling.

Most of us envision rather than visit the classic sites, where open space becomes a kind of mat within the frame around the photograph. Even if we have

Tacita Dean, film still from JG, 2013, 35mm color/ black and white anamorphic film with optical sound, 26 ½ minutes (Courtesy of the artist and Frith Street Gallery, London; Marian Goodman Gallery, New York/Paris). Dean's film was inspired by her correspondence with science fiction writer J.G. Ballard, a favorite of Smithson's, who told Dean "to treat the Spiral Jetty as a mystery her film would solve." It became a "speculative conversation" between the three artists, "across decades and disciplines."

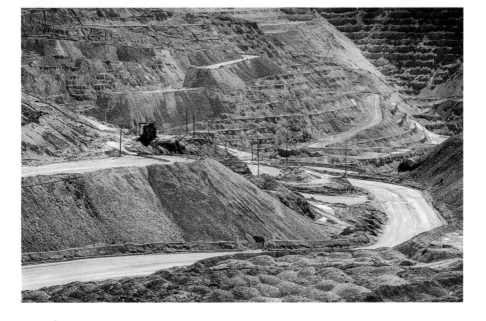

actually seen them, our impressions are mediated by the glamorous aerial photographs in publications, which are critical to earth art's esthetic impact and dissemination. Early land artists without frequent access to the "timeless" western deserts often adopted readymade pits (quarries in New Jersey, for instance), where the "timeliness" of nearby skyscrapers could be ignored. Smithson, Michelle Stuart, and Charles Simonds, among others, employed these geographically ambiguous sites as temporary substitutes for the West. Their works are sometimes inspired by the ruins of great monumental civilizations of the past. Some also visited, and lusted after, the gigantic western open pit mines (epitomized by the Santa Rita/Chino pit in New Mexico, the Bingham pit in Nevada, and the Berkeley pit in Butte, Montana). Aside from their visual impact, these awesome earthworks, created by Kennecott Copper, Rio Tinto, the aptly named Anaconda, and other global giants, also raise questions about the sustainability of the classic artworks. How does Heizer's

Joan Myers, *Chino Pit (aka Santa Rita del Cobre)*, southwestern NM, 2013. © Joan Myers. Operating since 1909 (and mined for copper by Apaches before the Conquest), once the world's largest open pit, Chino is now owned by Freeport-McMoRan. Recent state law frees up corporations to pollute groundwater, though a lawsuit is pending. Of the surrounding landscape (which includes an interpretive site for tourists), the only erection spared devastation is a prominent feature known as the Kneeling Nun.

"WE DON'T HOLD WITH NO SITE-SPE
WORKS ROUND THESE PARTS, STRA
WARNED THE CURATOR

Double Negative, for example—the biggest gully around—protect its matrix from the erosion that cuts through every arid western landscape, where roads, trails, and even animal paths can become running streams and then harsh arroyos when the infrequent rains descend?

"One's mind and the earth are in a constant state of erosion," wrote Smithson, a New Jersey native and one of the originators of the earthworks genre. It is impossible to talk pits in an art context without confronting his influential presence/absence; his romantic attraction to eerie, dreary, post-industrial landscapes; and his paeans to entropy. Although we often disagreed forty years ago, I now find Smithson's preoccupations with mirrors, pits, geology, the West, sprawl, and entropic suburbs reflected in my own life and work. And I am hardly alone. Smithson is the only one of his generation of land artists in the late 1960s whose ideas, disseminated through his compelling writings, seem particularly relevant and provocative today.

Land Arts at Double Negative, near Overton, NV, 2010 (Photo: Chris Taylor, Land Arts of the American West). Michael Heizer's *Double Negative* (1969–70, 1500' x 50' x 30') was followed by *City Complex*—1 mile long, 500' high, visible primarily from 20,000' above. A nearby mountain was removed by Anaconda and donated piecemeal to the artist. ● Glen Baxter, *"We Don't Hold with No Site Specific Works Round These Parts, Stranger," Warned the Curator*, 2007–08. Digital inkjet print, 29.5" x 22.4", edition of 100. (Courtesy of Flowers Gallery, London). © Glen Baxter.

Smithson's first proposed earthwork, in 1966, was *Tar Pool and Gravel Pit* and just before his death he was trying to persuade Peabody Coal to fund a reclamation piece. In his 1967 *Tour of the Monuments of Passaic NJ*, he wrote about a gigantic parking lot that covered old railroad tracks, dividing the city like two sides of a mirror, and noted how full of "holes" prosaic Passaic seemed in contrast to "solid" New York. He liked to quote his friend, sculptor Carl Andre: "A thing is a hole in a thing it is not." Smithson was simultaneously involved in the place and self-consciously removed from it. Views, or vistas, interested him less than what was underfoot. When he and Nancy Holt visited me in coastal Maine in 1972, he peremptorily dismissed the sparkling ocean view and turned his attention to the geological history of the rocks on which we stood. Like Icarus, Smithson's grand ideas ended tragically in 1973 when his small plane plunged to the earth as he was overseeing a Texas earthwork in progress.

Robert Smithson, *Tar pool and gravel pit*, 1966, (destroyed model, proposal for Philadelphia), 36" x 30". (Licensed by VAGA, © Estate of Robert Smithson; Courtesy of James Cohan Gallery, New York/Shanghai). Tar poured into a square sink in a gravel sink, making us "conscious of the primal ooze . . . [bringing] to mind a tertiary world of petroleum, asphalts, ozokerite, and bituminous agglomeration."

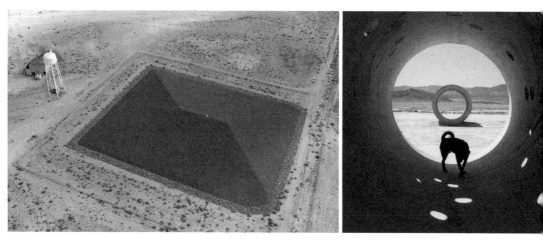

Smithson's account of finding the Salt Lake site for *Spiral Jetty* (the best known earthwork in the world, though it was underwater for decades) sounds like the reporter's description of the Zuni Salt Lake: "a transplanted segment of crumbling New Jersey industrial shoreline," but Smithson embraced rather than deplored industrial detritus. At first, he couldn't get to the "wine red" Salt Lake because of Keep Out signs and angry ranchers. (Welcome to the West.) The next day, he recalled, "We followed roads that glided away into dead ends. Sandy slopes turned into viscous masses of perception . . . an expanse of salt flats bordered the lake, and caught in its sediments were countless bits of wreckage. . . . The mere sight of the trapped fragments of junk and waste transported one into a world of modern prehistory. The products of a Devonian industry, the remains of a Silurian technology, all the machines of the Upper Carboniferous Period were lost in those expansive deposits of sand and mud." It was an epiphany, with or-

Center for Land Use Interpretation Photo Archive, *Green River Uranium Disposal Cell*, Utah (flight support from LightHawk), 2012. Low geometric mounds (up to 100' high and over half a mile) built to last thousands of years, confront but hardly solve the nuclear waste problem. ● *Rez Dog at Nancy Holt's Sun Tunnels*. Holt's 1973–74 work near Lucin, UT, is four concrete, steel, and earth structures in an open cross (diagonal length 86') aligned with Summer Solstice sunrise and sunset, framing the Great Basin landscape and the cosmos. Light through holes equals magnitude

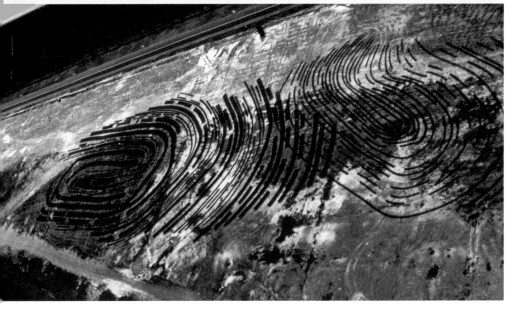

gasmic overtones. "From that gyrating space," he continued, "emerged the possibility of the Spiral Jetty. . . . My dialectics of site and nonsite whirled into an indeterminate state, where solid and liquid lost themselves in each other."

When land art was new, bringing provincial New Yorkers out of their lofts and into the hills, the expansion of consciousness it offered was both experiential and esthetic. Ideally part land and part art, it is best located deep in place, where one comes upon it unexpectedly, like ruins and rock art—poignant reminders of human agency and time's victories. The viewer, like the artist, is so awed, so sensitized, so aware of seasons and materials, space and wildlife, that the work truly co-exists with the place it creates. Religious undertones and the nineteenth-century "sublime" are part of the attraction. Artists were thinking on a grand (sometimes grandiose) scale. Forty years later, climate change, shrinking resources, threats of drought, and federal administrations

of several constellations. (Licensed by VAGA.) (See Alena J. Williams, *Nancy Holt: Sightlines*. Berkeley: University of California Press, 2011.) ● Dennis Oppenheim, *Identity Stretch*, 1970–1975, hot sprayed tar, 300' x 1000', Artpark, Lewiston, NY. © Dennis Oppenheim. Thumb prints (son Erik Oppenheim's) on elastic material were pulled to maximum and photographed; site surveyed for grid; spray truck worked on mason's grid following enlarged papillary ridges of thumb prints—human touch, or the human stamp on earth.

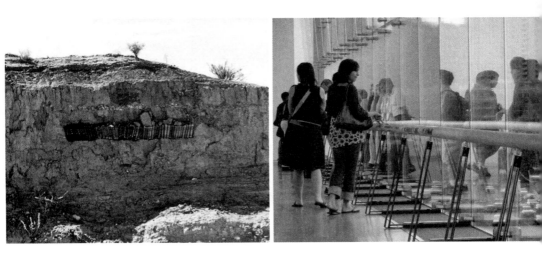

bent on destroying the environment for corporate gain have changed the rules of the game.

In the mid-1990s, I called a talk I gave in Marfa "Land Art in the Rear View Mirror," because by then I had gone on down the road. Cultural geography and the politics of land use have replaced land art in my windshield over the years I've been living in the West. My views haven't changed because I have less respect for the older work, but because the better I know the New West the more my attention is claimed by peripheral vision—by the side-of-the-road shows, by life on the land. I argue now for the nearby, a microview of land and art, grassroots connections rather than macro pronouncements. In fact, I've come to the reluctant conclusion that much land art is a pseudo rural art made from a metropolitan headquarters, a kind of colonization in itself. It offers an antidote to an urban landscape crammed with art and visual competition. In a rural setting,

Zane Fischer, *Bookshelf*, 1995, Galisteo Basin (Photo: Colette Hosmer). Installed in a rural New Mexico arroyo to be happened upon, to weather, to disappear, like knowledge itself. ● Teri Rueb, *Core Sample*, GPS-based sound walk (Spectacle Island, Boston Harbor) and sound sculpture (Boston Institute of Contemporary Art), 2007. This two-part work was accessible over headsets on the island (a former fishing port, landfill, now a park), evoking its material and cultural histories. Rueb has "horizontalized" the vertical hydrologist's tool.

however, land art would more often entail subtractions (of "ranchettes" dotting the open landscape) than additions. The land art we know best in rural New Mexico is abandoned adobes, trophy homes standing out like sore thumbs in this beige landscape, and aging vehicles nobody can afford to haul away.

When I was a city dweller, I welcomed visual extravagance, graffiti, oddities, or subtle alterations in my already hectic daily surroundings. Public art belongs in towns, places where people interact with the built environment on a frequent, familiar, pedestrian basis where art can literally inform or enhance a neighborhood or public domain. The task of land art, on the other hand, is to focus landscapes too vast for the unaccustomed eye to take in, or to give us views into the cosmos, connecting the places where we stand with the places we will never stand.

Significant objects have their place in the art world. It remains to be seen

Michelle Stuart, *Fragment*, Sayreville Quarry, NJ, 1976. The site was "environmentally haunted . . . like a desert in the middle of New Jersey. . . . It was the color[s] of the earth that kept bringing me back." ● *Jemez History Book*, 1975, earth from Jemez, NM. Stuart studied the ancient and contemporary Pueblo cultures associated with the sites from which she acquired the earth rubbed into paper to make her "books" and large wall pieces. (See *Michelle Stuart: Sculptural Objects, Journeys In & Out of the Studio*. Milano: Edizioni Charta, 2010.)

if they still have a place in land art. There is a point where artists too must take some responsibility for the things and places they love, a point at which the colonization of magnificent scenery gives way to a more painfully focused vision of a fragile landscape and its bewildered inhabitants. The land is not separate from the often harsh realities of lives lived upon and around it. A land art in the New West could acknowledge the rough edges as well as the romance. It could be integrated into a cultural landscape, which is a forever changing production featuring vegetation, wildlife, water, and human agency. A vernacular land art might include commemoration that looks to the smaller scale, land-based notions of nature, remembering small farms and common lands, the disappearing histories of places and ecosystems.

I have to admit that today my favorite art in the land is not contemporary but aboriginal earthworks—rock art (petroglyphs and pictographs), earth mounds, geomorphs, the ruins of ancient puddled adobe towns found

"Supernova" Pictograph, Chaco Canyon, NM, believed to mark an astronomical event in 1054. ● Charles Simonds, *Landscape/Body/Dwelling*, 1973, still from film by Rudy Burckhardt. In the Sayreville, NJ, clay pit, Simonds covers his body with a clay landscape and builds with tiny bricks a home for his imagined "Little People."

by roadsides, on golf courses, and in the most remote deserts, forests, and canyons. Where contemporary land art demands all the attention, rock art quietly absorbs us into its place, even when we understand very little about the messages we are getting. Although individual images stand out, they are most evocative in relation to each other and to the place and clues they offer about the cultures that created them. (Many of these sites are still utilized ceremonially.) And of course it is easier to identify with the people who were once relatively peaceful stewards of that particular landscape than with to-day's property owner, who is likely to appear with a rifle and arrest you for trespassing.

"Adventurers" from more populous parts of the country and abroad forge their way over bumpy dirt roads, deciphering labyrinthine directions, to see the classic earthworks. They have become trophies on the art tourism checklist and attract a rarified coterie, contributing to regional economic

Circle Petroglyph, c. 1300–1500, Galisteo Basin. There are a vast number of petroglyphs in the basin, ranging from densely complex to "minimal," like this one.

development while also calling attention to the fact that many famous western landscapes are surviving precisely because of cultural tourism. The Land Arts of the American West programs at the University of New Mexico and Texas Tech, led by artists Bill Gilbert and Chris Taylor, offer students a temporary nomadism, a rugged art-making intensive, and a chance to consider not only art and non-art but also "forms of travel as different measures of the landscape," as Chris Taylor has put it. They explore old and new ideas in increasingly contextualized frameworks, stretching the initial tenets of land art with pop culture, humor, and new technology, inaugurating a whole new field—institutionalized student tourism.

The earthworks play their part as the myth of the Old West gives way to the mundane real estate realities of the New West in a region where the land itself is more compelling than any museum; or, more pessimistically, where protected land and beauty strips are "museumized" in a landscape

Charles Ross, *Star Axis* (Photo: Edward Ranney, *Looking South, 9/20/2012*). Ross's earthwork, in process for over thirty years, creates an instrument for seeing time. From below, this form perfectly frames the circle drawn by the earth's axis through the stars over its twenty-six-thousand-year cycle of precession. A staircase climbs 76' through the Star Tunnel in the Solar Pyramid. Ranney has been photographing *Star Axis* since 1979, drawn to its affinities with ancient American sites. (See *Charles Ross: The Substance of Light*, Santa Fe: Radius Books, 2012.)

marred by extraction and greed. Eventually, *Star Axis* and *Roden Crater*, already under construction for a more than a quarter century, will boast visitor centers and tourist facilities. The DIA Art Foundation's *Lightning Field* is meticulously stewarded, but even the sought-after overnights cannot cover its maintenance. Reservations for a six-person cabin must be made months in advance; supper and breakfast are provided and exactly twenty-two hours (from pick up in Quemado to pick up at the cabin) are spent on the site for a hefty fee. Photographs are not allowed. My own experience was somewhat tempered by the fine old time we had in the cabin after dark, which blotted out the feeling of full immersion I anticipate when wandering through a landscape, taking my time, picking my focuses. We expected no lightning in May, and got none, but as the light shifted and the sun set, turning the silver poles gold and then black, I was struck by how lonely earthworks are.

Eve Andrée Laramée, *Slouching Toward Yucca Mountain, Danger Ranger,* 2011, video, photography, performance, translating research and oral histories into visual forms. A cast of fictional time-travelers explores the post-atomic West. Danger Ranger is the environmental whistle-blower at the Bonnie Clare mill in Nye County, NV, abandoned with toxic tailings in situ. • *Corn, Lightning, Cloud and Bird,* 1200–1400, Three Rivers, NM (Photo: Polly Schaafsma). Lightning in ancient Pueblo cultures symbolized life-giving power from above.

TOURISM IS THE STRAW GRASPED BY DESPERATE ECONOMIES ravaged by mining and gas/oil development or abandoned by second-homesteaders. It has been described as a mixed blessing, a double-edged sword, and a devil's bargain. Tourists' values are both local and global. Some destinations are culturally specific, targeting those of us who like places and their histories, while others are generalized for recreational or stereotyped consumption. New Mexico, the lens through which I view the New West, is heavily dependent on tourism, along with the military, nuclear, and extractive industries. Yet thanks to the Four Corners plants, the Rio Grande Valley to the east is sometimes veiled by a noxious cloud—this in a state dubbed the Land of Enchantment that brags about its clear light and pure air.

"Culture" is an acknowledged money-maker in the Land of Entrapment. The "mystery" of the Chaco Culture National Historic Park's thousand-year-old ruins are southwestern archaeology's favorite conundrum, still wide open

Center for Land Use Interpretation Photo Archive, *A Tour of the Monuments of the Great American Void*, a CLUI bus tour of the Great Salt Lake region, 2004. *Spiral Jetty* is on the video screens.

to interpretation, though its isolation deprives it, or saves it, from the hordes that visit Mesa Verde in southwestern Colorado. Tour bus companies and other commercial entities campaigned for years to pave the miles of dirt road to Chaco Canyon, but eventually lost. In this case, distance and isolation are integral to the experience. Archaeology (with its focus on dead Indians) is one of the Southwest's subtler attractions, along with the arts and ceremonial dances of the twenty contemporary pueblos, though daily life in these dusty villages is less marketable. Native people are still considered by many to be another kind of natural resource, almost inseparable from wilderness—icons of the past rather than living citizens. Contemporary Native artists have tackled these issues with gusto.

New Mexico's tourism does not depend as heavily on the macho image of the Old West as some of its neighbors' does, but it is not above resurrecting that history as spectacle. Dude ranches, rodeos, mining ghost towns, any

Mark Klett and Byron Wolfe, *Desert View: from the window of the Watchtower gift shop*, Grand Canyon, 2008, digital inkjet print, 18.5" x 24". Inset: undated color postcard.

place even vaguely associated with Billy the Kid, represent the Disneyfication of the Old West, like Tombstone's staged shootouts in Arizona. Bizarre and often inaccurate notions of the past are veneered onto the present. Hispano pasts (the *vaquero*, for instance, the original "cowboy") are subject to a kind of touristic class system, made less appealing to tourists than noble savages and bloodthirsty Anglo killers.

Film is armchair tourism—once again removed, enhanced by fantasy, although Robin L. Murray and Joseph K. Heumann point out that Gene Autry's cowboy films were often focused on ecological issues. The 2007 remake of *3:10 to Yuma* (shot on the Silverado set, within view of my house, and directed by James Mangold, the son of artists, who grew up in the loft above mine on the Bowery in Lower Manhattan) minimized issues of water rights and drought that played large roles in the 1957 original. Over the last decade or so, the film industry has prospered in New Mexico thanks to generous incentives, to

Billy the Kid's Grave, outside Fort Sumner, NM, 2013. William H. Bonney was twenty-one when he was gunned down in 1881. His 80-pound marker has been stolen three times. A yearly foot-race commemorates the thefts. ● *Billy the Kid Museum*, Fort Sumner, 2013. This is one of those crowded, funky commercial museums still found in the West, complete with a replica of the Kid's actual grave, a few miles away.

which the current Republican governor is opposed. One of the films partially shot in the Galisteo Basin was the hilarious *The Lone Ranger*, starring Johnny Depp as a shamanically-headressed Tonto—a slap in the face to Native actors, though Tonto (it means dumb in Spanish) is hardly a hero, and Depp, who claims some Cherokee ancestry, has been adopted by the Comanche Nation.

DESPITE CROWDING, DETERIORATING INFRASTRUCTURES, POOR support from the government, and subsequently rising fees, the National Parks are a secular society's sacred spaces—all the more so as their counterparts on private and public lands fall prey to more pits and erections, and "pristine wildernesses" become almost mythical. (Historian William Cronon contends that the problem is not with wilderness per se, but with "what we ourselves mean when we use that label.") The grandest pits in the West are its ubiquitous canyons, their large and small gorges hidden among flat grasslands

Silverado Movie Set, Galisteo, NM, c. 2010. The set, on a ranch owned by a famous designer, is still active today, just over the hill from my house, offering spectacle superimposed on daily reality. ● *Shop Window*, Santa Fe Plaza, 2009.

and sandstone mesas, the streams and cottonwoods in their depths belying the arid landscape in which they lurk. Canyons are the underworld of the visible terrain, except of course for the grandest of them all—that pit to end all pits, defying description.

Amazing as it is from the rims, the commonest viewing points, you have not been *in* the Grand Canyon without the descent into its underworld. Postmodern academic criticism argues that the whole world is packaged for us, that nature is no exception, and we never see what is before us without an invisible frame courtesy of the mass media or even of great art and literature. There is truth in that, but at the height of postmodernism's popularity, we were virtually forbidden to experience anything directly, emotionally, or kinetically. If we did so, we were accused of being "essentialists," ignoring the imposed frames, falling for the propaganda. However, those who have immersed themselves in the stewardship of western lands refuse to forego lived experience and close scru-

Mark Klett and Byron Wolfe, *Man Peering into Space (bottom left: photographer unknown, n.d.; bottom right, Alvin Langdon Coburn, c.1911)*, 2008, Grand Canyon, digital inkjet print, 24" x 24". "In the world of the camera," writes Klett, "a period of long duration or multiple points in time may exist side by side as the expression of one moment on a single sheet of film." (Klett, *Reconstructing*).
● Paula Castillo, *the world is flat*, 2011. "In las barrancas slightly east of Alto Huachín and Córdova," history lies in the land, not in official plaques, especially in New Mexico.

tiny, adding more not less strata to the consideration of places like the Grand Canyon, which some now think is not 7 million, but 700 million years old.

A macho society like ours has always found it difficult to deal with places like the Grand Canyon, Yosemite, and Yellowstone. History demonstrates that the first impulse is to control them, tame them. Many of the great western rivers have been multiply dammed, their meanings and their forms reconstructed. The Snake River in Idaho, for instance, acquired one dam in 1962, two more in 1970, and a fourth in 1975, taking out 140 miles of river, 14,400 acres—much of it lost habitat—and forty-eight islands. The damming of the Colorado River, with the destruction of the glorious Glen Canyon landscape and its multiple archaeological sites for the birth of the now endangered Lake Powell (aka Lake Foul), was followed by plans to dam the Grand itself, which fortunately failed.

In the 1950s, according to Stephen Pyne, the Grand Canyon underwent "an immense cultural metamorphosis, becoming again, though the imperial

Mark Klett and Byron Wolfe, *View from the handrail at Glacier Point overlook, connecting views from Ansel Adams (1935, left) to Carleton Watkins (1861, right)*, 2003. "We realized Adams had become a grandfather," writes Solnit, "his shadow no longer reached us, the era of reacting against him and against modernism was itself history. . . . The future was wide open, and we had chosen to try to travel there through the past." (See Klett, Solnit, and Wolfe, *Yosemite in Time: Ice Ages Tree Clocks Ghost Rivers*. San Antonio: Trinity University Press, 2005.)

overtones this time were somewhat muted, part of a national 'geography of hope.'" Since then the canyon has been regularly threatened by some eight thousand mining claims (many for uranium) in its periphery, owned by entities from Russia, South Korea, and Canada, among others, as documented by the Pew Environment Group in the early twenty-first century. When a temporary ban on mining was imposed, corporations and their congressional allies fought tooth and nail to deny protection to the Grand Canyon. Finally, on January 9, 2012, the Obama administration issued a "long term" (only twenty years) moratorium on new uranium claims on 1.1 million acres of public lands surrounding the national park—with the support of water officials in Arizona, Nevada, and California, citing threats to drinking water. Environmental groups are currently pushing for the establishment of a National Monument in the Grand Canyon's watershed.

Yet the moratorium is merely a reprieve, and other national parks remain

Mitch Dobrowner, *Isis Temple*, Grand Canyon, AZ, 2008.

under siege: Bryce Canyon, Zion, Arches, and Canyonlands in Utah alone. When oil and gas leases near the parks were auctioned off in 2008, in the closing days of the George W. Bush administration, University of Utah student Tim DeChristopher spontaneously bid up to $1.7 million to protect public lands, with no intention of paying. He became a national hero . . . and served twenty-one months in prison, plus three years of probation, even though the Obama administration scrapped the leases he fought against. (Energy companies are trying to win them back in a Colorado court.) Aggressive oil shale and tar sands drilling threatens other parks and protected public lands. A new copper mine which would be the nation's third largest is proposed only 30 miles from the city of Tucson. In March 2012, the BLM approved 1,300 new gas wells in Utah's Desolation Canyon—the largest unprotected roadless area in the lower forty-eight. One of its defenders is movie star/environmentalist Robert Redford. The EPA's call to design the area as a "wilderness" that

Lewis Koch, from *Twentyone Yellowstone Parking Lots*, artist's book, 2012. Drawing upon Ed Ruscha's formative influence (and specifically his 1967 artist's book *Thirty Four Parking Lots in Los Angeles*), this series is part homage and part environmental critique, depicting car culture as it accesses a landscape celebrated and despoiled in equal measure.

included drilling—a decision criticized even by the CEO of Black Diamond, Inc.—was ultimately rejected. Yet national parks generate more jobs than drilling does. Mining now produces less than 1 percent of Arizona's economy, while tourism accounts for almost 10 percent. Years ago conservationist David Brower asked a question that we must ask ourselves today: "If we can't save the Grand Canyon, what the hell can we save?"

OUR CULTURAL USE OF NATURE MAKES IT STAND FOR WHAT WE are unwilling to stand up for. We have yet to learn that natural processes, once triggered, can easily get out of human control, even when we have pulled the trigger. As William deBuys writes in *A Great Aridness*, his passionate book about climate change in the Southwest, "No big thing happens for just one reason," and "the human contribution to change in the natural world more often catalyzes than dictates the outcome."

Michelle Van Parys, *Future Exhibit*, AZ, 1991. (See Van Parys, *The Way Out West: Desert Land-scapes*. Chicago: The Center for American Places at Columbia College, 2008.) ● Debra Anderson (director), poster from *Split Estate*, 2009. Documentary film has provided the most effective opposition to fracking. The 2010 Emmy–winning *Split Estate* and *Gasland*, and *Gasland Part II* (2010, 2013, directed by Josh Fox), among others, are more likely to grab a media-addicted American audience than print or demonstrations. ● Adam Horowitz,

What You Don't Know CAN Hurt You

SPLIT ESTATE

Nobody likes to foul their own nest, but those nests are often too narrowly defined. In 2011, *High Country News* compiled a list of forty-eight major players in the West's multinational economy. One was dubbed "Tierra Amadrillya," with wells on the nineteenth-century Tierra Amarilla (Yellow Earth) Land Grant in northern New Mexico. An under-reported aspect of undermining is the dreaded "Split Estate" rule, which means a landowner can sell land twice—once on the surface—real estate as usual, and once for subsurface mineral rights. When the surface changes hands, the new owner is unlikely to realize that someone else owns the land under her home. The practice of horizontal drilling from next door, or miles away, to get at thin layers of gas is especially frightening. Most western residents with small properties (myself included), have no idea who owns the resources beneath them, if there are any, or how that presence and ownership could undermine our domestic lives. And it's not easy to find out, at least in my area, where

Stonefridge: Fridgehenge (early stage),1998, transfer station, Santa Fe (Photo: Jack Parsons). Subsequent incarnations of this project, with hundreds of fridges, were constructed by performance artists. A "pagan temple" to the cult of "technological materialism," Fridgehenge was destroyed three times by government officials. Anne Valley Fox called *Stonefridge* "food coffins" whose "license to chill has expired."

the County Clerk's records are incomplete. The subterranean economy escapes us, as we try to escape its effects on our worlds. But we all end up there.

Ignorance of what goes on beyond the nest in the larger picture and how it all connects is dangerous. The Environmental Justice movement calls attention not only to the places we desecrate, but to the people who live there. I have a poster on my wall reading "Nothing About Us, Without Us, Is For Us"—a resounding message to industries, politicians, clueless do-gooders, and to each other. At best NIMBY (Not in My Backyard) means resistance to the destruction of local environments for so-called progress. At worst it means keep poor people and people of color in the places that are being destroyed by nuclear waste dumps and other hazardous matter. Poverty is one of the criteria for finding a home for toxic waste. For example, the Torres Martinez tribe in Thermal, California, was persuaded to accept toxic illegal dumps on their

Julius Badoni (Diné), *Tó éí íínó (Water Is Life)*, 2011, lino-cut, edition of 30. The artist grew up on the Navajo Nation and witnessed the effects of water unavailability firsthand. He serves on the advisory board for the Black Mesa Water Coalition: "My art is a protest, a protest in various mediums . . . [raising] awareness about the effects of colonization on Indigenous communities. I believe in educating and unifying people through my art."

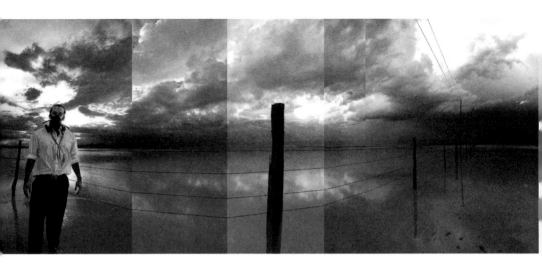

reservation. Mountains of debris up to 50 feet high include sewage from San Diego. It is now declared a Superfund site. New Mexico's Republican governor, Susana Martinez, mistress of short-term thinking, considers all environmental caution to be "anti-business."

IN A NAVAJO ORIGIN STORY, AS RELATED BY PETER EICHSTAEDT in his book *If You Poison Us*, when the Diné emerged into the fourth and present world they were given a choice between two yellow powders—one dust from the rock, the other corn pollen. They chose the pollen, "and the gods nodded in assent. They also issued a warning . . . leave the yellow dust in the ground. If it was ever removed, it would bring evil." Navajo sheepherder Paddy Martinez ignored this message. Around 1951, he led geologists to uranium-bearing ore at the base of Haystack Butte in what would soon be known as the Grants Mineral Belt. Another story told in Navajo land: "each

Will Wilson (Diné), *Auto Immune Response no. 6*, 2005, archival pigment print, 44" x 107" (Collection National Museum of the American Indian). This series is about "the quixotic relationship between a post-apocalyptic Diné (Navajo) man and the devastatingly beautiful, but toxic environment he inhabits . . . an allegorical investigation of the extraordinarily rapid transformation of indigenous lifeways, the disease it has caused, and strategies of response that enable cultural survival."

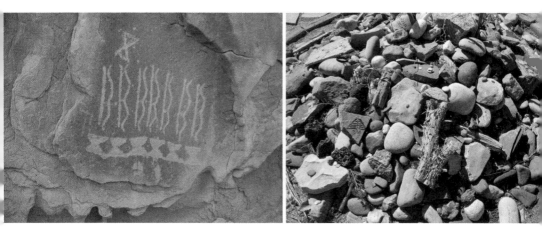

time a group of white men arrived, the Navajos asked: What are you looking for? In the 1920s the answer was oil; in the late '30s and early '40s, it was vanadium; in the '50s through the '70s, it was uranium. In the '90s it is spirituality." In the 2000s, we are back to uranium, which has a particularly noxious history on the Navajo Nation (the largest reservation in the U.S. at 27,000 square miles).

When vanadium was being mined in the 1920s, there was little interest in the yellow stuff surrounding it. Uranium was used for watch dials and the red glazes on Fiesta Ware (as well as for sand paintings in traditional Navajo healing ceremonies). Everything changed with the advent of atomic weapons and the Cold War. Since the 1940s, more than five thousand people, many of them Navajos working for low wages in terrible conditions, were exposed to yellowcake (concentrated uranium powder). In July 1979, the town of Church Rock, north of Gallup, NM, suffered a nuclear disaster when a dammed pond

Symbols of Monster Slayer (Naayéé' Neizghání, bows) and Born for Water (Tó Bájíschíní, hour glass), petroglyph in the Dinétah (Navajo homeland). Navajo history tells of the Warrior Twins, who slew all the monsters except sickness and death. ● *Monument at Bosque Redondo,* Fort Sumner, NM, 2009. Constructed in February 1971 with rocks brought from all over the Navajo Nation, it commemorates the Diné and Apache who were exiled and died here in a U.S. government internment camp from 1863 to 1868.

containing 90 million gallons of radioactive waste collapsed, contaminating water for 70 miles of the Rio Puerco (which means dirty, all too appropriately) and causing birth defects and cancer clusters. The spill was larger than Three Mile Island but garnered little attention from the outside world.

When uranium prices plunged in 1990, the Navajo Nation inherited some 1,100 abandoned uranium mines, tailings piles, and four mills, still working their toxic magic. The EPA dismantled radioactive hogans. Water sources were contaminated. Cancer, heart disease, and birth defects riddled the communities, many of which have received no restitution despite decades-long attempts to right this terrible wrong. Physician Louise Abel, then with the Indian Health Service in Shiprock (and now my doctor), said in the 1990s that those worst affected were dead, and "what we're seeing are the survivors." Others cited years-long "death watches" as the forbidden yellow powder took its toll.

Corral in the Village of Paguate (Laguna Pueblo), near the Jackpile Mine, 1975–76 (Photo: Kay Matthews). ● *Red Water Pond Road Community*, 2012 (Photo: Eric Shultz). This Diné village, between the Northeast Church Rock mine (the largest underground uranium mine in the U.S.) and the Kerr McGee/Quivira mine, has twice been evacuated to Gallup motels due to contaminated soil, for which each mine blames the other.

Many open mine shafts in Navajoland have been closed, but radiation remains a concern. In 2001, Navajo from the Crownpoint area and the Albuquerque-based Southwest Research and Information Center celebrated a victory when a uranium leach-mining provision was stripped from nuclear power legislation in the U.S. Senate. In 2003, New Mexico's congressional representatives remained divided (not entirely along party lines) on a bill that would kickstart a new wave of uranium mining in aid of nuclear power. In 2005, the Navajo Nation banned uranium, an action basically ignored by other governments. But in 2010 the courts concluded that the Hydro Resources (Uranium Resources Inc.) site was not on Indian land; it lies on the "checkerboard" of lands deeded to the railroad in 1911 that is surrounded by the Navajo Nation. In May 2011, the Nuclear Regulatory Commission reactivated Hydro's license on ten claims in the long-suffering Crownpoint/Church Rock area. A group called Eastern Navajo Diné Against Uranium

Bonnie Devine (Serpent River Ojibwa), *U308 Yellow Cake*, 2009, installation on the impact of uranium mining from northern Canada to Los Alamos, NM, Museum of Contemporary Native Art, Santa Fe. ● Marcela Armas, *I-machinarius*, 2008, industrial chain and gears, motor, electronics, crude oil, electricity, Rubin Center, University of Texas, El Paso (Photo: Marty Snortum). "Celebrating" Mexican Independence, a moving chain forms an inverted map of Mexico; an electronic lubrication system dispenses crude oil. Armas depicts her country as "an injured

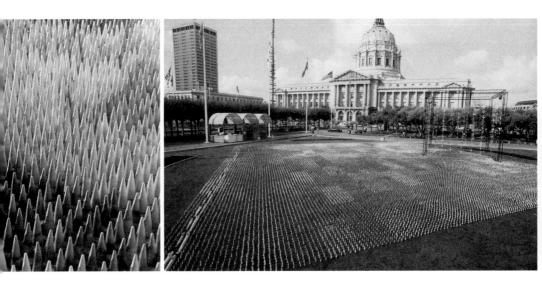

Mining (ENDAUM), fiercely opposed to the plan to reinstate uranium mining there, submitted a petition to the Inter-American Commission on Human Rights to rescind the permit until the company remediated existing contamination from in situ leaching in Church Rock. Ominously, the EPA prohibited drinking water from the entire aquifer, even after extensive remediation was required of the company. In May 2012, ENDAUM and the New Mexico Environmental Law Center asked the EPA to stop the planned mine. All of this despite the fact that in August 2012, the residents of Fukushima, Japan—site of the worst nuclear accident in history—demanded an end to nuclear energy.

Drinking water for thousands of Navajos is still threatened and the impact of mercury and selenium on fish in the San Juan River is another issue. Although over 40 percent of Navajo homes do not have running water, and many drive miles to haul water for basic needs, non-Indian adversaries on a

machine" interrogating sovereignty and energy dependence in the global context. ● Barbara Donachy, *Amber Waves of Grain*, ceramic, 1986, installation at the Boston Science Museum (Photo: Robert Del Tredici). ● *Amber Waves of Grain*, 1986, Civic Center Plaza, San Francisco (Photo: Dennis Kennedy). Represented are every one of the c. 33,000 U.S. nuclear warheads and weapons systems at the peak of the nuclear arms race in the early 1980s.

second front—the border towns of Bloomfield and Aztec—are challenging the amount of water granted to the Navajo Nation in a settlement contested since the 1960s. The towns (incredibly) claim seniority of water rights over Navajo. But the billion-dollar, 280-mile pipeline for the Navajo-Gallup Water Supply Project and the Jicarilla Apache Nation to the east is moving ahead— a mixed blessing, as the pipeline will disturb grazing as well as water access. Given the long history of land appropriation by governments, even their own, Navajo are justifiably suspicious of the project.

The damages wrought by uranium are not limited to Navajoland. Anaconda's notorious Jackpile mine—at 3,000 acres, it was the nation's largest open pit uranium mine—operated on Laguna Pueblo land from 1953 to 1982. Laguna resident Dorothy Purley, who died of lymphoma in 1999 at age sixty, said "it seemed like a dream come true. It gave so many of my people on the reservation a chance to find employment without having to venture off

Patrick Nagatani, *Kweo/Wolf Kachina, United Nuclear Corporation Uranium Tailings Spill, North Fork of Rio Puerco, near Gallup, New Mexico*, (Nuclear Enchantment series), 1989, chromogenic print. Nuclear Enchantment parodies New Mexico's tourism moniker, Land of Enchantment. The Kachina appears to be vowing revenge for the destruction of Indian land. ● Patrick Nagatani, *Uranium Tailings, Anaconda Minerals Corporation, Laguna Pueblo Reservation, New Mexico* (Nuclear Enchantment series), 1993, chromogenic print. (See Eugenia Parry Janis, *Nuclear*

the reservation. . . . It never occurred to us that our children and our grand-children's lives would be put at risk."

Nor is the damage done by these lethal pits limited to Native people. Residents of Yerington, Nevada, filed a class action suit against Atlantic Richfield (and parent BP America Inc.) for negligence and cover-ups of a plume of uranium, arsenic, and other contaminants stored on nearby property that leaked from the old Anaconda copper mine into private wells. The lawsuit has dragged on for thirty years, and little has been done to clean up the site. Yet in 2006, residents of Eunice, in southeastern New Mexico, welcomed a Louisiana Energy Services uranium enrichment plant with no provision made for waste disposal. Depleted uranium has a half-life of 4.5 billion years. And so it goes.

LOCAL LANDSCAPES REFLECT GLOBAL CRISES. NOTHING IS more local than ecology (from the Greek word for home). Nothing is more

Enchantment: Photographs by Patrick Nagatani. Albuquerque: University of New Mexico Press, 1991.) ● *Land Arts of the American West Visiting Remains of Jackpile Mine, Laguna Pueblo, N.M.,* August 2011 (Photo: Chris Taylor, Land Arts of the American West). Laguna Pueblo member Curtis Francisco with students. The industry did not clean up the mine, and the pueblo had to take on the task of reclamation.

global than a nuclear world. We're all on the spot when we begin to consider where we are and what's going on there. The notion of a nuclear ecology can seem an oxymoron, but for better or worse, humans too are part of nature, if a uniquely destructive element. How we treat our home—both the planet and our exact location, is a matter of survival—for us. The planet will continue, as Alan Weisman explains in his provocative book *The World Without Us.*

I find great comfort in Galisteo's identity as a mere point in a vast landscape of gullied rangeland and distant mountains. At the same time I'm forced to concede how global my beloved local really is. A mile to the east, trucks are carrying drums of radioactive waste to WIPP near the popular tourist destination of Carlsbad Caverns. The plant receives waste from all over the country—Hanford, Idaho National Laboratory, Savannah River, Oak Ridge, and our own Los Alamos. Whereas extraction craters give up their earthly goods, WIPP is a devastating pit that merely receives, a geological

Patrick Nagatani, *Contaminated Radioactive Sediment, Mortandad Canyon, Los Alamos National Laboratory, New Mexico* (Nuclear Enchantment series), 1990, chromogenic print. Ancient petroglyphs are scratched into the black smoky ceilings of the canyon's shallow caves. In the early 1990s, looking down into Mortandad Canyon after a light snow, we noticed perfect circles, snow free, on the canyon floor, apparently marking pits of some kind that were literally "hot."

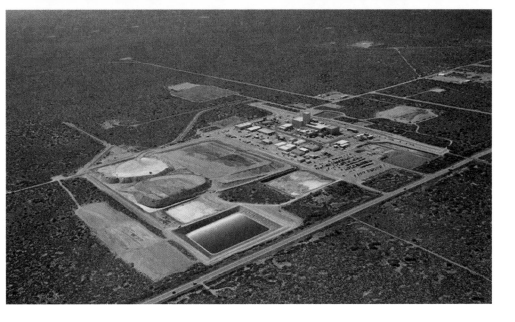

lockbox for chemical sludge, lab gear, and filters laced with plutonium—the "fiendishly toxic" detritus of national nuclear weapons production buried almost ½ mile underground in deep salt deposits, supposedly secure for ten thousand years, despite doubts about leakage and dangerous transportation.

When President Obama decommissioned Yucca Mountain in Nevada, intended as the final resting place for radioactive materials with an inconceivably long half-life (a classic combination of mountain and pit), WIPP was presented as a possible understudy. In August 2012 the Department of Energy announced plans to send 14.4 tons of surplus plutonium to the Los Alamos National Laboratory (LANL) and/or WIPP. "Hot particles of plutonium" in the soil can lodge in bodies and damage ten thousand cells within its range; they are millions of times more dangerous than uranium dust. New Mexico activists contend that instead of sending waste across the country to us, it should stay on site, minimizing the danger and expense of transportation.

Juan Rios, *WIPP (aerial view)*, 2012, Carlsbad, NM. The U.S. Department of Energy is lobbying for "improvement" of the facility, and some expansion has been approved to accept more and different types of nuclear waste, including that from commercial industries, despite doubts about security of the salt deposits.

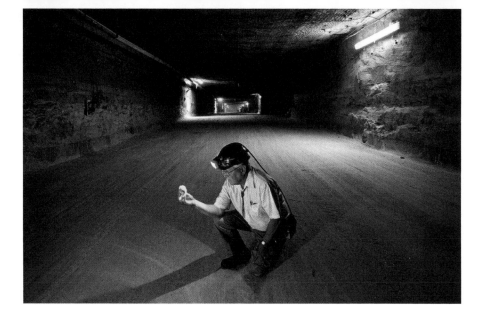

Our little Galisteo volunteer fire department has received Hazmat (hazardous material) training.

About 60 miles to the south of my home is the Sandia National Laboratory, where much of the national nuclear arsenal is stored. Seventy miles to our northwest is LANL, home of the atom bomb and now projected site for the production of plutonium "pits" (triggers). Like the 1872 mining law, these pits "keep on giving." Recently, thanks to persistent local activism and the threat of more immense wildfires in the Jemez Mountains, where the lab is located, LANL was forbidden to burn nuke waste in the open air. Much rejoicing. Then the decision was rescinded. One step forward, one step back. In 2012, the lab promised to speed up removal of thousands of gallons of radioactive waste that has been waiting for decades in insecure pits and drums—some six hundred shipments eventually headed for WIPP.

Around 200 miles to the southeast is the Trinity Site at White Sands Missile

Juan Rios, *WIPP, Completed Salt Tunnel*, 2012. On a tour with local government officials, the photographer descended in an elevator 2.5 miles into the earth.

Range, where the first atom bomb was detonated just before dawn on July 16, 1945. Within a month bombs had been dropped on Hiroshima and Nagasaki and the rest of that story is the world we live in. Food and water were contaminated, according to the Tularosa Downwinders Consortium, representing thirty thousand people living within a 60-mile radius of the test blast—involuntary guinea pigs for the nation's greatest science experiment. As a native of New York City, I lived for years a few blocks from Canal Street and Broadway, a site once chosen "by experts" as the most efficient target in the New York area for a nuke drop. (Claes Oldenburg proposed a monument for the hot spot.)

New Mexico is only one of several "nuclear states" in the West. In the l980s, an Air Force colonel told photographer Carole Gallagher, author of *American Ground Zero,* "There isn't anyone in the United States who isn't a downwinder." As westerners, we're haunted by the invisible poisons lurking in our dramatic landscapes, considered the "perfect places to toss used razor

Patrick Nagatani, *The Evening News, Native American Pueblo Dwelling, New Mexico,* (Nuclear Enchantment series), 1990, chromogenic print. On the TV screen is an image of WIPP by Robert Del Tredici. Words on the Scrabble board are: "piling, radioactive, sheep, Laguna, Nagasaki, atomic, bomb, red, hero, and Gnome" (referring to a 1961 nuclear accident near Carlsbad, one of several in New Mexico, including one on Jicarilla Apache land in 1967 and another 5 miles from downtown Albuquerque).

blades," in the words of another military officer in the 1950s. The Rocky Mountain Arsenal and Rocky Flats plutonium production site, both near Denver, are classic examples where activists have been calling for saner inspection and cleanup for decades. Kirsten Iversen's recent book, *Full Body Burden*, is a terrifying page-turner that fuses the stories of a dysfunctional family with a dysfunctional atom bomb plant. In early 2012 it was reported that the east side of Rocky Flats is as contaminated today as it was forty to fifty years ago, despite the federal EPA insisting that it is safe for workers, wildlife, and a new "parkway," once Superfund status is lifted. Lawsuits are pending.

The story of the former town of Uravan in southwestern Colorado offers a perverse take on devotion to place. The site of a uranium mine that outgrew its usefulness, the town was so toxic that it had to be totally dismantled at huge expense. As *New Yorker* writer Peter Hessler saw it, the locals, including widows and family of those who had died and are still dying from

Robert Del Tredici, *Radiation-safety technicians check workers John Bower and Bill Milligan for possible contamination before they exit a Rocky Flats Production Building now undergoing cleanup*, March 1994. © Robert Del Tredici/The Atomic Photographers Guild, 2013. During the Cold War, the Rocky Flats plant was the primary facility for processing and machining plutonium used in nuclear weapons. ● Eve Andrée Laramée, *Uranium Decay* (*Thorium 230, 8,000*

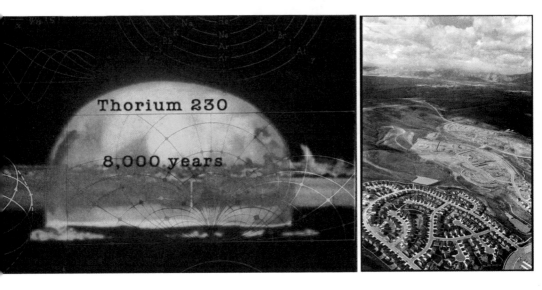

small-cell lung cancer caused by radiation exposure, were less upset about the loss of their relatives than about the loss of the mine and the radioactive town itself. Former residents of Uravan wept while talking about the town, "which never happened during a discussion of a family death from cancer." At a public hearing, one woman actually said she had "no regrets" about losing family members; the toxic landscape was perceived as an "accepted risk"—the price one pays to get a job. (Hessler found residents very savvy about work-related radiation, often proving the authorities wrong or tentative about its dangers.) This is the new American Dream. Uravanites are overwhelmingly in favor of a proposed new uranium mill. In fact, the locals even approve of making the fenced-off former site of Uravan a tourist destination, complete with the signs warning "Radioactive, Do Not Enter, Dangerous, Use Caution." A member of the Chamber of Commerce made a statement that could come only from a town called Paradox, where many

Years), 2012, still from video on the American West and Fukushima. "The dark, inverse form of alchemy of the Atomic Age" illuminates the 4.47 billion-year half-life decay cycle of Uranium-238 (superimposed on thermographs and news footage) as it "transmutes into 'uranium daughters'" ● Robert Del Tredici, *Suburban Development with Rocky Flats Plutonium Processing Plant in the Distance*, March 1994. © Robert Del Tredici/The Atomic Photographers Guild, 2013.

Uravanites now live: "Uranium and tourism can coexist." Uravan may be reinhabited soon.

Such attitudes take the irony out of the title of Michael A. Amundson's 2004 book—*Atomic Culture: How We Learned to Stop Worrying and Love the Bomb*. The ecological ramifications of such nonchalance, or fatalism, will affect people and places far from that particular Paradox, where Doctor Strangelove would be right at home. The Atomic Age is not over. Video games and a plethora of over-the-top apocalyptic movies take on a new level of reality, and cold warriors remain in or close to power. Years after fallout shelters and "Duck and Cover" became laughable, the former citizens of Uravan have shown us new ways of practicing denial. Fear is what drove those futile exercises and fear still drives support for U.S. nuclear policy today. Since 1992 there has been a hold on full-scale nuclear weapons testing at the Nevada Test Site (which began in 1951). Closed-computer simulation has replaced explo-

Carole Gallagher, *Deserted Schoolyard in Amargosa Valley, 10 miles south of Nevada Test Site,* 1988. Since the first test in 1951, downwind lands were seriously contaminated, a fact finally revealed in the 1970s. Gallagher's images and oral histories with residents, cancer victims, and Army veterans were inspired by Dorothea Lange, who had worked in the area. ● *Atomic Street Sign*, Amargosa Valley, 1988. (See Gallagher, *American Ground Zero: The Secret Nuclear War.* Cambridge: MIT Press, 1993.)

sive tests, although "subcritical experiments" continue, including one point-edly undertaken on December 7, 2012.

The puzzle that no one has solved concerning nuclear waste is how to mark its deposits in a manner lasting for the thousands of years that con-stitute the half-life of radioactivity. This is the so-called Forever Problem. No culture has lasted that long, and we have no idea who—if anybody—we might be contacting in ten millennia or more. It is entirely possible that no language or symbol system now known will be comprehensible then, even the trefoil (radioactive!) symbol. So the markers have to be visual and "uni-versal." It's an unmet challenge for artists. Competitions and exhibitions for long-term nuclear markers have drawn artists, scientists, futurists, and experts in linguistics, anthropology and semiotics to design "landscapes of peril." One was a 50-foot-high forest of concrete thorns or claws. Others were men-acing lightning-shaped earthworks, a black hole, a rubble landscape, huge

Michael Brill (concept) and Safdar Abidi (art), *Landscape of Thorns, Nuclear Marker*, c. 1990, from *Message to 12,000 AD*, addressing the staggering problem of storing the world's nuclear waste. ● Marguerite Kahrl (with Andrew Davidson, Kathleen Sullivan, Mothers for Peace), *Paradise Lost*, 2010. Proposal for nuclear guardianship at Diablo Canyon, CA, with real time radia-tion data synthesized with Milton's metaphors; conventional superheroes countered by "Meek and Timid Action figures" (bald from radiation), increase awareness of nuclear waste.

forbidding blocks or spike fields, and spokes bursting through a grid (destroying order). The winner of one competition was a field of biologically-created, unnaturally blue yucca plants that would reproduce themselves "forever" . . . or not. There are no plans to construct the featured project. And who's to say that all yuccas won't be blue in the distant future?

Despite these competitions for Yucca Mountain and WIPP (which will be filled up by 2033, or well before if shipments continue), nothing sensible has emerged. The cultural constrictions on art, the habits of fashion, were more evident than thinking beyond the box, or rather the pyramid—the most popular model. Writer and anti-nuke activist Rebecca Solnit suggests that signs at nuclear waste dumps read: "This place is not a place of honor. No highly esteemed deed is commemorated here. Nothing valued is here. This place is a message and part of a system of messages. Pay attention to it. Sending this message was important to us. We considered ourselves to be a powerful culture."

Eve Andrée Laramée, *Slouching Towards Yucca Mountain, Dark Character*, 2011, (Badwater Basin, Death Valley), still from video. The Dark Character represents the mining industry. The U.S. government began developing Yucca Mountain in Nevada as a deep repository for high-level radioactive waste. The project was terminated, given geological faults and climate uncertainties, though a seven-mile maze of tunnels remains beneath the mountain. With no master plan for permanent disposal, waste sits in temporary storage at hundreds of sites across the country.

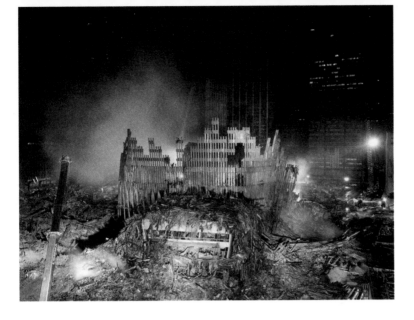

THE WORD GRAVEL INCORPORATES THE WORD GRAVE, AND gravity may also be entangled in this imaginary equation. One detour away from the New West is relevant to a riff on pits and erections. In an urban context the pit usually represents both destruction and construction, reflecting the rapid movement and change that characterize city life. September 11, 2001, sped up the process, charged the meanings, and undermined national assumptions of invulnerability. Since then, the relationship between skyscraper and pit has taken on new implications, at least new to this country, which has been spared inner-city ruins like those of postwar Europe, Asia, and the Middle East. In the U.S., ruins have been for the most part rare and picturesque, imparting nostalgia and moral lessons, a titillating play of presence and absence, a mediation (and for some a meditation) between life and death, between the built and the natural environment, between architecture's sources and its inevitable resting places.

Joel Myerowitz, *Assembled panorama of the site from the World Financial Center, Looking East* (detail), 2001–02. (Courtesy of Howard Greenberg Gallery). © Joel Myerowitz. After 9/11, Ground Zero was classified as a "crime scene." Although photography was generally prohibited, Meyerowitz gained unlimited access to document ongoing work and workers at "the pile." (See Meyerowitz, *Aftermath: World Trade Center Archive*. New York: Phaidon Press, 2006.)

The fall of the Twin Towers rekindled thoughts about "tragic tourism," the title of a book chapter I'd written several years before 2001 without guessing how close it would come to home. The conflict between spectacle and engagement is heightened at the site of tragedy. Going up, staying up, coming down, the World Trade Center was always a destination. Intelligent tourism is, after all, about detail, about filling in the blanks, about seeing for yourself. If people travel to find what is missing in their daily lives, the grandeur of tragedy is curiously near the head of the list. Since September 11, gawking at Ground Zero passes for patriotism. New York City—hitherto mistrusted and disliked by many Americans who think it's only a nice place to visit—came for a while to epitomize America. (The wounded Pentagon, embedded in the national corridors of power, was merely the understudy, not even as evocative as the crash site in a Pennsylvania field.) The event is so infamous that near Hopi there is a rock art image of the towers and a plane heading for

them—one of some five thousand mostly ancient images on sandstone boulders that make up *Tutuveni* (newspaper rock). The addition of this image was considered vandalism at a sacred site—now protected by a chain link fence.

Living in Lower Manhattan, in what was becoming SoHo in the 1960s, I watched the Twin Towers of the World Trade Center go up, and idly wondered if my building would be in range if they toppled over like a tree. In 2001, I heard them come down over the radio, on the way to becoming the most famous pit in the world. (They imploded, missing by miles the loft building where my son and family still live, but coming far too close to the school where my daughter-in-law taught and a grandson had just begun first grade.) I was in the city a couple of weeks after the attack, trying to avoid touristic voyeurism. The night we arrived, we walked down West Broadway to Canal Street. SoHo was pretty much business as usual. But Canal was lined with emergency vehicles. Tribeca was pitch dark and deathly still. It was as if a

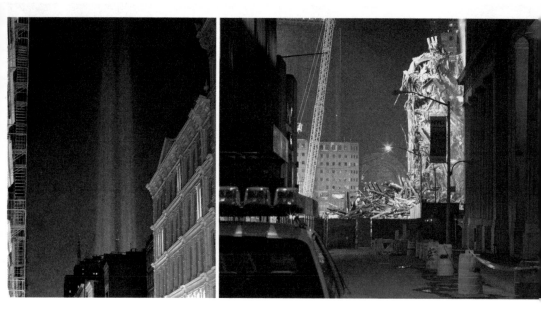

chunk of Lower Manhattan had simply been erased. But below the blackness, where the rescue crews were at work, the site itself was another world, harshly illuminated by white light—the light at the end of the tunnel—later transformed annually by artists into ghostly towers of light, metaphorical erections suggesting a different future, which did not come to pass.

For at least a year, our national consciousness was totally colonized by photography—the towers coming down, over and over again. That crash, that fire, those clouds of smoke, those heartrending ruins are burned into our retinas. Millions of words and thousands of images have been expended. Yet today it is difficult to find a *single* photographic image that defines the event, even the fall of the towers, which was only the beginning of the story. Joel Meyerowitz's iconic image of the steel girders jutting up from devastation comes close, remaining far more moving than the sterile architectural platitudes that were proposed as memorials.

Julian LaVerdiere and Paul Myoda, *Tribute in Light*, 2002, (Photo © Charlie Samuels; Courtesy of Creative Time). The phantom projections replayed annually for ten years. ● Connie Samaras, *Angelic States—Event Sequence: NY Financial District/World Trade Center*, November 2001. Her work examines control of "public" space; she posed as an authorized photographer to point out that banning photography at Ground Zero deprived "average people of capturing their own images" of a significant event in U.S. history.

By the time I returned to the city in February 2002, Ground Zero was just a hole in the national psyche replacing earlier ground zeros—the Trinity site in southern New Mexico and the core of the Nevada nuclear test site. We have been living in increasingly porous borderlands, but after that black Tuesday, the previously insulated American world is different, full of holes previously only suspected, and an erosion of civil liberties hitherto considered sacrosanct. As vengeance continues to unwind and the United States continues to bomb the hell out of other parts of the world, many more pits and erections are in our future. Dubai boasts the world's tallest building, and Kuwait is next in line. Competition between Arab and Asian states to build something taller is heating up. Basharat Peer reminds us of this parable: "When the Angel Gabriel asks the Prophet when the world will end, Muhammad replies, 'When the destitute camel herders compete in building tall structures.'"

While 9/11 pales in comparison with losses suffered in other parts of the

Connie Samaras, *After the American Century: Dubai Skyline*, 2009. The Burj Khalifa was the tallest building in the world, "named after the emir of Abu Dhabi, who rescued Dubai from the financial collapse of 2008 . . . its three-lobed, bundled tube design is putatively inspired by a flower, perhaps an effort to shine a bit of humility over its towering ambition." (Matias Viegener, in Irene Tsatsos, ed., *Connie Samaras, Tales of Tomorrow*. Pasadena: Armory Center for the Arts, 2013.) The new tower at the World Trade Center is now allegedly the world's tallest.

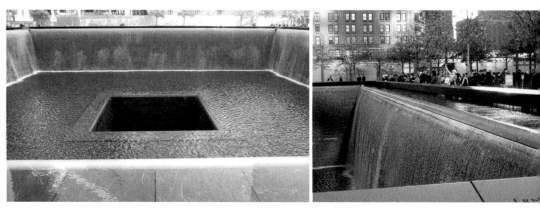

world, it's the worst single human-caused disaster on American soil, and we think big when it's our own tragedy. Size was in fact the primary virtue of the otherwise uninspired architecture of the Twin Towers. As Paul Goldberger remarked, the rules change "when the biggest things in a city that prizes bigness becomes the most fragile thing, and the void has more weight than the solid." Like the sensation of feeling in a missing limb, more than a decade later I still find myself looking for the towers looming over Lower Manhattan.

The monumental battles over how to memorialize the Twin Towers raised questions about how and whether to rebuild and whether to fetishize the tragedy or to transcend and dematerialize, focusing less on the architectural object than on the ambiance of the whole, avoiding what has been called *topolatry*, worship of place for the wrong reasons.

The visceral power of the immediate populist response—hundreds of street shrines and photos—was universally acknowledged. But when they were

National September 11 Memorial Plaza, 2012. (Photos: Ethan Ryman) *Reflecting Absence*, designed by Michael Arad, the 1-acre square pools (fueled by rainwater, stored in subterranean tanks), with 30' waterfalls on each side, drain 16' further into a central "void," so that "they always remain empty."

taken out of context and exploited as art, they became poor substitutes for the tragedy they originally represented so well. What kind of memorial could possibly embrace all the ramifications of the September 11 attack—not just the number of dead, the fallen erections, and the pervasive fear, but the chauvinism, the xenophobia, the ongoing attacks on privacy and democracy ironically mounted in the name of democracy, on freedom in the name of freedom?

When an Islamic center was proposed in 2010, two blocks away and not visible from Ground Zero, xenophobia unfolded like a contemporary morality play. Park51 (at 51 Park Place)—the so-called Ground Zero Mosque (though it was not a mosque)—had a rocky launch, with a majority of New Yorkers and Americans opposing it as an insult to those who died on September 11. (Rarely mentioned were the insults borne by Muslims and non-Muslim Sikhs in the aftermath.) The center opened in a temporary building in September 2011 with a bland show of photographs of children. Its website stated that it welcomes "New

Joan Myers, *Natural Gas Plant*, near Blanco, NM, 2013. © Joan Myers. The role of fossil fuels and the extraction industry in the events of September 11 is obvious.

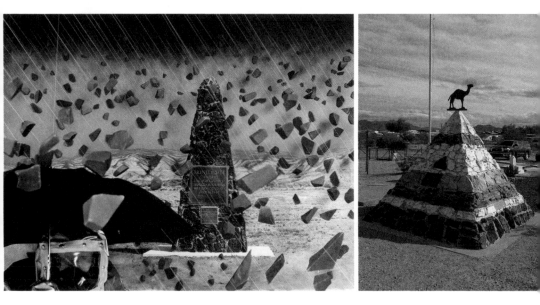

Yorkers of all backgrounds for interfaith workshops, films, and lectures." Plans for the fifteen-story building slated to rise on the site, including a 9/11 memorial along with a swimming pool and health services, have now been abandoned.

The Trinity Site in southern New Mexico, where the world's first atomic bomb was detonated—an event far more globally significant than 9/11—is marked by a modest, almost abject, monument, a roughly mortared mini-obelisk of stone. It can be seen as a cairn, the oldest known human mode of memorializing, communal and participatory. Cairns grow organically over time, measuring the extent of loss, stone by loosely piled stone, more likely to be destroyed by time than by violence, or recycled for other uses when the original one is forgotten. But the Twin Towers fell suddenly, compacting space and time, changing our sense of scale with instant symbolism. At only twenty-eight years old, it was youthful cannon fodder. "Lest We Forget" is countered by the "closure" so touted by our national pop psyche.

Patrick Nagatani (with Andrée Tracey), *Trinitite, Ground Zero, Trinity Site, New Mexico*, (Nuclear Enchantment series), 1988–89, chromogenic print. The first atomic bomb explosion, July 16, 1945, happened here, where radiation lingers on this heavily visited tourist site. ● *Grave of Haji Ali (aka Hi Jolly)*, 2012, Quartzite, AZ (Photo: Brian Kenny). A volcanic rock on the back of the cairn bears a pre-European petroglyph. Haji Ali was a Syrian camel driver employed by the US

Army in the mid-nineteenth century during a short-lived experiment with camels in the desert.

The first round of hackneyed proposals for rebuilding the Trade Center—happily rejected—hardly reflected the melodramatic rhetoric about Everything Has Changed Since September 11. In fact the scariest thing was how little actually did change. I had hoped that the fall, tragic as it was, would serve some purpose, open up some crack in the system through which a new kind of activism might bubble up: a new humility, a new capacity to imagine a different way to continue, in the arts and in tourism. The inability to imagine a different future, a different site, and a different agenda doomed us to build another pair of ugly towers and get them shot down, literally or figuratively, again and again.

Consider the rare or non-existent monuments in this country to slavery, poverty, Native American genocide, Irish famine, Chinese railroad workers, Japanese internment, and Latino labor exploitation and deportation. Perhaps it is time to rediscover the unspectacular, to create a counter space, to incorporate the Islamic sense of the sacred void, or dare to imagine a truly civic

Caroline Hinkley, *Buddhist Cairn, Zanskar, Northern India*, 2000, color transparency. ● Charles Simonds, *Ritual Cairns*, detail of *Excavated and Inhabited Railroad Tunnel Remains*, 1974, Niagara River Gorge, Artpark, Lewiston, NY. Artpark—a hilly, wooded, former chemical dump and spoils pile—was the location of an extraordinary series of temporary, site-specific, land-oriented artworks. This piece was "inhabited" by Simonds's "Little People," coincidental counterparts of local Seneca legends.

space. Amanda Griscom and Will Dana proposed a pragmatic Green Ground Zero: a pedestrian transportation hub producing its own energy with zero emissions—a hopeful guide to the future rather than a reconstruction of past business as usual. A rare green note in this black history was the unlikely survival of a pear tree remaining on the site.

One memorial option that was not considered, so far as I know, was ruins. J.B. Jackson once wrote that for Americans, history is "a dramatic discontinuity," giving rise to "the necessity for ruins" to provide an incentive for restoration, a return to social origins, and "a born-again landscape." Just before September 11, Solnit wrote: "Eradicating the ruins can function as an urban lobotomy, erasing memory and dream, and rationalist amnesia is the current mental illness of American cities." Afterwards, architect Susana Torre wrote: "To build a new World Trade Center on the ruins of the old would be to pretend that what happened never did."

Roger Minick, *Tourists on Liberty Island*, 2000, from the Sightseers series. ● Brian Tolle, *Irish Hunger Memorial*, 2002, Battery Park City, New York, 96' x 170', 2002. Near Ground Zero floats a more distant ruin—a ¼-acre monument to an older social disaster that also changed the face of the city. Tolle's memorial to the Irish famine and migration (1845–52) is a surreal vision of green field, crumbling stone walls, and ruined cottage on a cantilevered hillock near the Hudson River. Some of its limestones—from each Irish county—contain fossils.

And yet new towers have risen, less clunky than their predecessors, but hardly visionary. On the tenth anniversary of 9/11, the 8-acre National September 11 Memorial and Museum, still under construction, was opened to the victims' families. In April 2012, I paid the fee and stood in line in the pouring rain with hundreds of other hardy tourists at the memorial. The towers were not completed, the museum wasn't open, and the makeshift visitor's center nearby was mostly gift shop. All there was to "visit" was art. Designed by architect Michael Arad, two great square "voids" mark the footprints of the disappeared towers, with waterfalls running evenly down every side into the pooling depths, swallowing those ghostly erections into evocative pits. On the wide metal edges are the names of all those who perished in the towers, on the flights, at the Pentagon, and at the 1993 bombing of the World Trade Center. Washed with rain and tears, as unrelenting as passing time, the falls and pools are impressive, if inevitably inadequate.

National September 11 Memorial Plaza, 2012. (Photos: Ethan Ryman). When the Twin Towers were constructed, historic neighborhoods were destroyed in favor of corporate aggrandizement. The new 1 World Trade Center (formerly called the "Freedom Tower"), ironically resembling a minaret, reaches a symbolic 1,776 feet.

Tragedy is messy. The World Trade Center's grave has now been restored to neatness, but the mess was the real message. We're once again deprived of our ruin, and perhaps of our tragedy as well, however strong the economic excuse to rebuild may be. Lest we disregard the power of ruins even as backdrop, consider Frank Gehry's horror at the possibility that the harsh industrial wastelands in Bilbao that now offer the perfect foil for his gleaming Guggenheim Museum might be "strategically beautified," dragging his building into banality. The nature of the "new powerful myth" provided by Gehry's "metallic flower" depends, Joseba Zulaika points out, upon "how it relates to the allegories cast by the city's ruins."

As gravel pits are graves in the landscape, the Fresh Kills landfill on Staten Island—slated before 2001 to be an outdoor art site—became another flattened erection, an actual cemetery without markers for unidentifiable human remains inseparable from detritus after the fall of the towers. The irony of the name is

Mierle Laderman Ukeles, *Penetration and Transparency Morphed* (view from Fresh Kills), 2001–02, six-channel video installation (Courtesy of Ronald Feldman Fine Arts). As Artist in Residence at the NYC Department of Sanitation, Ukeles was first intrigued by Fresh Kills in the late 1970s, when she began conceiving of projects for the 2200-acre site. In 2001, 55 acres were set aside for human remains from Ground Zero. Plans to create a park on the landfill continue.

mind-boggling and accidental. (*Kil* is Dutch for creek.) The former landfill is almost three times as large as Central Park and contains 50 million tons of garbage. In 1977, Mierle Laderman Ukeles proposed a series of "Urban Earth Works" in all operating New York City landfills so the public could see land art "on public transportation without having to hire a private plane." In 1989 she was awarded a percent-for-art commission for Fresh Kills, closed in March 2001, then reopened when 50 acres received "debris" from Ground Zero. Ever since then, various groups have worked on making Fresh Kills into a park. Ukeles' own goals are consistant with her lifelong "maintenance art" and her mission to show the public what happens to their waste. She sees her proposals as redeeming social sculptures. Among them, *Garbage Out Front* would include a 36-foot-high installation—*Landfill Cross Section*—and her *Proposal for 1 Million People to Participate in a Transgenerational Public Artwork for Freshkills Park* would involve public offerings released into the larger community.

Mierle Laderman Ukeles (with Kathy Brew and Roberto Guerra), *Penetration and Transparency Morphed* (Fresh Kills drainage system), 2001–02, from her video installation. (Courtesy of Ronald Feldman Fine Arts). Ukeles's proposals are included in the 2006 Fresh Kills Draft Master Plan and her Percent for Art concept—*Landing*, for the South Park area, comprised of *Overlook, Earth Bench,* and *Earth Triangle,* finally accepted in 2013—is nearing the "final design" phase. "The future for Fresh Kills is still open. . . . This is the only permanent artwork there for now."

We don't yet commemorate our eco-tragedies, leaving the task to artists, photographers, journalists, and science fiction. Landscape ruins are slaughtered forests, grasslands chewed down to the nub and gullied beyond repair, mountains decapitated by mining, acidified oceans of swirling plastics, oil spills, and crumbling corals, fields undermined or overbuilt, wetlands parched by drought, rivers sickened by pollution—the scorched-earth policies of a late and increasingly desperate capitalism. Alaska is still called "the last frontier." The proposed (and now rescinded) Pebble Mine above Bristol Bay was to have a 104-mile access road over the wild Iliamna River to Cook Inlet. Smacking of an opportunist frontier mentality that should be obsolete, it would have spelled doom for salmon and beluga whales in the region.

EVERYONE KNOWS WHAT (IF NOT EXACTLY WHERE) THE OLD West was, thanks to movies, novels, and advertising. Our national concept

• Marguerite Kahrl, *Remote-Controlled Vehicle Powered by Landfill Gas (Sparkling Fawn)*, 2001, Honda engine, converted carburetor, steel, hydraulic pressure system, remote control, hardware, 51" x 32" x 65", created for the exhibition *Fresh Kills: Artists Respond to the Closure of the Staten Island Landfill*. At its height, the landfill produced about 2 percent of the world's methane. Before climate change claimed much public attention, Kahrl (with Paul Ruff) created these vehicles (running on refined methane from garbage) from a Maine junkyard.

of nature has its home in the Wild West, and protecting its open spaces and public lands against the human agency that produced them in the first place is tantamount to preserving the American ideal. Obviously the West is no more "natural" than any other place, and few genuine (and roadless) wildernesses remain. However, for Matthew Irwin, like many Americans, "the American West remains the world frontier, symbolizing and encapsulating the central conflicts of our time: self determination versus collaboration, for example, property rights versus preservation. Here, opposites converge; progress meets tradition; urban sophistication meets wild imagination; and individuality meets community." And, I'd add, local meets global. Yet the New (global) West is less familiar to most Americans, except in the western states themselves; even there, it grows in the shadow of its famous forebear.

When asked to consider globalization, I always find myself returning to the local—the small picture that we can actually see, and do something about,

Michelle Van Parys, *Culture Clash*, 1990. The image (more of an exchange than a clash) was taken at the Four Corners Monument; the figures could be standing in Arizona, Colorado, Utah, or New Mexico.

which is why this book, which started out with an unrealistically broad focus, became so New Mexico-centric. The assumption of a dichotomy between local and global ignores the fact that the global is simply the sum of many locals. Eudora Welty once wrote: "One place understood helps us understand all other places better." Interesting things seem to happen in the spaces and relationships between local and global, urban, exurban and suburban, rural and semi-rural, which includes both working landscapes and bedroom communities like the village I call home, where despite its history, farming is only a distant memory. Western historian Patricia Limerick suggests that the picture window has ruined the West, with its introduction of the longer and longer view that must be bought up in order to "preserve" the vista. I can't throw the first stone here. I sold a drawing given to me by Eva Hesse to buy 5 acres across the road so no one's ranchette would interfere with my view of the Ortiz Mountains and their scenic gold-mine scar.

Stephen Chalmers, *Baby with Tractor at Sunset*, 2009. The 20'-tall cut-out sculpture by John Cerney, assisted by Dong Sun Kim, on Highway 10, Goodyear, AZ, was commissioned in 1998. Chalmers noticed it while making his Transience project, documenting individuals living in RVs—"moderately affluent 'snowbirds' as well as those living off the grid and squatting" in the desert Southwest. The sculpture had been vandalized, the man's head removed, and an anarchy symbol painted on his chest.

Westerners, like so many other Americans, are in motion, though ancestral lands remain central to many. Native people's well-being is often rooted on the reservation, whether or not they live there or have even been there. Many Hispanos and Anglos still struggle to hold onto generations-long homeplaces. Yet nomadism and cosmopolitanism—concepts embraced by contemporary artists not afflicted by senses of place (or perhaps missing them)—are as endemic in the West as anywhere else. Thanks to a vociferous non-urban minority, it comes as a surprise to many that the arid western states are both more urban *and* more rural than any others—"most urban because no other region concentrates a larger proportion of its population in cities, and the most rural because outside the cities, no other region has a lower population density." Hungry sprawl gobbling up those "empty" spaces for which the West is famous is curtailed only when building booms run into public lands and Indian reservations acting as buffers to urban manifest destiny.

Connie Samaras, *Angelic States—Event Sequence: Voodou Lounge, Rio, Las Vegas,* 1998. Like Ground Zero, photographs are forbidden in the casino—a directive again ignored by Samaras. ● Jacques Garnier, *For Sale,* 2005, chromogenic print, Twentynine Palms, Mojave Desert, California, from the series Second Chances, described by the photographer as "part voyeuristic and part documentation," about people moving into a landscape of "harsh brutality" and "surreal beauty." © Jacques Garnier.

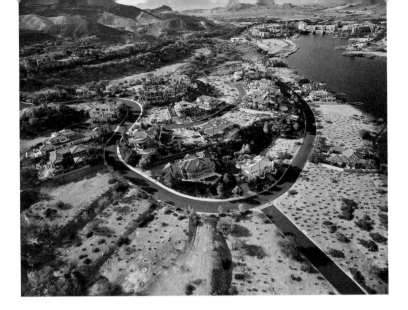

In *Bird on Fire: Lessons from the World's Least Sustainable City*, Andrew Ross writes that cities like Phoenix can't be "written off as hopeless cases. They are simply the weakest links in a chain that has to be strengthened ten-fold" in the face of climate change. He recommends green building, weatherization, community gardens and farms—jobs spread over a broad section of the population to replace what Van Jones has called "eco-apartheid," where only the rich can afford to be "green." Back as far as 2001, the publisher of *High Country News* (the West's Colorado-based paper of record) predicted with unrealized optimism the housing bust that arrived seven years later: "Worker housing may no longer be an oxymoron in some of the West's resort towns, and a market may open for those who figure out how to convert trophy homes into bed-and-breakfasts."

The inevitable result of reckless sprawl turned out to be foreclosure. A recent issue of *High Country News* devoted to "dead and half dead developments

Michael Light, *Gated "Monaco" Lake Las Vegas Homes, Bankrupt Ponte Vecchio Beyond*, Henderson, NV, 2010, 40" x 50" pigment print. (Courtesy of Hosfelt Gallery, San Francisco). © Michael Light. This artificial 320-acre lake was created by damming the Las Vegas Wash (the city's wastewater). The resort boasts 3,600 acres with 1,600 homes, golf courses, hotels, and a casino, embodying the American Dream—"classless classes and Medici living" protected from real life beyond. By 2001, it was foreclosed; vultures moved in, but the resort could revive.

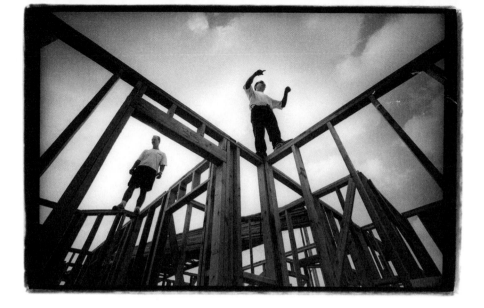

in the rural West" and titled "The Zombies of Teton County," describes the battle for responsible development around Jackson, Wyoming. Sprawl's bullying big brothers are the McMansions of those who have profited from others' losses. Ross argues that true sustainability must include a rejection of growth, which in turn means achieving social equality. Some people agreed when they set fire to three "green" multimillion-dollar McMansions in Washington state in 2008; the over-4,000-square-foot homes were built on spec and unsold; a realtor dismissed the label "green" as "mostly marketing." Bank of America—the number one target of the Occupy movement in 2011—is also the number one forecloser on American homes, and not coincidentally the number one funder of the U.S. coal industry—a lot of dirty business all rolled into one.

The New West's recent history and the battles for its future are taking place on the ground and in local politics, as well as in Washington, D.C. Suburban sprawl and shrinking water resources, dams, pollution, militarism, agribusiness,

Douglas McCulloh, *Untitled* ("David and Brent discover a major problem with the 492 model. The roof trusses fall three feet short of a bearing wall in the master bedroom") from *Dream Street*, 2005, silver gelatin print. In a silent auction, McCulloh won the right to name a street in a new subdivision on the site of a former farm, orchard, and fruit stand in Los Angeles County. He documented his street's birth, growth, and the questionable practices of the construction industry. (See *Dream Street*. Berkeley: Heyday Books, 2009.)

gophers and wolves, Superfund sites and the extraction industries, deteriorating national parks, recreationists versus ranchers, northern New Mexicans versus the Forest Service, developers versus smart growth advocates, and "enviros" versus those who remember the "Sagebrush Rebellion" as the good old days. There is no lack of controversy, contradiction, and work to be done.

IN THE WEST, IT'S BEEN SAID, NATURE IS POLITICS AND POLITICS is nature. In a literary commemoration of her native land—the Colorado Plateau—Terry Tempest Williams writes: "I believe we are in the process of creating our own mythology, a mythology born out of this spare, raw, broken country, so frightfully true, complex, and elegant in its searing simplicity of form . . . the high points of excursions into the Colorado Plateau are usually points of descent. Down canyons. Down rivers. Down washes left dry, scoured, and sculpted by sporadic flash floods."

Donald Woodman, *Eagle Nest,* Hyatt Pinon Pointe Resort, Sedona, AZ, c. 2003, from The Selling of the West series. © Donald Woodman. ● Nancy Buchanan, *Full House,* screen image (aerial view of Encino housing tracts) from *Developing: The Idea of Home,* 1994–99, interactive CD-ROM. The concept of home is examined from the personal to the global and environmental, with images, texts, animation, video, and audio. Southern California history exemplifies boom-bust cycles in real estate.

Down under the land we walk on, more toxic subterranean substances are entering the bodies of southwesterners (and now northeasterners and midwesterners as well) in the form of the unknown chemicals used in hydraulic fracturing (fracking) for oil and natural gas, in which enormous amounts of water and toxic chemicals are blasted into deep rock to release resources that would be unprofitable to extract any other way. Fracking fluids are generally 99.5 percent water—bad enough. The remainder is a horrific mix of some 750 chemicals that can include acids, xylene, tuolene, benzene, formaldehyde, polyacrylamides, chromates, diesel fuel, hydrochloric acid, gels, and methanol. The fracking process has been in use for some sixty years, though the addition of horizontal drilling in the past decade provoked the current boom. "Pumping fractures rock. Fluid invades fracks. Oil comes to Papa," is how one engineer explained it.

The process is still considered by some to be relatively safe if—and it's a big

Eve Andrée Laramée, *Fluid Geographies*, 2001–04, detail of installation at Cochiti Dam Turnout, Cochiti Pueblo: mirrors engraved with a list of fifty-five known contaminants buried at Los Alamos National Laboratory (LANL), flowing into the Rio Grande from the Pajarito Plateau, inserted in "scenic overlook" plaques. The artist's team (Lost Artists in Nuclear Landscapes, or LANL) were threatened with arrest by armed guards for a federal offense—photographing signage.

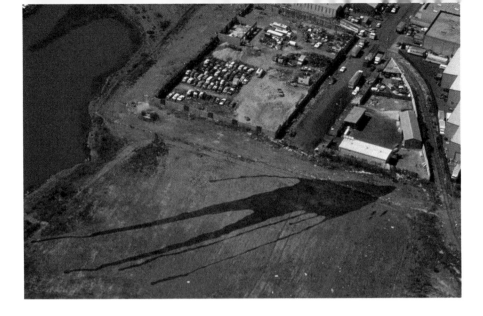

if—wells are designed properly and are regularly inspected. The exponential rise of fracking in the last few years has made this a losing battle. The majority of the nearly one hundred thousand oil and gas wells in production in New Mexico alone have been fracked. Not only is the combined state and federal inspection force in this poor state (rich in shale gas) only one hundred strong, but the best petroleum engineers and environmental inspectors are leaving the public sector to work for the industry at double the salary. Until monitoring systems are installed around gas well sites, computer modeling provides the best evidence of abuse.

Federal monitoring is almost non-existent, with few violations resulting in fines—rare slaps on the wrist for drilling crimes—hardly commensurate with the billions the industry is hauling off. In 2005, Congress and the EPA exempted fracking fluids from the Clean Air, Clean Water, and Safe Drinking Water Acts, but they are being forced to reconsider. Fracking's nasty cocktails

John Ammirati, *The Plume Project*, 1991, charcoal and water, 210' x 560', converted from film to digital. The artist's studio was in an industrial landfill. The installation, a comment on toxic leaks made with non-toxic materials, inspired by ancient earth drawings, was executed at Candlestick Point State Recreation Area, San Francisco. ● Ellen K. Levy, *No Potable Water*, 2011, contaminated water, spray paint, print, and acrylic, 30" x 24" (Photo: David E. Levy). The lower level shows coal mining from Diderot's eighteenth-century encyclopedia; above is a fracking

can migrate into aquifers through natural faults and fractures more quickly than once predicted—in decades or less, countering assumptions that the rock layers are impermeable. Not enough is known about the presence or extent of subterranean faults to guarantee that they won't be breached.

Evidence of contamination of aquifers goes back as early as 1984, to a case in West Virginia unreported in the media. Even then it was suspected to be among hundreds of cases affecting drinking water for millions. But it was "unproven" and impossible to investigate, in part because the industry is allowed to keep the chemical ingredients secret. Incidents of damage are "unavailable for review," as stated in a 2011 EPA report. The New Mexico Oil Conservation Commission has approved a rule requiring companies to disclose the chemical contents of their fracking fluids, but the industry prefers to do so only after the fact, when it is too late to protect populations and environment. The diluted current version, backed by then-Secretary of

scene from a recent patent drawing promising to deliver "Portable Water." This false promise led Levy to delete the "r" and add "no," yielding the title's warning. ● Aviva Rahmani, *Oil & Water #10*, digitized photograph, 11" x 11", 2011, from artist's book inspired by conversations on global warming with Dr. James White and Dr. Gene Turner. Rahmani's mantra is "What the World Needs is a Good Housekeeper."

the Interior Salazar, requires disclosure only within thirty days after use, and the industry is busy finding loopholes with the help of ALEC (the conservative American Legislative Exchange Council). As of April 2012, only eleven states require some disclosure, with widely varying laws. Colorado has model disclosure rules, but New Mexico Governor Martinez is not on board and has even succeeded in getting rid of the "pit rule"—a law requiring plastic linings for copper mining pits. She has supported not a single protection for clean air and the state's diminishing clean water.

Leaking, a slow, invisible process, is less dramatic and more insidious than monstrous oil spills like the 1989 Exxon Valdez and the BP/Deep Horizon disasters, which attract all the media. Smaller spills of fracking fluids like one in North Dakota in 2011 get little or no national coverage. While methane (a greenhouse gas twenty times more potent than carbon dioxide) exists naturally in ground water, fracking with faulty cement seals on the well

Debbie Fleming Caffery, *Protective Suit Worn by Oil Spill Workers Floating in Oil*, 2010, gelatin silver print. © Debbie Fleming Caffery. The New Orleans-based photographer, who had previously worked with local fishermen, went on to shoot the disastrous British Petroleum/Deep Horizon spill that spewed 40,000–50,000 gallons a day into the Gulf of Mexico and the Florida Panhandle's beaches. Human and animal populations continue to suffer serious health problems, which are only expected to worsen.

casings is estimated to leak 40 to 60 percent more methane than conventional wells. It takes 1 to 5 million gallons of water to frack a single gas or oil well—more, the second time around. In a classic example of short-term thinking, some Colorado cities are selling their "excess" water (as though any arid western state has excess water) to oil and gas companies, earning revenue while risking their future. In the huge floods of 2013, 18,000 gallons of oil leaked into Colorado rivers. There is also disturbing evidence that the fracking process—particularly the resulting wastewater wells—is causing earthquakes.

Nobody is looking gift horses in the mouth in these days of economic hardship. Liquefied natural gas is now being exported from the U.S., which means an increase in profits and fracking all over the country, not just in the West but in the vast Marcellus shale deposits of New York and Pennsylvania. In 2011, fossil fuels were the U.S.'s top export and the Big Five gasoline makers enjoyed record profits. A warm winter, and overproduction, however, led to

Janet Culbertson, *The First Billboard*, 1989, oil on canvas, 34" x 48". "Inspired and horrified" at the "pollution and lifelessness" of an industrial area near Elizabeth, NJ—"an image of hell" with billboards touting luxuries, the Statue of Liberty in the distance—the artist chose the billboard as a vehicle for her environmental activism. ● Bremner Benedict, *Alewife*, 2004, color print, Gridlines series. An outdated national electrical grid spans the West, defining landscapes with graphic shapes. Rising temperatures and volatile weather challenge its future.

falling prices. There is a shortage of storage for surplus. Laid-off workers are put to work drilling oil, adding to the glut of gas as byproduct.

Jeff Goodell's interviews with billionaire natural gas tycoon Aubrey McClendon reveal that fracking "is about producing cheap energy the same ways the mortgage crisis was about helping realize the dreams of middle-class homeowners. . . . [It's] more about land rights and leases than anything else." In the meantime, major media and official sources are touting natural gas as "inexpensive," echoing the American Petroleum Institute's boast: "Shale energy is the answer. It creates jobs, stimulates the economy, and provides a secure energy future for America." However, following the initial euphoria, a report showed official downgrading of the nation's estimated shale gas reserves by 40 percent and a shrinkage of 66 percent in the northeastern Marcellus shale reserves. Yet the boom is on (and the fix is in).

Local geology combined with fracking makes for complex situations.

Christy Rupp, *Flood Plain/Food Plan*, 2010, cut-paper collage, 16" x 20". ● Christy Rupp, *Big Bail*, 2010, cut-paper collage, 16" x 20", from the series Wake Up and Smell the Benzene. Nearly half the fracking in the U.S. is happening in places already water-stressed, like New Mexico, Texas, and Colorado, yet billions of gallons of water are being wasted and prices driven up by energy companies to levels unaffordable for farmers, some of whom are selling their water

Increased scrutiny of individuals and communities complaining of health effects and a chemical stench in their water (also known to burst into flames at the faucet) finally resulted in the EPA presenting one thoroughly documented contamination case in Pavillion, Wyoming, from 2005. Reports keep coming: high school students in Texas complaining of nosebleeds, chest pains, and disorientation; mothers in a Denver suburb reporting asthma, migraines, nausea, and dizziness; Pennsylvania water bubbling with methane or turning brown and causing sores on those who shower in it; cattle and pets dying. It will get worse.

In 2011, France became the first country to ban fracking (but not shale gas exploration) until it is proven safe for environment and landscape. In the U.S., Longmont, Colorado, and Mora County, New Mexico, lead a growing list of places with bans, and a number of states are considering them. (In November 2013, even Pope Francis came out against fracking.) On the other hand, many

rights. Some corporations are beginning to recycle wastewater. One Texas oil field uses about half the water recharged annually in an area that is home to 330,000 people. ● Brandi Merolla, *Where Has All the Water Gone?*, 2011, digital photograph, 16" x 20", 2011. ● Brandi Merolla, *Frack Is Wack*, 2012, digital photograph, 16" x 20". Merolla composes and photographs antiques and collectibles "to create mysterious narratives" from their interactions.

states welcome the process with open arms. Pennsylvania State University even allows fracking on its campus. Thanks to environmental activism—and perhaps to onomatopoeia—fracking is acquiring a very bad rep. The industry reportedly loves the process and hates the name. Matt Damon, John Krasinski, and Frances McDormand have produced a feature film about fracking in the East—*Promised Land*—which could have been the *Chinatown* of the early twenty-first century.

MY CONSTANT MANTRA—LONG-TERM THINKING IS IN SHORT supply—is egregiously confirmed by TransCanada's proposed (and already partially executed) Keystone XL Pipeline, approved by Canadian Prime Minister Stephen Harper, a Christian Libertarian and not incidentally the son of a Calgary oil accountant. XL would transport the hard-to-extract (hitherto inaccessible) bitumen, or "tar sands oil"—one of the world's dirtiest fossil fuels—over 1,700 miles, from Alberta in western Canada through

Louis Helbig, *Residual Bitumen, N 56.51.42 W 111.20.36, Suncor Southern Tar Pond, Alberta, Canada*, 2008, from the series Beautiful Destruction—Alberta Tar Sands Aerial Photographs. A massive dike holds a manmade lake in the Athabascan Tar Sands north of Ft. McMurray. While the residual bitumen floating on the surface (escaped from the extraction process) is quite dramatic, the brown water/sludge is more dangerous. Waterborne silt, saturated with carcinogens and toxins, is integral to the mining process. In over forty-five years of bitumen production, no

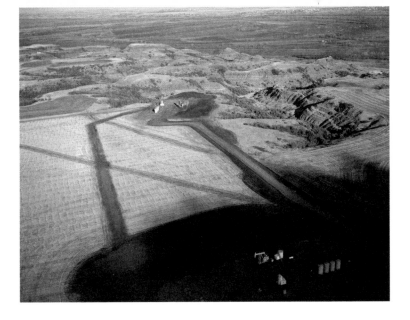

private land in the Midwest, across the Missouri, Yellowstone and Platte Rivers, over the vast underlying Ogallala aquifer, to refineries on the Texas Gulf Coast, where it can be shipped out to the rest of the world. According to journalist Andrew Nikiforuk, Harper's government has muzzled scientists, gutted environmental laws, cracked down on dissidents (even those leaning Right), and ignored water quality in downstream First Nations in his zeal to make Canada "an emerging energy superpower." The culprit is "a costly junk crude . . . which even Big Oil describes as ugly . . . mined from Canada's northern forests or steamed from deeper deposits."

In January 2012, the Obama administration rejected the XL pipeline for all the right reasons. Only a few months later, TransCanada was given the go-ahead to begin construction on a 485-mile stretch of the pipeline's southern leg, without even a thorough environmental review. Native protesters from Oklahoma (originally Indian Territory) were forced to speak from a fenced

commercial process has been applied to dispose of this effluent. ● Terry Evans, *South of Williston, south of Missouri River looking north, North Dakota*, April 2012. Evans has photographed the prairie for decades, beginning with "the untouched virgin prairie . . . now it has come to the point where the prairie is being very damaged and very changed." In her work on the Bakken oil fields, she makes strikingly visible those long-term changes, short-term economic benefits, and the underlying complexities.

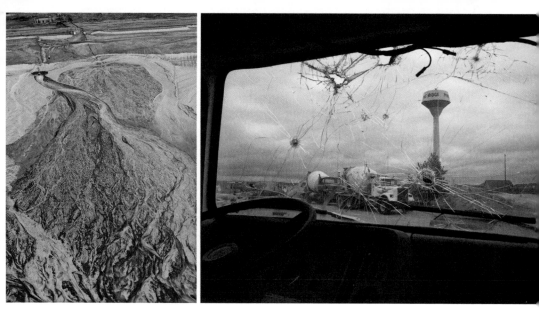

"cage" far from the President's speech announcing an apparent change of heart. Two years later the decision has been postponed yet again, stalled by news of serious conflicts of interest: the consulting firm contracted to decide whether the pipeline would or would not be "good for the environment" had lied about its strong industry ties. Ironically, "Black Eagle" Obama has done more for Native nations than any previous President. Yet on this issue, they are up in arms. Because the project will "desecrate known sacred sites and artifacts," the Crow tribe, which adopted him as a candidate, publicly stated its sense of betrayal. The Nez Perce tribe has blocked tar sands "megaloads" in Idaho, and Canada's First Nations joined the Yinka Dene Alliance of British Columbia on a "Freedom Train" to Toronto in April 2012.

Approval of the XL Pipeline will set back renewable energy production, produce three times the carbon emissions of regular mining, threaten drinking water across a swath of the continent, and destroy habitats for rare and en-

Louis Helbig, *Effluent Delta, N 57.13.58 W 111.33.48, Shell Albian Sands, Alberta, Canada*, 2008. In June 2013, in a victory for the wildlife of Spirit Bear Coast, the government of British Columbia announced its opposition to the Northern Gateway pipeline, but July brought the tar sands derailment disaster in Lac-Megantic, Quebec. The southern route is described as a Trojan horse bringing this "asphalt" not to, but through the U.S., endangering local environment for global

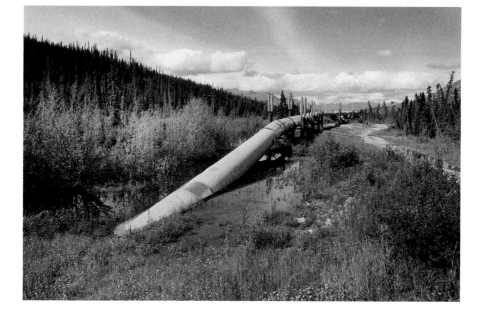

dangered species like whooping cranes, piping plovers, and American burying beetles. There have been major protests not only in the Northeast—since tar sands oil may also be shipped across Canada and New England to Portland, Maine—but even in Texas, where it threatens agriculture, public health, and property rights. By December 2012, Vermont had banned the pipeline, and Montana—where it will cross the Missouri and Yellowstone Rivers—had welcomed it. Nebraska was still thinking about it. So is President Obama.

There have already been at least fourteen spills along the pipeline's course since sections began to operate in June 2010. A crude oil spill in the Red Deer River in Alberta, Canada, following a much worse spill in late April 2011, was exacerbated by heavy rains. Cleanups cost millions, while local agriculture and the nation's food supply also suffer. Although the pipeline is touted as a path to cheap gas, a Cornell University research institute concludes that it would actually raise gas prices in the U.S. ten to twenty cents, particularly in fifteen central states,

export. ● John Willis, *Water Tower, Pine Ridge*, 2004. Each housing community on the Pine Ridge Reservation has a water tower, reminding the photographer of the poverty of the residents and the government's choices of apparently worthless property for reservations. ● John Ganis, *Alaska Pipeline, North of Valdez, Alaska*, 2001, chromogenic print. The occasionally leaky pipeline lies near the site of the disastrous Exxon-Valdez spill, since dwarfed by other disasters.

not to mention the increase in methane gases sent into the atmosphere. Despite Obama's admirable declaration for better fuel economy standards (the last significant update was in 1975), conversion to natural gas vehicles, cutting circa 25 percent of emissions (it's already a fact in Armenia), is waiting in the wings until someone dares to invest in it and construct stations across the country.

The XL pipeline is a line in the (tar) sand, weighing environmental catastrophe against our apparently inoperable national consumerism. A pipeline inspector turned whistleblower who reported on shoddy materials and sloppy construction on the XL has stated, "I am not telling you we shouldn't build pipelines. We just should not build this one."

"THE AMERICAN WEST HAS A DRINKING PROBLEM," WRITES Pete Zrioka. It is impossible to ignore water here. We watch the skies anxiously in an ever-expanding drought, and we ponder each conflicting report

Kim Stringfellow, *There It Is—Take It! Owens Valley and the Los Angeles Aqueduct, 1913–2013,* self-guided audio tour along U.S. 395 through Owens Valley, CA, examining the social, political, and environmental history of the Los Angeles Aqueduct system and illuminating the impacts of this divisive water conveyance infrastructure over its century-long history. Aqueduct stories are told from multiple perspectives in the voices of historians, biologists, activists, Native speakers, environmentalists, litigators, city employees, and residents of Los Angeles and the Owens

from developers and hydrologists. As climate change settles in, "the Southwest comes out as one of the big losers," writes deBuys, citing computer models indicating that by the mid twenty-first century, the region will have a fifth less available water than during the previous century, droughts included. We live in an "orphaned land" as V.B. Price puts it in his comprehensive book on New Mexico's environment.

Deep wells and mountain runoff are among the significant pits and erections of the New West. Wars over land here have always been wars over water, as desert land without water is "useless." Two old western sayings sum up the ongoing situation: "Whiskey is for drinkin', water is for fightin,'" and "Water runs uphill toward money." According to the EPA, 40 percent of the headwaters of western watersheds have been polluted by mining. Now these adages are applicable all over the globe, where available fresh water is less than 3 percent of the planet's water.

Valley. California is the first state to explicitly connect transportation and land use to the reduction of greenhouse gases. Half the billions of gallons of water imported from the Owens Valley diversion is now used simply to tamp down dust. ● Andre Ruesch, *Big Water at 760 Feet*, March 2002. Too much water is still drawn from domestic wells in the Southwest as federal and state agencies grapple with outdated regulations in the face of uncharted territory—a new norm (not just a serious "drought").

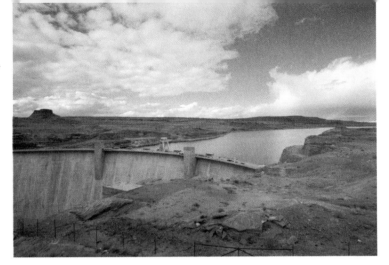

WATER
ABSENCE-PRESENCE

Average annual rainfall in New Mexico over the last two thousand years is 14.5 inches; in most areas, 2012 clocked less. After the last devastating long-term drought in the 1950s, the state had a welcome but dangerous thirty-year "wet" spell, then returned to normal, which is potential drought with no letup in sight. In 1956, when the Rio Grande dried up before reaching the Elephant Butte reservoir and ranching was devastated, rainfall was *above* the two hundred-year average. Yet population continues to grow, and the powers that be continue to permit irresponsible expansion. In 2002, New Mexico's water-cooled power plants each used 52 million gallons a year; fifteen new plants are imminent. How much fossil water is left underground? One thing is sure: sooner or later it's not going to be enough.

Most of New Mexico's water is stored in dynamic and variable aquifers below the surface, occupying small spaces between grains of sand or gravel and small cracks or fractures in the rock—notoriously difficult to chart.

Wanda Hammerbeck, *Untitled*, 1991, Lake Powell, Page, AZ. This dam on the Colorado River serves seven states as well as Mexico. Since the water was apportioned during a series of atypically wet years, the river is severely oversubscribed. Nearby is a golf course—a contentious presence in the West. Sustainable models include sand courses and those fed by effluent treated in ponds on the grounds (as at Santa Ana Pueblo's Tamaya Resort in New Mexico).

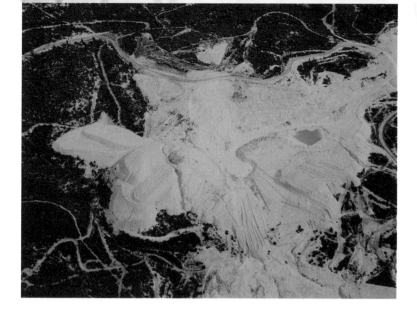

Groundwater is not wholly non-renewable like a mineral deposit, but it is not reliably renewable like scarce surface water. Most water that hits the ground is used up by plants and evaporation before it gets to the acquifers. Alluvial aquifers (like our Galisteo creek) lie in sand or gravel; other categories lie in other kinds of rocks—sandstone, limestone, etc. In unconfined aquifers, recharged by rain to some extent, the level of water is the level of the aquifer; in confined aquifers, like those in shales, not much water gets through.

The ankle-deep Rio Galisteo (which would barely pass for a creek in better watered regions) accumulates agricultural runoff in its short journey from the Sangre de Cristo Mountains to the Rio Grande, where it joins the waters committed to several states in two countries, the U.S. and Mexico. Downstream from Los Alamos, the Rio Grande is threatened by decades of sloppy nuclear waste burial. Sandia National Laboratories, which operated a nuclear weapons dump from 1959–88, "is estimated to contain 1.5 million cubic feet of

David T. Hanson, *Atlas Asbestos Mine, Fresno County, California* (detail), 1985, Ektacolor print, modified USGS map, and gelatin silver print text panel, 17½"x 47", from the series Waste Land, 1985–86. © 2013 David T. Hanson. Landscapes like these "are in dramatic flux, the kind that not only destroys life, but also shapes it and creates it anew. . . ." (Sarah Gilman, *High Country News,* January 23, 2012). (See Hanson, *Waste Land: Meditations on a Ravaged Landscape.* New York: Aperture, 1997.)

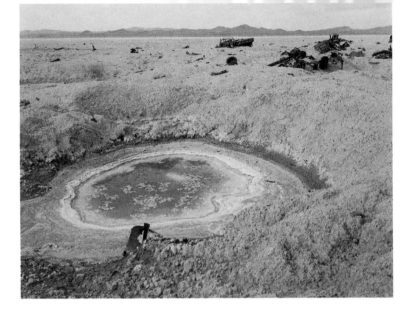

radioactive and hazardous wastes disposed in unlined pits and trenches." In late 2012, authorities triumphantly announced that they may have found the edge of the plume originating there that is threatening Albuquerque's drinking water aquifer. In 2013 they announced that a jet fuel line leak from Kirtland Air Force Base (rumored to be twice the size of the Exxon Valdez spill) has not (yet?) reached the city's water supply.

Given another saying—*aqua es vida* (water is life)—it makes sense that the tanks of our village's Mutual Domestic Water Consumers Association stand right between our two cemeteries. For close to a century, Galisteo farmers depended on *acequias* (Arabic for irrigation ditches) brought to northern New Mexico by the Spanish in the late sixteenth century, though the indigenous Hohokam of the Phoenix Basin had built an extraordinary ditch and canal system a millennium earlier. Over centuries of Native and Hispano culture, the acequia has represented communal endeavor. The large scale "American"

Richard Misrach, *Bomb Crater and Destroyed Convoy*, Bravo 20 Bombing Range, NV, 1986. Misrach describes the site on alkali flats between the Stillwater and Humboldt ranges and the Carson Sink, on land once occupied by Paiute tribes: "Only the smell of rusted metal. Bombs and lifeless holes. Side-by-side were great beauty and great horror. . . ." • Joan Myers, *Old Galisteo Cemetery and Community Water Tank*, 2013. Water was hauled in wagons to village

ditches of the nineteenth and twentieth centuries, like the Aztec and Inca ditches in northwestern New Mexico, were commercial schemes that sometimes paid off and sometimes didn't. But the little ditches in the precarious valleys of the Southwest, dug by the Spanish/Mexicans in the seventeenth and eighteenth centuries (a few wooden flumes still exist) made life possible. Galisteo's ditches were left high and dry when erosion—resulting from overgrazing, deforestation, railroad construction, and, some say, the eruption of Krakatoa halfway across the world—cut the creek 20 feet down into the arroyo, ending access and any future for farming in the village.

Mutual Domestic Water Consumers Associations are ubiquitous small independent community systems with a fixed number of water rights (Galisteo has 42.56 acre-feet annually; an acre-foot is roughly 326,000 gallons). This number does not change when communities grow, although the state is required to allow anyone not hooked up to the current system to dig a private

homes until 1962 when the first community water system was initiated by residents. ● Sharon Stewart, *Teddy at the Desagüe, the Annual Spring Cleaning of the Acequia Madre, El Cerrito, N.M.*, 1993. © Sharon Stewart. The desagüe is the gate used for flushing detritus from the freshly cleaned and recharged gravity flow irrigation ditch back into the Pecos River.

157

18 Black	21 Black	23 Black	33 Black	40 Red	44 Red	49 Off-white	51 White	52 White	54 Off-white

well using up to (and often more than) a quarter acre-foot annually. (I waited for almost eighteen years to hook up to the system, hauling water after my well went bad.) Few rural settlements in New Mexico have community sewers, and the dangers posed by makeshift septic tanks to clean water systems are becoming obvious. (When one old adobe home in Santa Fe was being tarted up, the septic tank was found to be a rusted Chevy chassis.)

Among the greatest changes—and indicative of how the old acequia culture is giving way to modernity—is the younger generation's proposal that those with more water rights have more votes, instead of the traditional one vote, one *parciante* (member). Even that democratic holdover, still employed by many acequias, has often succumbed to the use of proxies from family members still listed on deeds but no longer living on their land. When bonds to family, neighbors, and acequias weaken, outside forces can step in and take advantage of divided loyalties. Water rights become simply private property

Hydrologic Core. (Courtesy of the *Journal of Contaminate Hydrology*, vol. 99, nos.1–4, July 2008). At a meeting with a local hydrologist, I was drawn to a hydrologic core that showed soils 600 feet down in the Galisteo Basin, a cylinder extracted from the earth to analyze soils for pending development in my own neighborhood. "Core logs" offer subtly varying colors and textures, evoking eons of geologic history. This record of my turf was a "readymade" that would stand up in any gallery and had far-reaching implications for the area.

rights, contradicting "the very concept of water as a community resource," writes Kay Matthews, fearless editor of *La Jicarita*, who lives in El Valle, a village to the north that is smaller and more isolated than Galisteo and still maintains some agriculture and three acequias. She has dared to expose "what we don't talk about. . . . How the internecine bickering and demographic changes within this community are just as big a threat to acequia vitality as is the transfer of agricultural water to what the powers that be define as the 'highest and best' uses: urban, industrial, and recreational."

Water prices range from $12,000 per acre foot in some areas to $30,000 in other more desperate places. Surface water is prioritized over aquifer water (which requires more treatment). "Paper" water rights parallel "wet" water rights in labyrinthine legal squabbles that can last decades. Today, corporate forces are buying up small agricultural water rights to send to metropolitan centers, endangering river ecosystems, forcibly fallowing small farms, and diminishing

Simparch (Matt Lynch, Steve Badgett, et al.), *Solar Stills*, 2007, detail of *Hydromancy* at the Rubin Center, University of Texas, El Paso, an offshoot of their Dirty Water Initiative; sound from both sides of the Rio Grande by Steve Rowell. "Simple architecture" fuses pop culture and DIY engineering. Rio Grande water from a holding tank on the hilltop was purified in the stills, then dripped into the gallery, via a temporary aqueduct, forming a puddle and drinking "fountain." The apparatus was later donated to Mexican communities. **159**

local food production. This, in turn, cranks up the amount of energy expended and exacerbates climate change. In early 2012 a New York-based company applied to pump billions of gallons of groundwater from a ranch near Magdalena in southwestern New Mexico to make it available to the cities. It was the largest amount of water ever sought by a private entity—about twice what the city of Santa Fe currently uses in a year—and the application was totally speculative, intended for no specific project. Enraged locals protested, and eventually, to a state-wide sigh of relief, a newly appointed State Engineer turned down the request. This does not mean we have heard the last of it.

Elephant Butte Reservoir in south central New Mexico is the state's largest body of water. The dam was built in the early 1900s for flood control, irrigation, and water distribution. It has been described as the "Rio Grande bank account for Colorado, NM, Texas and Mexico . . . the place where their water debits and credits are counted" and the place where the buck stops in the

David Ondrik, *Elephant Butte*, 2004, archival pigment ink print. As a child, Ondrik boated and jet skied on the reservoir. Returning as an adult, he found a new island exposed by years of drought and "Please Add Water"—a local call for help—spelled out in stones on the ground. Some 75 percent of New Mexico's water goes to agriculture, which has simply "outgrown its water supply" (*High Country News*, February 18, 2013). • *Water Meter on Site of New Subdivision Overlooking the Galisteo Basin*, c. 2007.

midst of our periodic droughts, rising population, agricultural demands, and unstable climate. Were it not for the Buckman Direct Diversion (BDD) into the Rio Grande, tunneled through mountains from the San Juan and Chama Rivers to the west, northern New Mexico would already be in trouble; it provides some 50 percent of our water, more than twice as much as the sinking reservoirs. In December 2012 it was announced that if the drought continues, the water received from San Juan Chama by the Middle Rio Grande Water District may be cut by 20 percent. The cities will survive on storage for the time being, but farmers may have to cut their growing season by one week, and many small towns will also suffer. Even the astounding rains and devastating floods of September 2013 did not solve these problems.

The U.S. and Mexico have agreed on a five-year pilot project to update the Colorado Water Compact so it is more equitable, more efficient, more conservation-oriented, and to restore the badly damaged Colorado River

Bremner Benedict, *Dry Lake*, 2009, color print, from the Re-Imagining Eden series ("Wayfinding" chapter). This series describes the arc of a child's maturity and her gradual distancing from the natural world as she grows up. In "Wayfinding," the artist's daughter finds her identity in encounters with nature. In "Field Trip," she experiences a vanishing state of the natural world as a fantasy in natural history dioramas. Finally, in "Wanderer," she becomes a virtual girl in a simulated natural world painted on city walls.

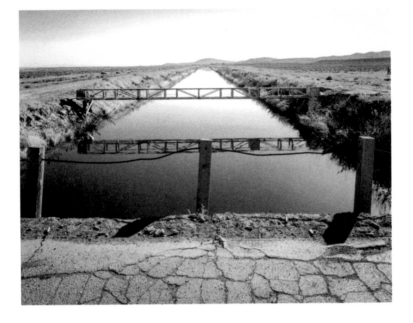

Delta. The New Mexico Interstate Stream Commission is in the process of updating the State Water Plan (covering sixteen water planning regions and twelve major river and groundwater basins) for the first time since 2003, and about time. But statewide planning, involving rivers that flow from one water district or county to another, one state to another, and one country to another via national and international water compacts, is a complex challenge. Mexican and Texan farmers are already fighting over water from the Rio Grande and Pecos Rivers. And as usual, Native water rights are even more precarious. Few Indian treaties deal with water in dependable legal terms, but in August 2013, the Navajo Nation was awarded enough water from the San Juan River to irrigate 40,000 acres of farmland, which was less than anticipated; its claims on the Colorado River could amount to more than 10 percent of the river's flow.

The Santa Fe River, running through the city, has been mostly dry for

Robert Dawson, *Shotgun shell casings and Truckee Canal, near Fernley, Nevada,* 1992, dye color print. Locals living along the Truckee River were skeptical about water restrictions despite living in an (unacknowledged) desert. "Why conserve water when it will just be gobbled up by casinos and developers? Might as well use it till it's gone," said one. And another: "I'm not going to let my lawn die if they are going to keep letting people from California move in and do here what they have done in L.A." (*A Doubtful River*).

162

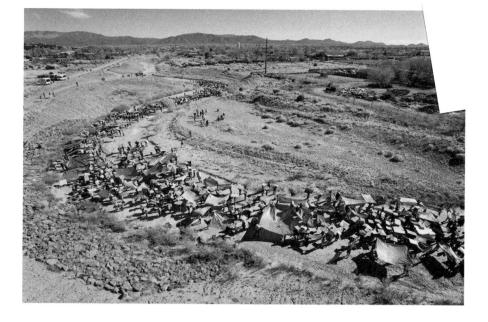

decades. Even during a recent year of dire drought, popular legislation was passed to release a paltry 1,000 acre-feet, in "pulses," to begin the restoration process. A "living" river is recommended not only for the ecosystem, quality of life, and survival of wildlife, but as an asset to tourism, always a consideration in the Land of Enchantment. While domestic rainwater harvesting seems to be a sensible decision, in some western states it is discouraged or even illegal because it swallows a large enough proportion of runoff to affect interstate and international compacts; eco-aware homeowners have actually been arrested. In parts of New Mexico, harvesting is encouraged. During peak summertime water use in Santa Fe, 44 percent of its water goes to landscaping, although the city is something of a role model, using only 105 gallons per capita per day—one of the lowest rates in the country (Phoenix uses circa 185 Los Angeles, 123). To avoid dry mouths, it is estimated that we will all have to get down to 85 gallons per capita by 2045.

Flash Flood, November 20, 2010, Santa Fe, NM (Photo: Michael Clark). The Santa Fe EARTH event, created by 350.org and the Santa Fe Art Institute, showed the Santa Fe River—one of the ten most endangered rivers in North America—with a blue "stream" running through it. Over one thousand people held up blue cardboard, tarps, or fabrics while a satellite passed over. A 2013 U.S. EPA report found that more than half the nation's rivers and streams are in biologically poor health.

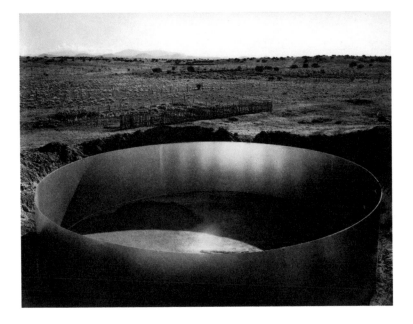

CLIMATE CHANGE UPS THE ANTE. A 2012 NRDC ANALYSIS FOUND

that twenty-nine of the fifty states have done little or nothing to prepare for the effects of climate change on their water supplies. Incredibly, New Mexico, Arizona, and Texas are among those that have done the least. New Mexico state regulators have unwisely overturned a feeble cap-and-trade program to control greenhouse gas emissions, despite the fact that May 2011 to April 2012 was the warmest consecutive twelve-month period on record in the contiguous U.S. Predictions are 3 to 6 (or 8) degrees hotter and 300-foot-higher sea levels by 2050. (In a quasi-art intervention, the Maldives Cabinet met underwater to make the point that rising seas will inundate their islands.)

While we may have heard too often that "everything is connected," there is no longer any doubt that it is. We ignore this truism at our risk. Water drained from the land undermines everything. Access to water should be a universal right, though not in plastic bottles. Global water security is already

Edward Ranney, *Water Storage Tanks Looking Northeast to the Sangre de Cristo Mountains, Chaquako, New Mexico,* 1974. Chaquako is an old ranch in the western Galisteo Basin where Ranney has lived for over forty years. ● Richard Misrach, *Dead Animals #327 ("Desert Cantos Canto VI: The Pit"),* 1987, digital chromogenic print, 30" x 37". The Bravo 20 bombing range in Nevada was described by the artist as "the most graphically ravaged environment I had ever

precarious. Well over half the world's population could face water shortages by 2025. And a handful of nations, including the U.S., are "guzzling their groundwater reserves" much faster than they can be renewed. We would rather have wars than collaborate on solutions to climate change. The creeping desertification of northern Africa serves as a ghastly warning for our own southwestern deserts. A recent U.S. intelligence report selfishly presented imminent water wars as a boon to the nation: we will pick up the slack on agricultural and industrial production made impossible in other countries by water scarcity. The need for genetically modified crops is also implied, which explains a recent ad from Monsanto headlined "How Can We Squeeze More Food from a Raindrop?" citing hybrid and biotech seeds as the answer. A blooming desert (like that in Israel, sustained by stolen Palestinian water) is only within reach by expending massive amounts of water—a contradiction in practice. Wealthy brokers continue to steal water, though the people of

seen." Along with burned out and abandoned tanks and weapons and toxic dumps of napalm and jet fuel, Misrach found pits of dead horses and cattle. (For a history of the military occupation of the American West, see Myriam Weisang Misrach's text in Misrach, *Bravo 20: The Bombing of the American West.* Baltimore: Johns Hopkins Press, 1990.)

Bolivia won a significant battle in 2000 when they pushed back the privatization of national water resources.

It is said that a good definition of a local is someone who gives more than they take. The same obviously goes for the global citizen. I'm always depressed by a much-quoted statistic: The U.S., with 5 percent of the population, uses 20 percent of the world's resources. Add China and it's almost 50 percent. Our way of life is endangering the whole world and those in charge seem powerless to stand up to the powers that profit from this global colonization. The poor pay the rich for their use and abuse of natural resources. Few Americans take into account the 95 percent of individual water consumption that is hidden, or indirect—like the 338 gallons needed to produce a 3-ounce steak, or the 2,900 gallons to make a pair of jeans, or the 44 gallons for one glass of orange juice. The true environmental cost of a McDonald's Big Mac is $200. Take it from there. . . . We can control our individual water footprints by paying

Robert Dawson, *San Francisco's entire water supply from Hetch Hetchey flows through this pipe, near Mather, California,* 1992, gelatin silver print.

attention to what kind of clothes and food we buy, how far they have had to travel, and at what cost, to reach our bodies—consumer's choice. (Those of us who shop mostly at thrift shops can smugly halve the expenditures.) The ever-diminishing flows, runoff, and monsoons should be haunting us. When all the water is sucked out from beneath us, we too go under.

PHOTOGRAPHY PLAYS A MAJOR ROLE IN COMMUNICATING land use issues to a public that resists change and takes our places for granted. Though we no longer see photography as "truth," and Photoshop has made lies easy, it still implies first-hand experience like no other medium, and works in the gap between art and life where I like to hang out. Art is a framing device for visual and social experience, and even photographic art forms cannot dispense altogether with the frame. Changing frames on the spot, offering a set of multiple views of the ways a space or place can be seen or used is

Postcommodity (Raven Chacon, Cristobal Martinez, Kade Twist, Nathan Young), *P'oeiwe naví ûnp'oe dînmuu (My Blood is in the Water)*, 2010, installation with sound (mule deer taxidermy, wood, water, red pigment, amplifier, drum), Museum of Contemporary Native Art, Santa Fe. The New Mexico-based Native multimedia collective deals with issues of land, culture and community, "pulsing as a beacon of indigenous noise." Dripping "blood" is amplified on the drum.

one alternative, now theorized as "sequencing." Since I began writing about photographs years ago, I see them everywhere, untaken, but framed, in my mind's eye. As Dorothea Lange once said, "A camera is a tool for learning how to see without a camera."

Yet without the aid of informative captions we have no idea what part of the world we're seeing—where it is, how it got that way, or what part of life it shelters. Socially engaged landscape photography is dependent on verbal contextualization. The photographer, having "been there," may feel she has captured the place, but communicating her fragments of insight to those who haven't been there or even to those who live there is another matter altogether. Cryptic, ironic, arty titles or captions, or none at all, distance the viewer from the subject by transforming it into a non-referential object, unleashed from anyone's reality.

The West's dramatic landscapes can be made merely melodramatic by generalized or banal imagery, overwhelming place with image, floating off

Michael Berman, *Bulldozed Spirals, Fowlkes Ranch, Texas, from the Chihuahuan Desert Project.* (See Charles Bowden in Bowden/Berman, *Trinity.* Austin: University of Texas Press, 2009.) ● Subhankar Banerjee, *Known and Unknown Tracks, Oil and the Geese,* 2006, 68" x 86", Teshekpuk Lake wetland, AK. The photograph was used in the campaign opposing oil and gas development in this Central Arctic wetland. Linear tracks on the tundra are from heavy seismic explora-

into artland on the wings of over-filtered clouds. These images are preferred by the apolitical connoisseur since they appear to have no content, though some of the most gorgeous have been used as propaganda to grease the wheels of manifest destiny and tourism. For this reason, all landscape photography can be implicated in the failure to articulate the social importance of landscape and land use. At the same time landscape photography has historically been a weapon in the battle to save the environment. With a critical edge, it can be a unique way of communicating many levels of places to those who will never see them first-hand.

The photographers represented in this book are among those who are deeply aware of the meanings embedded in their images, even when they are not obvious. Some, like Subhankar Banerjee, known for his stunning images of the Arctic and his eloquent advocacy on its behalf, declare themselves activists first and artists second. (Banerjee's *Climate Storytellers* blog is an integral part of his

tion vehicles used by oil companies. There should have been no development permits for this ecologically significant section of the wetland, but the George W. Bush administration opened up the area. Environmental groups and the indigenous Inupiat community filed a successful lawsuit against the U.S. Department of the Interior. For the moment the wetland remains development free, unlike many of its counterparts worldwide.

work.) Many are not challenging their medium in art world terms, because individual style may not be their primary concern; in fact, it can be difficult to distinguish their works. Yet there is a fundamental disjunction: when even the most critical photographs are exhibited, they become art objects. Their activism is in danger of being diminished by context. Where a view of the future, an imagined landscape, is called for, painting can be equally effective.

I think of a photograph as a field rather than an artifact, suggesting sequence, layers, and periphery even when the number of images is limited. In a sense, photography is the original readymade, "found" in the moment it is taken and again in the moment it is perused. As Jan Tumlir has suggested, the photographic process is subtractive, "literally a cut into the space time continuum. It is a minute, fragmentary part of an infinitely greater whole— the world that is shaved off at its edges." Photographers talk a lot about edges and the ethics of cropping, the effects on formal decisions and visual margins,

Amy Stein, *Howl*, 2007, chromogenic print, 24" x 30". (Collection the Nevada Museum of Art, The Altered Landscape, Carol Franc Buck Collection). The coyote is stuffed. "The use of taxidermy in the series is integral to its meaning and something I've been pretty open about," writes Stein. "Each image from the series is based on true stories of human/animal encounters in and around Matamoras, Pennsylvania," but it could be anywhere in the U.S. Coyotes rule. ● John

Willis, *The Mass Gravesite at Wounded Knee*, 2002. In 1890 the U.S. Seventh Cavalry massacred

as well as on marginality in the social landscape. The most powerful images present not just what we see; they are also haunted by what we don't see.

Photography has been called the only art form that is still disputed. Virtually every other medium (or esthetic strategy) has been welcomed into the "high art" canon . . . or dismissed as "low art." Photography remains in a kind of privileged limbo—even as it dominates the contemporary art scene with video, installation, documentation, testimony, and esthetic invention, even as it appears in museums, attracting more and more critical attention, perhaps precisely because it does remain contested ground. Scale has something to do with this. Movie screens and huge flat-screen TVs have set the mark. Photographers aiming for the museum/gallery scene realized long ago that size counts. In order to compete with contemporary paintings and sculpture, photographs sometimes rival in size the scenes themselves, recalling Jorge Luis Borges's map that was so detailed that it covered the entire area

more than two hundred Miniconjou and Hunkpapa Lakota, led by Chief Big Foot, who had already surrendered. In 1973, the Wounded Knee occupation by the American Indian Movement protested federal practices in Indian Country. Amnesty and open talks were promised but not delivered. ● Robert Adams, *A second growth stump on top of a first growth stump, Coos County, Oregon*, 1999 (Courtesy of Fraenkel Gallery, San Francisco; Matthew Marks Gallery, NYC). © Robert Adams.

it described. The longtime standard 8 x 10-inch or 20 x 36-inch prints now seem overly modest, especially when displayed in the increasingly cavernous galleries of New York's Chelsea art district. At the same time, looking in rather than out, better (and more expensive) technology allows extraordinary attention to detail; a new device will even refocus entire images, so the background becomes as sharp as the foreground. What does this mean for vision itself? A deeper map or a shallower one?

The context of documentary photography in particular—originally the purview of journalism rather than high art—has endowed it with a functional mission once associated in the public eye with infallibility, fueling a barrage of criticism over the last few decades. Spanish writer Pepe Baeza contends that both press and documentary images have become pawns of the advertising industry, a co-optation necessary to business because reality interferes and conflicts with marketing. Because the same images are used for everything,

Robert Adams, *Clearcut, Humbug Mountain, Oregon*, 2001, from his book *Turning Back*, a photographic journal on the anniversary of the Lewis and Clark expedition, including images of clearcutting in Oregon, where the photographer lives. (Courtesy of Fraenkel Gallery, San Francisco; Matthew Marks Gallery, New York). © Robert Adams. Adams has referred to this destruction of old growth forests as "ecocide." *Science News* (May 22, 2010) reports that some 3 percent of forests standing in 2000 were gone by 2005.

reality is reduced to "stereotypes that conceal the diversity of the phenomena to which they refer, and conceal the most obvious information—who is *bene-fiting* from such injustice and violence." While blockbuster photography, war correspondence, and the spectacular continue to get most of the attention, the social consequences *in place* are often neglected.

Landscape photography is a unique kind of documentation, and it has been redefined by any number of talented photographers, heirs to the 1970s New Topographers, who insisted on context and a seriality that is quasi-narrative, though inevitably fragmentary. "We rely, I think, on landscape photography to make intelligible to us what we already know," writes Robert Adams, whose serial approach to landscape photography gave it a new social life. "Landscape pictures can offer us 3 verities (truths): geography, autobiography, & metaphor. Geography is, if taken alone, sometimes boring, autobiography is frequently trivial, and metaphor can be dubious. But taken together . . . the three

Robert Adams, *Denver, Colorado*, 1973–74. (Courtesy of Fraenkel Gallery, San Francisco; Matthew Marks Gallery, New York; and Yale University Art Gallery). © Robert Adams. Adams was one of the first photographers to focus on the extent of western agricultural land being swallowed up by subdivisions and shopping malls. "No place is boring," he wrote, "if you've had enough sleep and have a pocket full of unexposed film." (See Robert Adams, *The New West*. New York: Aperture, 1974/2008).

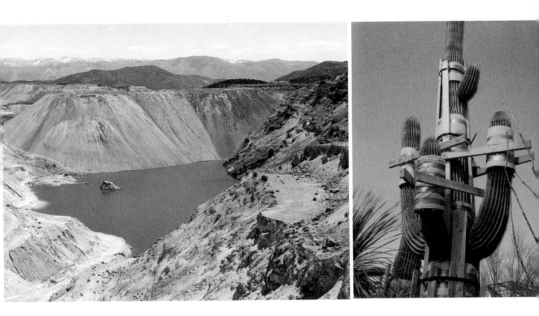

kinds of information strengthen each other and reinforce what we all work to keep intact—an affection for life. . . . What a landscape photographer traditionally tries to do is show what is past, present, and future at once. You want ghosts and the daily news and prophecy. . . . It's presumptuous and ridiculous. You fail all the time."

The battle between esthetics and reportage in landscape photography is an old one, but has yet to be resolved, which is a good thing, since it forces artists, critics, and environmentalists to carefully consider images and the artists' intentions. Driven by a short-lived conviction that there was no point in putting more stuff into the world, conceptual artists in the 1960s and 1970s focused on the appeal of absence rather than presence, the invisible rather than the visible, the dematerialized rather than the commodified object. The snapshot, often paired with Xeroxed texts (now called "photo-text work"), became a staple of Conceptualism.

Peter Goin, *The Liberty Pit*, Ruth, NV, 1986. In 1909, the Nevada Consolidated Copper Co. excavated the Liberty shaft, which became a large, open-pit copper mining operation, contaminating water supplies. By 1986, the pit was inoperable and filled with water. ● Judy Natal, *Wrapped Saguaro*, Las Vegas, NV, archival inkjet print from *Future Perfect* (2006–12): "a photographic sweep" of three sites where we can imagine the future: a sustainable Las Vegas desert preserve, Biosphere II's controlled ecosystems (Oracle, AZ), and Iceland's geothermal

Today, while specificity and local knowledge provide the base lines when the vortex of land and lives are being followed, a rich liminal space has opened up between disciplines, between "fine art," photography, geography, history, archaeology, and sociology—space occupied, for instance, by Trevor Paglen, whose "landscapes" follow the night skies and the black sites of governmental secrecy. He coined the term "experimental geography"—the title of an important exhibition. Curator Nato Thompson says Paglen "combines the tools of urbanism and cultural geography with those of contemporary art. . . . Using both tool sets (and the fields that inform them) allows him to consider knowledge as a complicated performance." CLUI is the leading contemporary model of this new conceptual art. Although its projects are often described as a maverick "land art," the center is actually a significant innovator in landscape photography—so much so that it has undermined the entire genre by reimagining what it might be in extra-art terms. Black Mesa, Mount

landscapes. ● Trevor Paglen, *Artifacts (Anasazi Cliff Dwelling, Canyon de Chelly, Spacecraft in Perpetual Geosynchronous Orbit, 35.78 kilometers above Equator)*, 2010. Some of the militarization of the West is invisible intrusion from above. Paglen suggests the abyss between celestial significance for those living in Canyon de Chelly in the thirteenth century and today's covert operations in space, using photography, astronomy, and "subversive geography" to represent the limits of vision.

Taylor, Zuni Salt Lake, Blackwater Draw, and the Chino Pit are the kind of layered and contradictory sites that are grist to its mill.

Many of these photographers have struggled with the beauty of ugliness. Photographs of wounds on the land, sculpturally destroyed or picturesque—graphic aerial shots or colorfully polluted waters—can be so striking that the message is overwhelmed and misery or horror is merely estheticized. On the other hand, beauty can powerfully convey difficult ideas by engaging people when they might otherwise turn away. Those who choose beauty for tragic subject matter are most effective when they're also aware of the flipside—when their choice of beauty is a conscious means to counter brutality.

WHERE DEVASTATED LANDSCAPES PROVIDE FODDER FOR photographic advocacy and raw materials for land art, the next hopeful step—in tandem with progressive land use politics—is a focus on actual re-

Center for Land Use Interpretation Photo Archive, *Cathedral Canyon, Nevada*, 1999. Religion rationalizes destruction. ● Patricia Johanson, *Ellis Creek Water Recycling Facility, Petaluma, California*, 2000–09 (detail). The project is a public park designed as a magnified image of living organisms (the Salt Marsh Harvest Mouse and Morning Glory pools), which simultane-

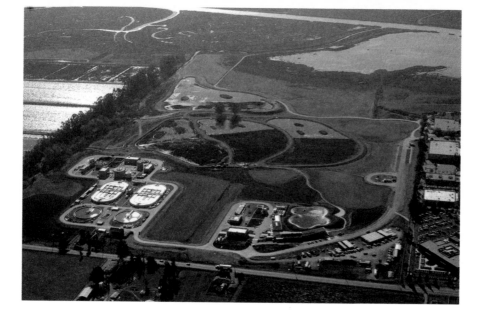

cycling, reclamation, or remediation. There are hundreds of thousands of exhausted sites littering the national landscape, waiting to be made meaningful: unsightly, dangerous quarries and mines, clearcut forests, slag heaps, mine shafts, trampled riparian areas, piles of hazardous waste leaking into our vulnerable waterways, and overgrazed pastures (victims of the Taylor Grazing Act of 1934). As Wes Jackson of the Land Institute in Salina, Kansas, often says in his pleas for agricultural polyculture to replace our disastrously expanding monocultures, "There's more to be discovered than invented." This caveat might have come from conceptual artists, recalling the Duchampian readymade esthetic. From Cubism and Dada to the present, artists have recycled society's detritus, sometimes to comment on its origins. Abandoned industrial sites begging for imaginative remediation, or damage control, qualify as large-scale found objects, but they are hard to access, not to mention running the gamut of endless bureaucratic rigmarole for permission, and finding

ously treats sewage, collects and cleanses stormwater, grows crops, creates wildlife habitat, and provides recycled water for urban and agricultural use (in the reservoir at the end of the mouse's tail). Nesting islands and duckweed (food for waterfowl) partially cover the water surface, keeping the system in balance.

the funds. There are Superfund sites that require superfunding. Money for art is way down the list. At the moment, in a nation with backwards, impotent environmental laws and without any cultural policy, there's little support for artists who want to challenge archaic regulations and create social and environmental change, especially in rural areas. Those brave enough to proceed must be braced for long confrontations, not just with the opposition but with clueless local bureaucracies. Maybe this is where the burgeoning global DIY (Do It Yourself) movement comes in, recalling the 1960s and 1970s when artists strove to act and make art independent of the commercial art world.

All of us concerned with the intersections of art, nature, and society (or "political ecology") need to learn how to read these competitive bureaucracies. Working primarily with art for years, I had no idea how complex and frustrating they could be until I started to get my feet wet, so to speak, in watershed protection, county open space, community planning, and local land

Hardrock Revision (Grant Pound, director), Colorado Art Ranch, Lake City, CO. Environmental artists at a 2011 interdisciplinary residency suggested restoration projects for toxic tailings at the Ute Ulay Mine (named for the Indians it displaced in 1873). The EPA has approved a $1.3 million cleanup. Bland Hoke, *Miners Tarp*, proposal to showcase and preserve the heritage of those who labored long ago (and protect the roof). • Linda Wysong, *Local Material*, photo collage—

timber headframe for pulley into mineshaft; gabions of different rock types.

use controversies. It's never easy. Among many cautionary tales is that of eco-artist Ciel Bergman, member of a group that invented and briefly produced plasphalt, a product consuming all types of unsorted waste plastic; it is now being used on highways in India and China, but the New Mexico company went bankrupt due to lack of local governmental support.

If we fail to heal what Karl Marx called "our metabolic rift with nature," it will just go on without us. New species will arise to replace those we have killed off. We need nature. Nature doesn't need us. It will simply be a different world. The model for reclamation art is often nature itself, in response to society's interventions. Nature takes what it is given but is likely to fight back in unexpected ways. And the assumption that her services are free disregards the trillions of dollars needed to restore our degraded ecosystems, as Jane Gleeson-White points out. Three quarters of American bird species depend on wetlands for rest, food, or nesting, but over the past two centuries

Anna McLeod, *Proposal for Watertower/Camera Obscura*, mixed media. The Ute Ulay's redwood tower becomes a viewing device where space, time, and presence collide. (See Emily Guerin, "It's a hardrock life," *High Country News*, February 4, 2013.) ● Shira Landman, *Adobe Mountain Lion*, Galisteo, c. 2005.

we have destroyed 60 acres of wetlands every hour. The devastating drought in Texas has dried up the wetlands necessary to migratory birds, and the BP oil spill in the Gulf of Mexico has made killing grounds of many habitats. As a result, gravel pits and even nuclear sites have become new eco zones (or potentially toxic parks)—partly because so much habitat is being destroyed by heedless growth that wildlife has to settle for what it can find. Abandoned pits and quarries become sanctuaries faster than anyone thought possible. A few years ago, an Ohio pit slated to become a landfill was discovered by migrating birds before people could act to make it a dump, which led to its (temporary) protection.

Although there are no illusions that anything can be returned to its "original" condition, art's purpose, as defined by James Baldwin, is "to lay bare the questions which have been hidden by the answers." Precedents for art as remediation have been set since the 1960s by Ukeles, Smithson, Holt,

Dorie Klein, *Deer, Birds Nest, at the Rocky Mountain Arsenal: Detoxification into Perpetuity,* 1994. A de-commissioned Army base in Denver—the largest Superfund site in Colorado—is being transformed into a (dangerous) wildlife preserve. ● M-12, *International School of Rural Experiences,* 2012, abandoned mine site, Nevadaville, CO. M-12 is a Boulder-based artists collective. This particular experiential "school" focused on mining sites and "ghost towns" in Gilpin County. Students felt "loss" and "vacancy" at the mine and remains of workers' housing; they com-

Helen and Newton Harrison, Johanson, Mary Miss, Agnes Denes, Stacey Levy, Rahmani, Lynn Hull, and Harriet Feigenbaum, among others. If the heyday of huge earthworks may be largely in the past, ambitious reclamation projects make sense. Here is a real and valuable function for artists who think big and really do want to escape cultural confines. (A one-percent-for-art program in the remediation/cleanup field would pick up the pace.) What is now called "eco art" differs from the earthworks of the 1960s and 1970s in its raised awareness of ecological issues and climate change, and in its strategies for invading infrastructural systems, sometimes collaborating with scientists. As theorist Timothy Morton has wryly observed, "we will lose nature, but gain ecology."

Ecosystems are local and specific. What goes for a forest in New Mexico does not go for a forest in Oregon or Brazil or Indonesia. Artists, architects, landscape architects, and sometimes community activists working together

posed memorial music, amplified with microphones dropped into the mine shaft. ● Peter Goin, *Old Town Mine View, Virginia, MN*, 1996. Some thirty-three people died in abandoned mine accidents between 1999 and 2007. Here a caged-in lookout protects sightseers from the potentially threatening landscape—a massive, heavily revegetated pit.

in urban contexts have come up with some provocative notions about how to transform the world's accumulating brownfields—from abandoned mines or railyards like the Santa Fe Railyard Park and Plaza, to immense factories and a cemetery in Europe. Pioneer solid waste artist Ukeles has worked for decades with the New York City Department of Sanitation. She pointed out almost forty years ago that it's no accident that so many women artists have tackled the handling of waste, maintenance, and cleaning up after civilization. Nature or nurture? Women identify with "nature," not because of "essentialism," but because we share with nature the dominant culture's attempts at control. Issues of urban waste management and recycling are also more accessible to artists than those at rural pits and mines hidden away in private preserves. Garbage is right at our doorsteps, domestic in every sense of the word, and it is free raw material, creative compost. Yet a paltry 2.5 percent of our waste is domestic; the rest is industrial and agricultural, out of the reach

Nancy Holt, *Drawing for Sky Mound: Sun Viewing Area with Pond and Star Viewing Mounds,* 1985, graphite on paper, 23½" x 47½". (Licensed by VAGA.) This project for a 50-acre landfill in the Hackensack Meadowlands, NJ, inspired by midwestern "Indian Mounds," was to be oriented to solstices and equinoxes, with pathways, a pond, and periodically flaming gas wells. After a decade of work, construction was halted. ● *Poison/Palate: The Bay Area in Your Body,* 2009. (Courtesy of Rebecca Solnit). Artwork by Sunaura Taylor; design by Lia Tjandra; cartogra-

POISON / PALATE

THE BAY AREA IN YOUR BODY

This is a little drama entitled The Mountain in the Greenhouse. The theme is the disruption living systems will undergo as the perturbations of global warming reverberate through the European high grounds. It is a drama being enacted in fast time if you happen to be a glacier but in slow time if you happen to be a person.

of most artists and activists demanding broader and more thorough schemes for remediation.

Interdisciplinary landscape studies programs are becoming popular at universities. Eco-artists and photographers involved in reclamation have begun to contextualize the history of production buried in the land. Some collaborate with nature on her own ground or on communal ground beyond the art context. A few collaborate in the field with grassroots environmental organizations. As their numbers increase, many of the barriers that separate the motives, thought patterns and educations of artists, activists, planners, and resource managers are being dismantled. Place-specific artists working in the public or within communities are becoming savvy not only about landscape design, but city planning and rural land use, infrastructure, traffic patterns, demographics, changing development regulations, zoning, water rights, land and stream reclamation, and inevitably, local politics and power

phy by Ben Pease; research and concept by Rebecca Solnit, from her book *Infinite City: A San Francisco Atlas*. Berkeley: University of California Press, 2010. ● Helen Mayer Harrison and Newton Harrison, *The Mountain in the Greenhouse*, 2001, video: a "little drama" about "the disruption living systems will undergo" as global warming takes its toll. Global research by Dr. Georg Grabherr shows that plants and their dependents move up the mountain with rising temperatures. Once at the top, there is nowhere to go.

structures. At an international art conference a few years ago in Cornwall, England, I was struck by the number of younger artists concerned with innovative practices on and about land—rural and urban. Looking for new angles from which to affect the ways we define and defile the natural, often without the ego adrenalin demanded by the art world, they aim to expose the layers of social and esthetic resonance in our relationships to local place, to tell the disparate stories about the intersections of land and lives, and expose the contradictions of twenty-first century political attitudes.

But what happens when a county or state (or nation, for that matter) has to say No More Growth because there's not enough water, for instance, to maintain the current population? Overpopulation is not the problem so much as overconsumption. Americans are immune to dire warnings about the distant future even since 9/11, even since Superstorm Sandy and her ominous sisters around the globe. We are reluctant to give up our vaunted quality of life even

Patricia Johanson, *Mary's Garden: Chrysanthemum coronarium (Mary's Seventh Sorrow: The Burial)*, 2009, acrylic/ink study for mine reclamation at Marywood University, Scranton, PA. Patterns are mining maps from the seven levels of the Marvine Colliery; miners' corpses remain below; culm banks, slag heaps, and waste ponds will be replaced by Johanson's pictorial wetlands, pond, and plantings. ● Futurefarmers, *Soil Kitchen*, Philadelphia, 2011. Temporary project by the San Francisco-based group (Amy Franceschini, lead artist), coinciding with the EPA's

as it crumbles before our very eyes, as money goes to ideological wars and support for the ever richer, instead of for social services and care of our lands. We prefer science fiction, wars of the worlds, star wars. In 1972, the authorial team of the controversial book *The Limits to Growth* predicted a cataclysm in the mid-twenty-first century if we kept going as we were then. We did. Today some say it is too late. But writer Chris Floyd insists that "this is the age of loss, not the age of defeat."

"Can a few conspicuous solar homes, constructed wetlands, bike paths, recycling industries, organic agricultural plots, and wind farms really be the key to saving the world?" asks Robert Thayer. "Isn't a much greater transformation needed in global economic, political and social institutions?" The answer to the last question has to be a resounding YES. "Sustainable capitalism" is a contradiction in terms because the entire system is based on growth, waste, and profits. As Slovenian philosopher Slavoj Žižek has quipped, it is

Brownfields Conference to pressure the city to deal with soil contamination. Free soup cooked by wind energy was exchanged for soil samples. ● Adriane Colburn, *Just Below (Sewer to Bay),* 2005, paper and ink, hung from 30' ceiling, Yerba Buena Center for the Arts. Installation charting the water course from the museum's pipes to San Francisco Bay through the city sewer system and wastewater treatment plants; layers of maps culled from the city's public library, sewer department, and California Historical Society.

easier to conceive of the end of the world than the end of capitalism. We have to wonder, with writer Charles Bowden, why can't we imagine a future where we *have* less but *are* more?

As Wallace Stegner wrote years ago, "The West is less a place than a process." Limerick argues that the ubiquitous industrial ruins of the American West must be seen as evidence of failure, rather than forgotten in favor of rarer successes. They offer lessons we ignore at our peril. Although I am astounded that so little is being done about climate change, and resigned to the vast amount of art that continues to isolate nature from culture and social justice, I hear Eduardo Galeano's counsel "to save pessimism for better times." The ubiquitous pits and erections can energize us. Bioregionalism offers strong tools for grassroots activism and visionary art. While there is not yet an appropriate context in place for artists responding to social energies and necessities (though some art schools are now on board), there is no reason

David T. Hanson, *Mine spoil piles and intersected water table*, 1984, Ektacolor print, 9 x 11", from the series Colstrip, Montana (1982–85). © 2013 David T. Hanson. Hanson was raised near Colstrip, which was once Crow tribal land. Wendell Berry writes that his photography "has given us the topography of our open wounds." (See Hanson, *Colstrip, Montana*. Fairfield: Taverner Press, 2010.) ● Mary Miss, *Connect the Dots: Mapping the High Water, Hazards and History of Boulder Creek*, 2007, mixed media. Blue discs indicating floodwater depth and extent at various sites in

IMAGINE SHAKING THIS LAND FROM BELOW STIRRING IT UP, TURNING IT UPSIDE DOWN TO EXPOSE ALL OF THE PLUNDERING AND EXPLOITATION, AND THEN SPREADING IT OUT AGAIN, WITHOUT A TOP AND WITHOUT A BOTTOM, EXCEPT FOR ITS MOUNTAINS AND VALLEYS

why artists should not be active participants in change. My guiding light for many years has been Antonio Gramsci's stirring call for pessimism of the intellect, optimism of the will.

"What sway does geographical specificity hold for the arts in today's cultural environment?" asks artist/poet Kenneth Goldsmith. "Over the past two decades, tremendous changes in technology, economics, and globalization have impacted the way artists live and work. Artists have sensed these changes and have responded with new forms of practice and distribution, skewing many of our long-held notions of geography. . . ." The rapid, complex maneuvers made possible by advancing electronic technologies offer new ways to collage or juxtapose vastly differing images and expose subtly connected issues. Intimate in content, but not in form, such inventive techno-ecological tactics raise a new cloud of questions for works embracing both local/global connections and disjunctures. The Internet—that amorphous and ominous

the city of Boulder made climate change visible to residents. Miss worked with local geologists and hydrologists for the exhibition *Weather Report: Art and Climate Change* at the Boulder Museum of Contemporary Art. In the fall of 2013, unprecedented floods proved Miss's premise.
● Oliver Ressler, banner, 2007–13, shown in public internationally as part of the artist's long-term project, *Alternative Economics, Alternative Societies*, begun in 2003.

mass in cyberspace—facilitates a multicentered community, even as social context and interaction remain specific. Spontaneous art activism—mass demonstrations, guerrilla actions, or political flash mobs—can be sparked by social networks, but ultimately it requires a face-to-face (not Facebook) meeting place, like Tahrir Square, or Occupy Wall Street's Zuccotti Park.

How well does culture stand up for nature in this disheartening morass? There has been a good deal of skepticism about international attempts to make art about society's failures. Despite good intentions, say some critics, artists have changed little and even alienated audiences. This is certainly true in some cases, but contemporary artists dealing with social/environmental issues no longer emulate the nineteenth-century avant-garde's desire to *épater le bourgeois*. To the contrary, they hope to appeal to broader audiences (though the bourgeoisie still comes in for some flack). Sometimes resistant art can wither when decontextualized, co-opted, and welcomed into the

The Yes Men (Mike Bonanno and Andy Bichlbaum), *We're Screwed*, 2009. At conferences and on TV, the Yes Men impersonate corporate officers announcing startling changes of heart on environmental issues. Their messages are picked up by the mass media, giving journalists excuses to cover the issues, while humiliating "big time criminals" and forcing them to angrily deny in public that they made any decisions for the common good. ● *Survivaballs*, 2009; very expensive refuges from the apocalypse, when all else fails.

mainstream, but the strongest works survive to move on upstream and spawn again. Without resorting to the quaint and the retrograde, many "biopolitical" artists and collectives are demonstrating that they can think micro and macro, local and global. Of course art cannot change the world alone, but it is a worthy ally to those challenging power with unconventional solutions.

IT MAY SEEM THAT WE HAVE TRAVELED FAR AFIELD FROM THE pits and piles of gravel and the towering erections threatening social gravity. But they are still out there, standing for the blurred boundaries between what we call the natural and the "human-made." This book documents only fragments of a moment in time. Almost every case study here could have been replaced by dozens of others as the narrative races on, becoming increasingly complex. Every issue raised here is in flux. Every outcome is a cliff hanger. My goal has been to take a rapid ride through a western landscape of beauty and

Judy Natal, *Biosphere II: Monet Experiment 2*, Oracle, AZ, archival inkjet print, 2006–12, from Future Perfect. © Judy Natal 2013. "Rising from the Arizona desert like the main terminal of a misplaced airport," this controlled biological experiment, bankrolled by a Texas oil man, "proved a true microcosm" of Biosphere I (planet Earth), "where venality, ideology, self-interest, and other elements of the globe's political ecology . . . have generated the greatest obstacles to solving environmental problems. . . ." (de Buys, *A Great Aridness*).

foreboding, flashing snapshots of damage, change and potential. If shallow change is the norm today, there is no escaping the storm of deep change on the horizon, whether or not we choose to pay attention. Aldo Leopold wrote: "We abuse the land because we regard it as a commodity belonging to us. When we can see land as a community to which we belong we may begin to use it with love and respect." On behalf of the land and everything living on it, new image wars must be waged.

Chris Jordan, *Running the Numbers: 320,000 Light Bulbs*, 2008. This is the number of kilowatt hours of electricity wasted in the U.S. every minute due to inefficient residential electricity usage (wiring, computers in sleep mode, etc.) Jordan has been graphically demonstrating our wasteful consumerism since 2005. (See Jordan, *Running the Numbers: An American Self-Portrait*. Munich: Prestel, and Pullman: Washington State University Museum of Art, 2009.)

NOTES

1. See Lucy R. Lippard, *Down Country: The Tano of the Galisteo Basin, 1250–1782*. Santa Fe: Museum of New Mexico Press, 2010. (Photographs by Edward Ranney).

5. Rimbaud in Daniel Mendelsohn, "Rebel, Rebel," *New Yorker*, August 29, 2011.

9. Henri Cartier-Bresson, in Susan Ratcliffe, ed., *People on People: The Oxford Dictionary of Biographical Quotations*. New York: Oxford University Press, 2001.

15. Chellis Glendinning, "Challenging Globalization: Returning to Place, interview with Chellis Glendinnning by Kay Matthews," *Eldorado Sun*, October 2002. See Glendinning, *Off the Map*. Boston: Shambhala, 1999.

18. William L. Fox, "Field Notes," in Mark Klett, *Third Views*.

26. David Owen, "Concrete Jungle," *New Yorker*, November 10, 2001.

28. Matthew Coolidge in Markonish, *Badlands*. CLUI's projects are described in its website and its newsletter, *The Lay of the Land* ("Margins in Our Midst" is in Winter 2003). The CLUI photographic database reveals the banal, the unorthodox, and the unseen.

33. See Douglas Preston, "Blackwater Draw: Mammoth Find Points to America's Ancient Hunters," *New Mexico Magazine*, November 1998; and Marc Simmons, *New Mexican*, April 3, 2010. Newer information from excavations at Buttermilk Creek, Texas, suggest even earlier dates—from 3,200 to 15,500 years ago, which may upend Blackwater Draw history. (See *Archaeology Southwest*, May 9, 2011, www.archaeologysouthwest.org.)

35. David Yubeta, quoted in Ariana Brocius, "Can Ruins Be Ruined?" *High Country News*, December 6, 2010.

37. See Edward Crocker's columns in *New Mexican*, 2005 to present. Portland Cement was invented in 1824 on the Isle of Portland, UK.

39. Alejandro Lopez, "Building in Adobe," *Green Fire Times*, September 2013.

40. Hassan Fathy, *Architecture for the Poor: An Experiment in Rural Egypt*. Chicago: University of Chicago Press, 1973.

40. Dennis Dollens, *Simone Swan: Adobe Building*. SITES Books, 2006 and *New Mexican Real Estate Guide*, April 2006.

46. Jewell Praying Wolf James, quoted in *New Mexican*, Dec. 2, 2002.

47. Dean MacCannell, *Empty Meetings Grounds: The Tourist Papers*. London: Routledge, 1992.

47. Andy Baldwin, quoted in *New Mexican*, April 24, 2001.

48. See Maybury-Lewis, Trope, and Ortiz, *American Indian Religious Freedom*.

56. Paul Robinson, "Challenges to Protecting Mount Taylor, *Voices from the Earth*, Summer 2010. See also Kay Matthews, "Mount Taylor Looms Large on the Horizon and in the Struggle Among Tribes, a Land Grant, and Ranchers," *La Jicarita*, November 30, 2012. lajicarita.wordpress.com.

60. Ben Neary, "Sacred Land Under Siege," *New Mexican*, January 7, 2001.

63. Jake Flake, quoted in *New Mexican*, December 13, 2001.

66. Personal communications with Kirk Bemis, Zuni Pueblo hydrologist and tribal member, 2012.

68. William Least Heat-Moon, *River-Horse*.

69. See Stephen Capra, "The Law That Keeps on Giving," *New Mexico Wild!*, Winter 2012, and Tony Davis, "Hardrock Showdown: Will the Forest Service Finally Say No to Mining?" *High Country News*, November 22, 2010. Another antiquated law is the Taylor Grazing Act of 1934 (with later modifications) allowing "ranchers," many of them the tax-break variety, to run cattle almost anywhere on public land in the West for a mere $1.36 per animal per month, subsidized, again, by American taxpayers. Given soil and waterway erosion, water pollution, and declining species whose wildlife refuges are overrun by bovines, "the consumption of more beef is stupid," opines Least Heat-Moon in *River-Horse*.

75. Daniel Kraker, "Is the Southwest's 'Last Real Stinker' on Its Last Legs?" *High Country News*, August 4, 2003.

77. Hopi water conference participants quoted in Brenda Norrell, "Covenant Broken," *Indian Country Today*, November 12, 2003.

80. Federal blog quoted in Susan Montoya Bryan, "Alternative Energy That's Close to Home," *New Mexican*, July 19, 2008.

90. The rough edges include cultural sensitivity that is often lacking in what northern New Mexican logger Ike DeVargas calls "enviromaniacs," or environmentalism *sin gente* (without the people). The editors of *La Jicarita* joined him in rejecting nature "disguised as a political construction in which some people claim to speak for a nature unrecognizable to the people who actually live there." (David Correa, *La Jicarita*, February 23, 2012. lajicarita .wordpress.com.)

92. Forms of travel: Chris Taylor, interviewed by William L. Fox in Taylor and Gilbert, *Land Arts of the American West*.

94. See Lucy R. Lippard, *On the Beaten Track: Tourism, Art and Place*. New York: The New Press, 1999, and Peter Goin and Lucy R. Lippard, *Time and Time Again: History, Rephotography and Preservation in the Chaco World*. Santa Fe: Museum of New Mexico Press, 2013.

97. Jon Margolis, "Do You Want More Wilderness?" *High Country News*, September 27, 1999, quoting William Cronon, "The Trouble with Wilderness, or, Getting Back to the Wrong Nature," in Cronon, ed., *Uncommon Ground*, New York: W.W. Norton, 1996.

99. Stephen J. Pyne, *How the Canyon Became Grand: A Short History*. New York: Penguin, 1988. See also Lucy R. Lippard, "Too Much: The Grand Canyon(s)," in Saunders, ed., *Nature, Landscape, and Building for Sustainability*.

102. David Brower quoted in Pyne.

102. Despite their inexplicable neglect, underfunding, and budget cuts, national parks bring $30 billion a year to the U.S. economy.

103. *High Country News*, July 25, 2011. The list includes Navajo Nation land leased for a feedlot for ten thousand cattle owned by a Brazil-based company. The New West's progress, and lack thereof, is chronicled weekly by *High Country News*, out of Paonia, CO, "for people who care about the west."

107. Louise Abel in Eichstaedt, *If You Poison Us*.

110. Dorothy Purley, quoted in Kay Matthews, "Uranium Boom and Bust: 'Otra Vez?' Part One," *La Jicarita*, August 4, 2012. lajicarita.wordpress.com.

113. Area B at LANL had been cleaned up at the cost of $110 million, but in 2012 the lab insisted that the expense was too great to continue cleaning up. The alternative, of course, is that LANL itself, increasingly at risk from uncontrollable wildfires in the Jemez Mountains, will become an informal permanent dump site.

114. As it was recently explained to me by Emergency Manager and Assistant Fire Chief Martin Vigil of the Santa Fe County Fire Department, there is no evacuation plan in place for U.S. 285, the WIPP route, for good reason: the choices are so limited in the current infrastructure, and unpredictable wildfires are the largest threat in the area. Santa Fe is one of the top counties in the U.S. in training for radiation risks, but Vigil says he is less worried about WIPP trucks—a known factor—than Wal-Mart trucks, because one has no idea of their contents: vegetables or pesticides.

116. Peter Hessler, "Letter from Colorado: The Uranium Widows," *New Yorker*, September 13, 2010. See also Michael A. Amundson, *Yellowcake Towns: Uranium Mining Communities in the American West*. Boulder: University Press of Colorado, 2002.

125. Basharat Peer, "Modern Mecca," *New Yorker*, April 16, 2012.

127. See Mary Marshall Clark, Peter Bearman, Catherine Ellis, and Stephen Drury Smith, eds., *After the Fall: New Yorkers Remember September 2001 and the Years That Followed*. New York: The New Press, 2011.

130. John Brinckerhoff Jackson, *The Necessity for Ruins and Other Topics*. Amherst: University of Massachusetts Press, 1980.

130. Rebecca Solnit, "After the Ruins," *Art Issues*, November–December 2001. Susana Torre, "Constructing Memorials," in Okui Enwezor et al, eds., *Documenta 11, Platform 2: Experiments in Truth*. Kassel: Documenta, 2001.

132. Joseba Zulaika, "Tough Beauty: Bilbao as Ruin, Architecture and Allegory," *Neon*, Winter 2000–01.

135. Matthew Irwin, "The Swedish West," *Santa Fe Reporter*, February 1, 2012.

139. Allen Best, "The Zombies of Teton County," *High Country News*, March 5, 2012, and Ed Marston, "The Once and Future West," *High Country News*, October 8, 2001.

140. Terry Tempest Williams, *Red: Passion and Patience in the Desert*. New York: Pantheon, 2001.

141. (Pumping fractures) quoted in Eric Konigsberg, "Kuwait on the Prairie," *New Yorker*, April 25, 2011.

145. When the Northeast became aware of fracking (already a major issue in the West), its much larger and more active artist population began to organize in opposition, including Yoko Ono and her son Sean Lennon.

146. Jeff Goodell, "The Big Fracking Bubble: The Scam behind Aubrey McClendon's Gas Boom," *Rolling Stone*, March 1, 2012. www.rollingstone.com.

146. Richard Heinberg contends that the fracking boom is "slouching toward bust"; production rates are flattening or declining because of environmental degradation and increasing expense paired with diminished returns (*Common Dreams*, August 24, 2013).

149. Andrew Nikiforuk, "Stephen Harper's Tar Pit," *Adbusters America*, Summer 2012; and "Insert Pipeline Here," *OnEarth*, Fall 2012.

151. Exxon's seventy-year-old Pegasus pipeline suffered major spills in Arkansas and Missouri in 2013. Yet even a spill of 1.7 million gallons would not trigger TransCanada's leak detection system. In addition, petcoke, an Alberta tar sands byproduct, has been dumped by the synonymous Koch Carbon Company along the Detroit River without any permitting process. The Bakken oil fields could be tied into the XL pipeline and it is well known that other

companies are lining up to build their own pipelines whether or not TransCanada fails. Yet it has also been pointed out that so far the production capacity of these companies exceeds their distribution capacity. Proponents claim that water and energy use is being cut significantly with new technology and that even if we produced all our own energy, prices would still be determined by the global market. If we import tar sands oil from Venezuela, it would be just as bad for the planet. In August 2013 an Associated Press article by Jonathan Fahey reported that rising production from new fields could lower oil prices. "But if big oil companies can't earn strong profits at today's oil prices, it may mean prices will have to rise higher to convince them to aggressively explore new fields. If they worry they can't make enough money, they'll cut back."

152. Pipeline inspector quoted in ThinkProgress, January 3, 2012. www.thinkprogress.org. The pipeline's proposed route was eventually changed to avoid Nebraska's Sand Hills.

152. Pete Zrioka, "Desert Southwest an Oasis or Mirage?" May 3, 2012, *Research Matters*, http://researchmatters.asu.edu.

154. For example, the acequia in Mesilla in Rio Arriba County, NM served seventeen families in the 1950s and now serves around two thousand.

155. See the three hundred-page report by Robert Gilkeson and Dave McCoy, "Defective Groundwater Protection Practice at the Sandia National Laboratories, Mixed Waste Landfill—the Sandia MWT Dump," 2011.

159. Kay Matthews, "The Political Economy of Acequias: From Democratic Communalism to Business as Usual?" *La Jicarita*, May 20, 2012. lajicarita.wordpress.com.

160. Elephant Butte: Staci Matlock, "Walk on History," *New Mexican*, December 17, 2011.

161. The climate-related floods in Colorado in September 2013 drowned gas and oil field infrastructure, as well as agricultural fields, releasing fuel and toxic chemicals into the entire environment. In addition, around two years ago the EPA approved the breaching of plutonium holding ponds at Rocky Flats and they were drained into local creeks. According to activist LeRoy Moore, the post-flooding results of such short-term stewardship have not yet been determined.

162. Forty million people in seven western states share the Colorado River water, and the demand already exceeds the supply. At the same time, Nestlé annually extracts 265 million liters of fresh water from British Columbia to bottle and sell, paying absolutely nothing for it, thanks to the lack of proper regulation from the provincial government.

164. In May 2012, land artist Chris Drury's handsome abstract sculpture, *Carbon Sink* (a spiral of raw logs level with a grassy campus lawn) was removed by the University of Wyoming within months of its installation, purportedly due to industry complaints. The state legislature then passed a law requiring the approval of all future art displays at the university's new gym.

168. Dorothea Lange, quoted in *Los Angeles Times*, August 13, 1978.

170. Jan Tumlir, "John Divola," *Afterimage*, May/June 2012. See Jana Prikryl, "Erosion," *The Nation*, December 12, 2011. See also Jon Anderson's Letter to the Editor and Prikryl's response, *The Nation*, January 12, 2012.

175. Nato Thompson in "The New Geography," panel edited by Jeffrey Kastner, *Bookforum*, April–May 2009. See *Trevor Paglen: A Compendium of Secrets*. Giessen, Germany: Kerber Art/Kunsthalle Giessen, 2010.

179. In a letter to the editor of the *New Mexican* (December 2, 2012), Bergman complained that "Recycling answers are there but ignored."

179. Jane Gleeson-White, *Double Entry: How the Merchants of Venice Created Modern Finance*. New York: W.W. Norton, 2012.

181. Lost nature: Timothy Morton, "The Dark Ecology of Elegy," in Karen Weisman, ed., *The Oxford Handbook of the Elegy*. London: Oxford University Press, 2010.

185. Chris Floyd, "Empire Burlesque: This Is Not the Age of Defeat," *Counterpunch*, April 2013.

185. Robert Thayer Jr., *Gray World, Green Heart: Technology, Nature and the Sustainable Landscape*. New York: Wiley, 1994. The book discusses topophilia, technophilia, and technophobia.

185. Slavoj Žižek, quoted in Rebecca Mead, "The Marx Brother," *New Yorker*, May 5, 2003.

186. Charles Bowden, paraphrased by Phillip Connors, "Not So Pretty Horses, Too," *The Nation*, September 30, 2002.

186. Wallace Stegner, *Where the Bluebird Sings to the Lemonade Springs*. New York: Random House, 1992.

187. Antonio Gramsci, *Letters from Prison*, New York: Harper and Row, 1973.

187. Kenneth Goldsmith, "Regionalism Reconfigured," *2006 Report*, Pew Fellowships in the Arts, Philadelphia, 2007.

190. Aldo Leopold, *A Sand County Almanac*. New York: Oxford University Press, 1966.

Nancy Holt, *Concrete Poem*, 1968, from original 126-format transparency, Las Vegas, Nevada (licensed by VAGA). "The black plastic letters were arranged haphazardly on the concrete stairs. . . ." Holt was on a summer trip with Robert Smithson and Michael Heizer.

SELECTED READINGS

The following periodicals, among others, are always pertinent: *High Country News, La Jicarita, Voices from the Earth,* and *OnEarth.*

Robert Adams, *Beauty in Photography*. New York: Aperture, 2005.

American Indian Religious Freedom: First People and the First Amendment, special issue of *Cultural Survival Quarterly*, Winter 1996. (Includes essays by David Maybury Lewis, Jack F. Trope, Alfonso Ortiz, and others.)

Thomas Barrow and Kristin Barendsen, eds., *Photography New Mexico*. Albuquerque: Fresco Fine Art Publishing, 2008.

John Beardsley, *Earthworks and Beyond*. New York: Abbeville Press, 1984.

Andrew Boyd, ed., *Beautiful Trouble: A Toolbox for Revolution*. New York: OR Books, 2012.

Matthew Coolidge, Sarah Simons, and Ralph Rugoff, *Overlook: Exploring the Internal Fringes of America with the Center for Land Use Interpretation*. New York: DAP, 2006.

Robert Dawson, Peter Goin, and Mary Webb, *A Doubtful River*. Reno: University of Nevada Press, 2000.

William deBuys, *A Great Aridness: Climate Change and the Future of the American Southwest*. New York: Oxford University Press, 2011.

Timothy Egan, *Lasso the Wind: Away to the New West*. New York: Alfred A. Knopf, 1999.

Peter H. Eichstaedt, *If You Poison Us: Uranium and Native Americans*. Santa Fe: Red Crane Books, 1994.

Jack Flam, ed., *Robert Smithson: The Collected Writings*. Berkeley: University of California Press, 1996.

David Frankel, ed., *Foreclosed: Rehousing the American Dream*. New York: Museum of Modern Art, 2012.

Peter Goin, ed., *Arid Waters: Photographs from the Water in the West Project*. Reno: University of Nevada Press, 1992.

Suzanne Gordon, *Black Mesa: The Angel of Death*. New York: John Day Company, 1973.

Morris Hundley Jr., *Water and the West: The Colorado River Compact and the Politics of Water in the American West* (second edition). Berkeley: University of California Press, 1975/2009.

Kristen Iversen, *Full Body Burden: Growing Up in the Shadow of Rocky Flats*. New York: Crown Publishers, 2012.

J.B. Jackson and Helen Lefkowitz Horowitz, ed., *Landscapes in Sight: Looking at America*. New Haven: Yale University Press, 1997.

Bart Kaltenbach, Barbara Anschel, and Steve Fitch, *Sun Sticks & Mud: 1000 Years of Earth Building in the Desert Southwest*. Madrid, NM: La Sombra Books, 2012.

Jeffrey Kastner and Brian Wallis, eds., *Land and Environmental Art*. New York: Phaidon, nd.

Mark Klett, ed., *Third Views, Second Sights: A Rephotographic Survey of the American West*. Santa Fe: Museum of New Mexico Press in association with The Center for American Places, 2004.

Mark Klett, *Reconstructing the View: The Grand Canyon Photographs of Mark Klett and Byron Wolfe*. Berkeley: University of California Press with the Phoenix Art Museum and The Center for Creative Photography, 2012.

Jake Kosek, *Understories: The Political Life of Forests in Northern New Mexico*. Durham: Duke University Press, 2006.

William Least Heat-Moon, *River-Horse: A Voyage Across America*. Boston: Houghton-Mifflin, 1999.

Timothy J. LeCain, *Mass Destruction: The Men and Giant Mines That Wired America and Scarred the Planet.* New Brunswick: Rutgers University Press, 2009.

Lucy R. Lippard, *The Lure of the Local: Senses of Place in a Multicentered Society.* New York: The New Press, 1997.

Jack Loeffler and Celestia Loeffler, *Thinking Like a Watershed: Voices from the West.* Albuquerque: University of New Mexico Press, 2012.

Denise Markonish, ed., *Badlands: New Horizons in Landscape.* North Adams: Mass MoCA, 2008.

Daniel McCool, *Native Waters: Contemporary Indian Water Settlements and the Second Treaty Era.* University of Arizona Press, 2006.

Andrew Menard, *Sight Unseen: How Fremont's First Expedition Changed the American Landscape.* Lincoln: University of Nebraska Press, 2012.

Peter Pool, ed., *The Altered Landscape.* Reno: Nevada Museum of Art and University of Nevada Press, 1999.

V.B. Price, *The Orphaned Land: New Mexico's Environment Since the Manhattan Project.* Albuquerque: University of New Mexico Press, 2011.

Sylvia Rodriguez, *Acequia: Water Sharing, Sanctity, and Place.* Sante Fe: SAR Press, 2006.

Andrew Ross, *Bird on Fire: Lessons from the World's Least Sustainable City.* New York: Oxford, 2012.

Hal K. Rothman, ed., *Reopening the American West.* Tucson: University of Arizona Press, 1998.

Julie Sasse, *Trouble in Paradise: Examining Discord Between Nature and Society.* Tucson: Tucson Museum of Art, 2009.

William S. Saunders, ed., *Nature, Landscape and Building for Sustainability.* Minneapolis: University of Minnesota Press, 2008.

Polly Schaafsma, *Indian Rock Art of the Southwest.* Albuquerque: University of New Mexico Press, 1987.

Kathleen Shields, Bill Gilbert, and Suzanne Sbarge, eds., *Land/Art New Mexico*. Santa Fe: Radius Books, 2009.

Robert Smithson, see Flam.

Robert A. Sobieszak, *Robert Smithson: Photo Works*. Albuquerque: University of New Mexico Press with Los Angeles County Museum of Art, 1993.

Rebecca Solnit, *Storming the Gates of Paradise: Landscapes for Politics*. Berkeley: University of California Press, 2008.

Michael Sorkin and Sharon Zukin, eds., *After the World Trade Center: Rethinking New York City*. New York: Routledge, 2002.

Kim Stringfellow, *Greetings from the Salton Sea: Folly and Intervention in the Southern California Landscape, 1905–2005*. Chicago: The Center for American Places at Columbia College, 2011.

Stringfellow, *Jackrabbit Homestead: Tracing the Small Tract Act in the Southern California Landscape, 1938–2008*. Chicago: The Center for American Places at Columbia College, 2009.

Chris Taylor and Bill Gilbert, *Land Arts of the American West*. Austin: University of Texas Press, 2009.

William M. Thayer, *Marvels of the New West: A Vivid Portrayal of the Stupendous Marvels in The Vast Wonderland West of the Missouri River* Norwich: Henry Hill Publishing Company, 1890.

Nato Thompson, ed., *Experimental Geography: Radical Approaches to Landscape, Cartography, and Urbanism*. New York: Independent Curators International, 2008.

Touring the Postmodern West, special issue of *High Country News*, June 25, 2012.

Katherine Ware, *Earth Now: American Photographers and the Environment*. Santa Fe: Museum of New Mexico Press, 2011.

Chris Wilson, *The Myth of Santa Fe: Creating a Modern Regional Tradition*. Albuquerque: University of New Mexico Press, 1997.

Ann M. Wolfe, ed., *The Altered Landscape: Photographs of a Changing* **199**

Environment. Reno: The Nevada Museum of Art and New York: Skira/Rizzoli, 2011.

Ann M. Wolfe, ed., *The Way We Live: Contemporary American Indian Art of the Great Basin & Sierra Nevada*. Reno: Nevada Museum of Art, 2012.

Xin Wu, *Patricia Johanson and the Re-Invention of Public Environmental Art, 1958–2010*, Burlington: Ashgate Publishing Company, 2013.

Linda Wysong, "On Location: Hardrock Revision," *Public Art Review*, Fall/Winter 2011, pp. 62–63.

Steven A. Yates, ed., *The Essential Landscape: The New Mexico Photographic Survey with Essays by J.B. Jackson*. Albuquerque: University of New Mexico Press, 1985.

Judy Tuwaletstiwa, *Northern Arizona*, c. 2010.